P9-CQR-664

PHOTOSHOP
for Lightroom Users

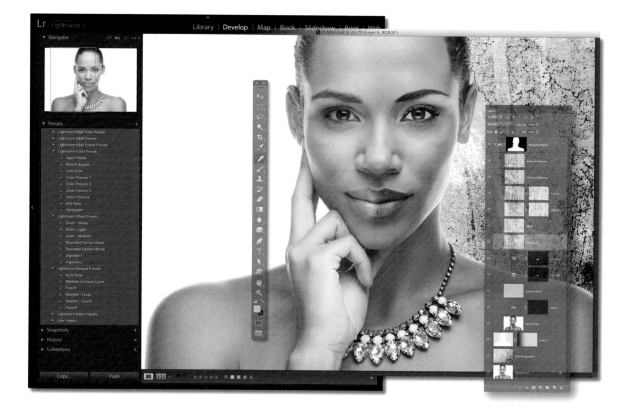

Scott Kelby

The *Photoshop For Lightroom Users* Team

Creative Director
Felix Nelson

Technical Editors
Cindy Snyder
Kim Doty

Art Director
Jessica Maldonado

All Photography By
Scott Kelby

Published by New Riders

Copyright ©2014 by Scott Kelby

All rights reserved. No part of this book may be reproduced or transmitted in any form, by any means, electronic or mechanical, including photocopying, recording, or by any information storage and retrieval system, without written permission from the publisher, except for the inclusion of brief quotations in a review.

Composed in Univers LT and Zag Bold by Kelby Media Group, Inc.

Trademarks

All terms mentioned in this book that are known to be trademarks or service marks have been appropriately capitalized. New Riders cannot attest to the accuracy of this information. Use of a term in the book should not be regarded as affecting the validity of any trademark or service mark.

Photoshop, Photoshop Lightroom, and Photoshop Elements are registered trademarks of Adobe Systems, Inc.

Macintosh and Mac are registered trademarks of Apple Inc.

Windows is a registered trademark of Microsoft Corporation.

Warning and Disclaimer

This book is designed to provide information about Adobe Photoshop Lightroom and Adobe Photoshop for digital photographers. Every effort has been made to make this book as complete and as accurate as possible, but no warranty of fitness is implied.

The information is provided on an as-is basis. The author and New Riders shall have neither liability nor responsibility to any person or entity with respect to any loss or damages arising from the information contained in this book or from the use of the discs, electronic files, or programs that may accompany it.

THIS PRODUCT IS NOT ENDORSED OR SPONSORED BY ADOBE SYSTEMS INCORPORATED, PUBLISHER OF ADOBE PHOTOSHOP LIGHTROOM AND ADOBE PHOTOSHOP.

ISBN13: 978-0-321-96870-8

ISBN10: 0-321-96870-0

9 8 7 6 5 4 3 2 1

http://kelbytraining.com
www.newriders.com

*This book is for my dear
friend and editor, Ted Waitt.*

ACKNOWLEDGMENTS

I start the acknowledgments for every book I've ever written the same way—by thanking my amazing wife, Kalebra. If you knew what an incredible woman she is, you'd totally understand why.

This is going to sound silly, but if we go grocery shopping together and she sends me off to a different aisle to get milk, when I return with the milk and she sees me coming back down the aisle, she gives me the warmest, most wonderful smile. It's not because she's happy that I found the milk; I get that same smile every time I see her, even if we've only been apart for 60 seconds. It's a smile that says, "There's the man I love."

If you got that smile, dozens of times a day, for nearly 24 years of marriage, you'd feel like the luckiest guy in the world, and believe me—I do. To this day, just seeing her puts a song in my heart and makes it skip a beat. When you go through life like this, it makes you one incredibly happy and grateful guy, and I truly am.

So, thank you, my love. Thanks for your kindness, your hugs, your understanding, your advice, your patience, your generosity, and for being such a caring and compassionate mother and wife. I love you.

Secondly, a big thanks to my son, Jordan. I wrote my first book when my wife was pregnant with him (16 years ago), and he has literally grown up around my writing. Maybe that's why he's so patient as he waits for me to finish a page or two so we can go play *Call of Duty: Black Ops 2* with all his friends, and my buddies Matt, RC, Brad, Hans, and Jeff. He's such a great "little buddy" to me, and it has been a blast watching him grow up into such a wonderful young man, with his mother's tender and loving heart. (You're the greatest, little buddy!)

Thanks to our wonderful daughter, Kira, for being the answer to our prayers, for being such a blessing to your older brother, and for proving once again that miracles happen every day. You are a little clone of your mother, and believe me, there is no greater compliment I could give you. You're my little sweetie!

A special thanks to my big brother, Jeff. I have so much to be thankful for in my life, and having you as such a positive role model while I was growing up is one thing I'm particularly thankful for. You're the best brother any guy could ever have, and I've said it a million times before, but one more surely wouldn't hurt—I love you, man!

My heartfelt thanks go to my entire team at Kelby Media Group. I know everybody thinks their team is really special, but this one time—I'm right. I'm so proud to get to work with you all, and I'm still amazed at what you're able to accomplish day in, day out, and I'm constantly impressed with how much passion and pride you put into everything you do.

A warm word of thanks goes to my in-house Editor Kim Doty. It's her amazing attitude, passion, poise, and attention to detail that has kept me writing books. When you're writing a book like this, sometimes you can really feel like you're all alone, but she really makes me feel that I'm not alone—that we're a team. It often is her encouraging words or helpful ideas that keep me going when I've hit a wall, and I just can't thank her enough. Kim, you are "the best!"

I'm equally as lucky to have the immensely talented Jessica Maldonado (a.k.a. "Photoshop Girl") working on the design of my books. I just love the way Jessica designs, and all the clever little things she adds to her layouts and cover designs. She's not just incredibly talented and a joy to work with, she's a very smart designer and thinks five steps ahead in every layout she builds. I feel very, very fortunate to have her on my team.

ACKNOWLEDGMENTS

Also, a big thanks to my in-house tech editor Cindy Snyder, who helps test all the techniques in the book (and makes sure I didn't leave out that one little step that would take the train off the tracks), and she catches lots of little things others would have missed.

The guy leading this crew of creative superstars is none other than my friend (and Creative Director), Felix Nelson, whose limitless talent, creativity, input, and flat-out great ideas make every book we do that much better.

To my best buddy and book-publishing powerhouse, Dave Moser (also known as "the guiding light, force of nature, miracle birth, etc."), for always insisting that we raise the bar and make everything we do better than anything we've done before.

Thanks to my friend and business partner, Jean A. Kendra, for her support and friendship all these years. You mean a lot to me, to Kalebra, and to our company.

A huge, huge thanks to my Executive Assistant, Susan Hageanon, for all her hard work and for handling so many things so well that I have time to write books.

Thanks to my Editor Ted Waitt at Peachpit Press. Like Kim Doty does in-house, you do outside by helping me feel connected to "the mothership." Thanks for all your hard work and dedication to making the kind of books that make a difference. Also, thanks to my Publisher Nancy Aldrich-Ruenzel, and her team, including Sara Jane Todd and Scott Cowlin. (Lest we forget Gary-Paul.)

Thanks to Adobe Product Manager Tom Hogarty for answering all my late-night emails, and to Bryan O'Neil Hughes for helping out in such an impactful way throughout the original development of this book.

I owe a special debt of gratitude to my buddy, Matt Kloskowski, for being such an excellent sounding board (and sometimes tech editor) during the development of this book. Your input made this book better than it would have been.

Thanks to my friends at Adobe Systems: Terry White, Jim Heiser, Winston Hendrickson, Mala Sharma, John Nack, Scott Morris, Greg Wilson, Bryan Lamkin, Julieanne Kost, and Russell Preston Brown. Gone but not forgotten: Barbara Rice, Cari Gushiken, Rye Livingston, John Loiacono, Kevin Connor, Addy Roff, and Karen Gauthier.

I want to thank all the talented and gifted photographers who've taught me so much over the years, including: Moose Peterson, Joe McNally, Bill Fortney, George Lepp, Anne Cahill, Vincent Versace, David Ziser, Jim DiVitale, Cliff Mautner, Dave Black, Helene Glassman, and Monte Zucker.

Thanks to my mentors, whose wisdom and whip-cracking have helped me immeasurably, including John Graden, Jack Lee, Dave Gales, Judy Farmer, and Douglas Poole.

Most importantly, I want to thank God, and His Son Jesus Christ, for leading me to the woman of my dreams, for blessing us with two amazing children, for allowing me to make a living doing something I truly love, for always being there when I need Him, for blessing me with a wonderful, fulfilling, and happy life, and such a warm, loving family to share it with.

OTHER BOOKS BY SCOTT KELBY

*The Adobe Photoshop Lightroom Book
for Digital Photographers*

*Professional Portrait Retouching Techniques
for Photographers Using Photoshop*

The Digital Photography Book, parts 1, 2, 3 & 4

*Light It, Shoot It, Retouch It: Learn Step by Step
How to Go from Empty Studio to Finished Image*

The Adobe Photoshop Book for Digital Photographers

The Photoshop Elements Book for Digital Photographers

The iPhone Book

Photoshop Down & Dirty Tricks

*Photo Recipes Live: Behind the Scenes: Your Guide to Today's
Most Popular Lighting Techniques*, parts 1 & 2

ABOUT THE AUTHOR

SCOTT KELBY

Scott is Editor, Publisher, and co-founder of *Photoshop User* magazine, Executive Editor and Publisher of *Lightroom* magazine, and host of *The Grid*, the weekly, live, webcast talk show for photographers, as well as the top-rated weekly video webcast, *Photoshop User TV*.

He is President of the National Association of Photoshop Professionals (NAPP), the trade association for Adobe® Photoshop® users, and he's President of the training, education, and publishing firm, Kelby Media Group, Inc.

Scott is a photographer, designer, and award-winning author of more than 50 books, including *The Adobe Photoshop Book for Digital Photographers*, *The Adobe Photoshop Lightroom Book for Digital Photographers*, *Professional Portrait Retouching Techniques for Photographers Using Photoshop*, *Light It, Shoot It, Retouch It: Learn Step by Step How to Go from Empty Studio to Finished Image*, *The Photoshop Elements Book for Digital Photographers*, and *The Digital Photography Book*, parts 1, 2, 3 & 4.

For the past three years, Scott has been honored with the distinction of being the world's #1 best-selling author of photography books. His book, *The Digital Photography Book*, part 1, is now the best-selling book on digital photography in history.

His books have been translated into dozens of different languages, including Chinese, Russian, Spanish, Korean, Polish, Taiwanese, French, German, Italian, Japanese, Dutch, Swedish, Turkish, and Portuguese, among others, and he is a recipient of the prestigious ASP International Award, presented annually by the American Society of Photographers for "…contributions in a special or significant way to the ideals of Professional Photography as an art and a science."

Scott is Training Director for the official Adobe Photoshop Seminar Tour and Conference Technical Chair for the Photoshop World Conference & Expo. He's featured in a series of Adobe Photoshop training DVDs and online courses at KelbyTraining.com and has been training Adobe Photoshop users since 1993.

For more information on Scott, visit him at:

His daily blog: **http://scottkelby.com**

Twitter: **@scottkelby**

Facebook: **www.facebook.com/skelby**

Google+: **Scottgplus.com**

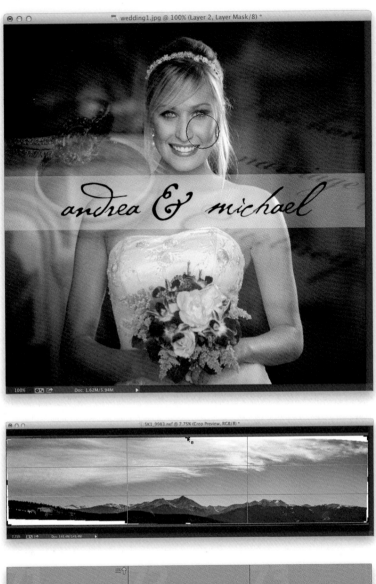

SEVEN THINGS YOU'LL WISH YOU HAD KNOWN BEFORE READING THIS BOOK

I really want to make sure you get the absolute most out of reading this book, and if you take two minutes to read these seven things now, I promise it will make a big difference in your success with Photoshop, and with this book (plus, it will keep you from sending me an email asking something that everyone who skips this part will wind up doing). By the way, the images shown below are just for looks. Hey, we're photographers—how things look matters to us.

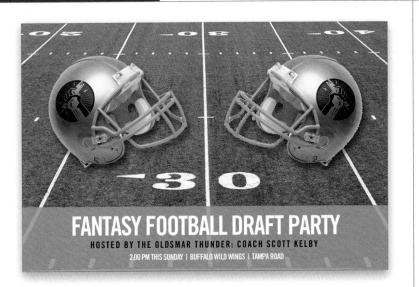

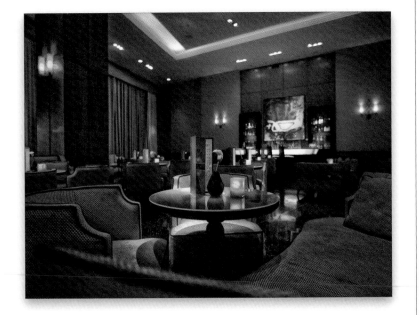

(1) You can download many of the key photos used here in the book (and the video I mention in #7 on the next page), so you can follow along using many of the same images that I used, at **http://kelbytraining.com/ books/PSforLR**. See, this is one of those things I was talking about that you'd miss if you skipped over this and jumped right to Chapter 1. Then you'd send me an angry email about how I didn't tell you where to download the photos or watch the video. You wouldn't be the first.

(2) If you've read my other books, you know they're usually "jump in anywhere" books, but since you're new to Photoshop, I would really recommend you start with Chapters 1 and 2 first, then you can jump to anywhere else in the book and you'll be fine. But, hey, it's your book—if you decide to just hollow out the insides and store your valuables in there, I'll never know. Also, make sure you read the opening to each project, up at the top of the page. Those actually have information you'll want to know, so don't skip over them.

(3) The official name of the software is "Adobe Photoshop CC." But, if every time I referred to it throughout the book, I called it "Adobe Photoshop CC," you'd eventually want to strangle me, so from here on out, I usually just refer to it as "Photoshop." Same thing with "Adobe Photoshop Lightroom 5." I just refer to it as "Lightroom." Just so you know.

(4) The intro page at the beginning of each chapter is designed to give you a quick mental break, and honestly, they have little to do with the chapter. In fact, they have little to do with anything, but writing these quirky chapter intros is kind of a tradition of mine (I do this in all my books), but if you're one of those really "serious" types, I'm begging you, please skip over them, because they'll just get you really irritated. I'm not kidding.

(5) At the end of the book is a special bonus chapter, where I cover things you might think you need to jump over to Photoshop for, but ya don't. I call this chapter "12 Things You'd Think You'd Need Photoshop For, But Ya Don't." Apparently, I like the direct approach. Anyway, it's worth checking out because although there are definitely times we absolutely need to jump over to Photoshop, if we can do the same (or similar) thing in Lightroom, it's usually quicker to do it there.

(6) What if this book makes me fall deeply in love with Photoshop? That wouldn't be a bad thing, ya know, and if that happens, I got ya covered with one of those big 500+-page books that covers everything you'd ever want to do (as a photographer) in Photoshop. It's called *The Adobe Photoshop Book for Digital Photographers* (I know, the name is kinda, well, direct), but don't worry about that right now—we've got plenty of work to do here first.

(7) I created a short bonus video for you. It shows you step by step how to use Photoshop to edit videos. I didn't include this in the book, because there's no direct link between Lightroom and Photoshop for editing your videos. It's basically an all-Photoshop kind of thing. When you're done with your video, you can import the final completed video back into Lightroom just so you can watch it there, but this is really a standalone Photoshop production. Anyway, I still thought you might dig it, so I made a video especially for you. See? I care.

ESSENTIAL TECHNIQUES

THE BASIC STUFF YA GOTTA KNOW FIRST

It's a tradition in all my books to use song, TV show, or movie titles for the names of the book chapters. In this case, it's a song title because I found a song that is actually named "Technique." It's a rap tune from a band named Def Shepard, which seems like a wink and nod to the big hair '80s band Def Leppard (either that or it's a shout-out to all those hearing-impaired sheep herders out there). Anyway, I have to say, that whole idea of taking part of an existing band's name and just changing a letter or two is brilliant! Not only is it much easier than coming up with a new name from scratch, but when people hear the name, they think, "Hey, I think I've heard of them before" and—boom—you've got instant name recognition and that translates into more record sales (well, it would if they actually still sold records). For years now, I wanted to be a rapper (they always look like they're having so much fun in those beer commercials), and I even had my rapper name all picked out: I was going to be "Plain White Rapper." But, now I'm thinking I should do what Def Shepard did and use a derivative of an existing band name. So, how about if I named my band, Bed Zepplin? Or maybe AC/BC? I thought The Rolling Jones might be nice, or how 'bout Elton Johnny, and I could do a song called "Goodbye Mellow Brick Toad"? Now, if you're a teen, you might be so young that you've never heard of these bands, so if my East Coast hip-hop style was aimed at this highly sought-after teen demographic, then I would go with a name like Mr. Gaga or Justin Timberpond. Or, if I wanted to go the rap route, I could be 51 Cent or Dr. Drayage, M&Ms, or my favorite, Snoop Scotty Scott (oh yeah, Snoop Scotty in da hiz-zay!). Now, if you're wondering, "What in the world does this have to do with Photoshop?" then you must have skipped over #4 in the "Seven Things You'll Wish You Had Known Before Reading This Book" back in the book's introduction. Peace out. Fo shizzle!

#1:
USING PHOTOSHOP'S TOOLBOX

You'll find all of Photoshop's tools in the vertical Toolbox on the left side of the screen. Now, while there are quite a number of tools in the Toolbox (compared to Lightroom's six tools), don't sweat it because there are a whole bunch of them we never ever use. Plus, once you see how Photoshop handles working with tools, you'll realize that it's much easier than it appears at first glance. Here are the most important things to know about Photoshop's Toolbox:

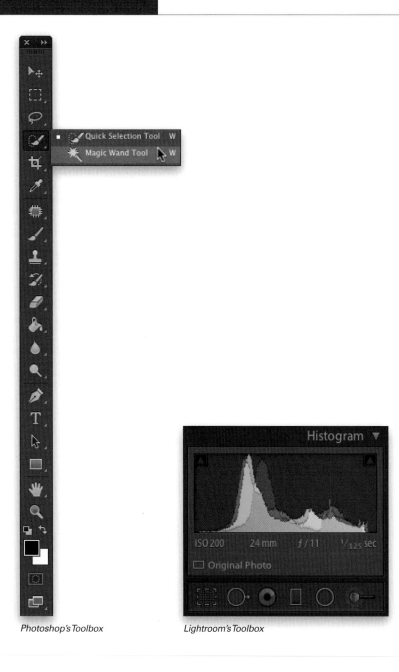

Photoshop's Toolbox

Lightroom's Toolbox

THE TOOLBOX:

You're probably already familiar with using tools since Lightroom has a horizontal toolbox in the Develop module, right below the Histogram (shown here, on the right). Of course, it only has six tools, whereas Photoshop has 71 (don't worry, you don't have to learn them all. As photographers, we actually only use a few of these tools). Photoshop's Toolbox is vertical (seen here, on the left) and runs along the left edge of the screen (although, if you want it somewhere else, you can click-and-hold right on the little tab at the top of it, drag it right off the edge, and it becomes a floating Toolbox you can put wherever you want).

ACCESSING OTHER TOOLS:

The tools you see when you look at Photoshop's Toolbox are the ones that Adobe figured you'd use the most. But, if you see a little triangle in the bottom-right corner of a tool's button, this means there are other tools nested (hidden) beneath that tool. Click-and-hold on one of those tools, and a little menu pops up displaying other tools (the "nested" tools). For example, if you click-and-hold on the Dodge tool, the Burn tool and Sponge tool (for desaturating) appear. In the example shown here, if you click-and-hold on the Quick Selection tool, its cousin, the Magic Wand tool, appears.

KEYBOARD SHORTCUTS:

Most tools have a one-key keyboard shortcut assigned to them. Some are obvious, like you'd press L to get the Lasso tool or B to get the Brush tool, but then there are some that are not so obvious, like pressing V will get you the Move tool. This one-key shortcut thing is great, but the problem is there are 71 tools, but only 26 letters in the alphabet. So, nested tools have to share shortcuts. For example, pressing the letter I will get you the Eyedropper tool, but there are two other eyedropper tools, plus a few other tools, all nested under the Eyedropper tool, and they all share the same shortcut. To toggle through any nested tools, just add the Shift key. For example, each time you press Shift-I, it brings the next nested tool to the front as the active tool.

MOST TOOLS HAVE OPTIONS:

When you click on a tool, any features or controls for that tool appear up at the top of the screen in the Options Bar (shown here are some of the Magic Wand tool's options). To return these options to their default settings, Right-click on the tool's icon in the left side of the Options Bar and choose **Reset Tool** from the pop-up menu.

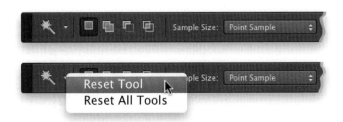

Continued

Color Picker (Foreground Color)

OK

new

Cancel

Add to Swatches

current

Color Libraries

⊙ H:	236	°	○ L:	30	
○ S:	85	%	○ a:	48	
○ B:	84	%	○ b:	-91	
○ R:	32		C:	88	%
○ G:	44		M:	80	%
○ B:	214		Y:	0	%
#	202cd6		K:	0	%

☐ Only Web Colors

FOREGROUND & BACKGROUND COLORS:

There are two large color swatches at the bottom of the Toolbox: the top one is your Foreground color and the bottom one is your Background color. If you're painting with a brush, the Foreground color swatch will show you the color you'll be painting with (in our example on the left, our current Foreground color is black). The Background color swatch shows the color the Eraser tool uses (here, it's white). To change colors, click once on a swatch to bring up Photoshop's Color Picker. Click in the gradient bar in the center to choose your color, then click in the large square on the left to choose how vibrant the color will be. To reset the color swatches to their defaults (black/white), press the letter **D**. To swap the Foreground/Background colors, press the letter **X**.

Unlike Lightroom, by default, Photoshop's panels are all on the right side of the screen (there are no panels on the left side, just the Toolbox). But also, unlike Lightroom, most of Photoshop's 26 panels are hidden from view (you can find them all by going under the Window menu). Again, like with the tools, there are only a few photographers actually use. Also, some of the shortcuts for viewing and making your way around your images will be very familiar to Lightroom users. (*Note:* I'm working in Application Frame here, so you can see the full Photoshop window. You can turn this off, though, by going under the Window menu.)

ZOOMING IN/OUT:

You zoom in/out in Photoshop using the same keyboard shortcuts that you use in Lightroom: **Command-+** (plus sign; **PC: Ctrl-+**) to zoom in and **Command--** (minus sign; **PC: Ctrl--**) to zoom out. If you want to fit your image as large as it can fully be viewed within Photoshop, just double-click directly on the Hand tool in the Toolbox, as shown here (its icon is a hand). To jump right to a 100% (1:1) view, just double-click on the Zoom tool (its icon is a magnifying glass). If you want to zoom right in to a particular area, then get the Zoom tool **(Z)** and click-and-drag it in the area you want to zoom in tight on. Lastly, once you are zoomed in tight, you can use the scroll bars on the right and bottom of the image window to move around, but it's easier to just press-and-hold the **Spacebar** on your keyboard, which temporarily switches you to the Hand tool, so you can click-and-drag around the image.

VIEW ANY PERCENTAGE YOU LIKE:

You can also type in any amount of zoom you'd like right in the zoom amount field in the bottom-left corner of the image window (shown circled here in red). For example, when I double-clicked on the Hand tool, so the image fit within my screen, it set the magnification at 25.02%. But, as you see in the previous image, that only fills the screen side-to-side. So, I clicked inside that zoom amount field, typed in 29% (as seen here), and now it fills the entire window (like Lightroom's Fill command).

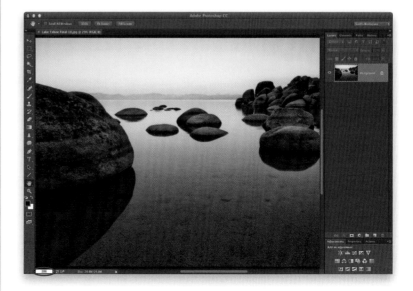

Continued

WORKING WITH PANELS:
To hide all the panels from view (including the Toolbox on the left and Options Bar at the top), press the **Tab key** and you'll get the view you see here—just your image, with no panels or Toolbox. If you only want the panels hidden, and to keep the Toolbox and Options Bar still visible, then press **Shift-Tab** instead.

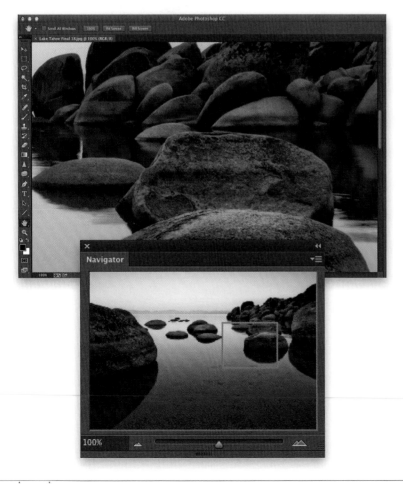

PHOTOSHOP'S NAVIGATOR PANEL:
If you like Lightroom's Navigator panel, there's one here in Photoshop, too. Go under the Window menu and choose **Navigator**. Once the panel appears, use the slider beneath the image thumbnail to zoom in/out (dragging to the right zooms in tighter; to the left zooms out). Once you've zoomed in, you can click-and-drag the red rectangle to where you want the zoom focus to be (as seen here).

COLLAPSING PANELS:

To give you more room to view your image, Photoshop gives you three ways to view your panels (shown here, from top to bottom): (1) full panel view gives you a full view of the panel(s); (2) click on the two tiny right-facing arrows at the top-right corner of a panel, and that panel(s) collapses down to just its name and icon; or (3) click-and-drag the divider bar between the image window and a panel over to the right, and it collapses the panel(s) to just its panel icon. To see any panel full size, just click on its icon. To see all nested panels again, click on the two tiny left-facing arrows at the top right of the top panel icon.

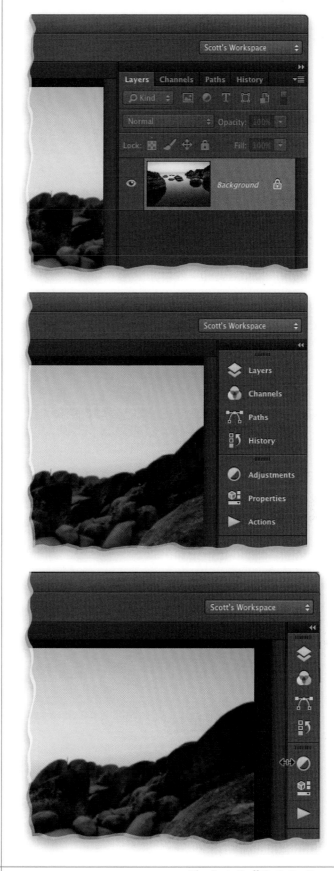

#3:
EDITING JUST PART OF YOUR IMAGE

In Lightroom, all the sliders in the Develop module pretty much affect the entire image at once. So, if you wanted to affect just part of an image, you'd get the Adjustment Brush and paint over the area you wanted to affect. In Photoshop, you can also do that (well, to some extent), but if you want to edit just one part of your image, you use Photoshop's Selection tools (there is a tool for every type of selection imaginable, which is one of the things that makes Photoshop so powerful). Here are the primary Selection tools you'll use the most (even though we'll cover others later in the book):

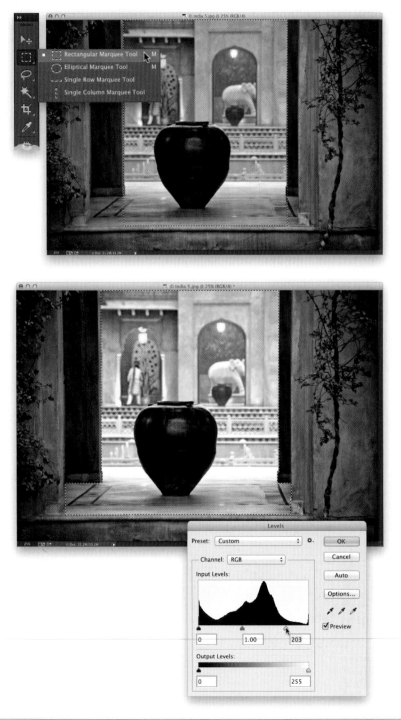

MAKING RECTANGULAR SELECTIONS:

If the area you want to select is either square or rectangular, there's one tool that does both: the Rectangular Marquee tool (I think they call it "marquee" because the animation that shows where the boundary of your selection is looks like a Holly-wood movie marquee twith chasing lights, but most folks call the boundary "the marching ants"). You just choose this tool (it's the second tool from the top in the Toolbox, or press **M**) and se-lect an area to work on by clicking-and-dragging a rectangle out over that area. Now, only that selected area will be affected by whatever you do to it (as seen here, where I drew a rectangular selection between the columns. And, now, if I were to lighten or darken the image, only the area inside that rect-angle would be affected).

ADDING OR SUBTRACTING FROM YOUR SELECTED AREA:

Once you have a selection in place, if you want to add more areas to it, just press-and-hold the **Shift key** and drag out more rectangles. That's what I did here where I selected the areas under the left and right columns by dragging out smaller rectangles. If you want to subtract an area from your selection, press-and-hold the **Option (PC: Alt) key** instead and click-and-drag over that area (which is what I did on the sides and very bottom of the col-umns). (*Note:* You can use these keys to add/subtract from selections made with any Selection tool.) Now that all those areas are selected, I brightened them by going to Photoshop's Levels command and dragging the Highlight slider to the left, as seen here (more on Levels later).

DESELECTING & SQUARE SELECTIONS:

If you want to remove your selection altogether (called "deselecting"), press **Command-D (PC: Ctrl-D)**. If you want to make a square selection (rather than a rectangle), just press-and-hold the Shift key, then click-and-drag out your selection and it will be perfectly square (as seen here). Once again, any changes I make will now just affect that selected square area, as seen here, where I went to the Levels command again and brightened the highlights. (By the way, Levels is found under Photoshop's Image menu, under Adjustments, and it lets you adjust the highlights [the white slider on the far right under the graph—drag to the left to brighten], the midtones [the gray slider in the middle—drag right to darken the midtones; left to brighten], and the shadows [the black slider on the left—drag to the right to make the shadows darker]. This is what we used before Camera Raw and Lightroom.)

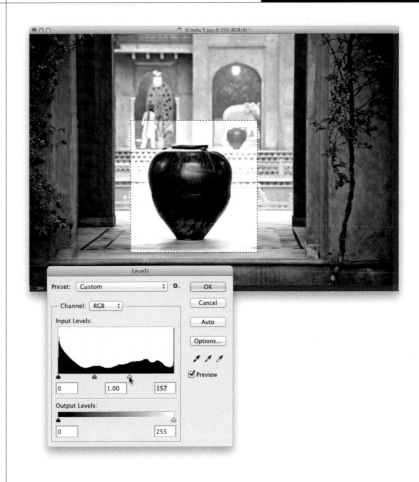

STRAIGHT LINE SELECTIONS:

Not every object with straight lines is a rectangle or a square, but there's a tool for that: the Polygonal Lasso tool (it's nested beneath the Lasso tool; press **Shift-L** until you have it), which lets you draw a selection made up of straight lines (for example, if you wanted to select a stop sign or a yield sign, you'd use this tool). It kind of works like a connect-the-dots tool: You click it at the point where you want to start, move your cursor to the next corner and click, it draws a straight line between the two points, and then you continue on to the next point. When you get back to where you started, click on the first point again and it creates the selection (that's how I selected the column on the left here. I started at the top-right corner and worked my way around, and then I brightened the highlights with Levels).

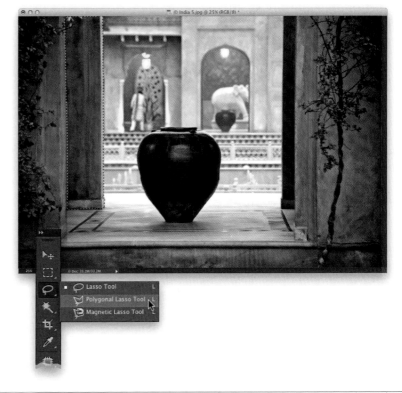

Continued

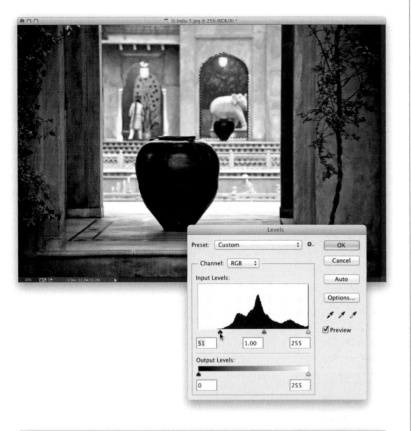

DRAWING FREEHAND SELECTIONS:

The Lasso tool (**L**; the third tool down in the Toolbox) lets you draw a free-form selection like I did here, where I selected the open archway in the background. You just click and start drawing, like you're tracing around the edges with a pencil or pen. When you get back to near where you started, just release the mouse button and it connects back to where you started and it makes the selection. I also went to Levels here and darkened the shadows.

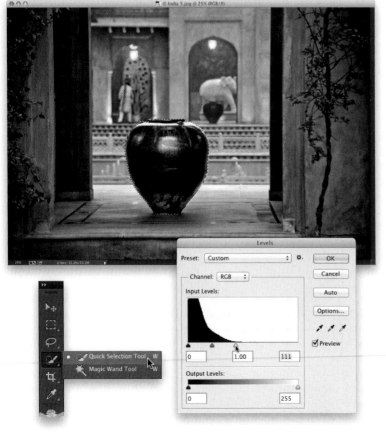

USING THE QUICK SELECTION TOOL:

If you want to select an object, like this vase (or is it a pot?), you'd get the Quick Selection tool (**W**; it's the fourth tool down in the Toolbox) and just paint over what you want to select (like I did here, where I painted over the vase), and it selects it by sensing where the edges are automatically (this is similar to the Adjustment Brush in Lightroom with Auto Mask turned on). (*Remember:* You can add and subtract from any of these selections that we've talked about—just press-and-hold the Shift key to add to your existing selection or press-and-hold the Option [PC: Alt] key to remove areas from your selection.) Here, I also went to Levels and increased the highlights.

USING THE MAGIC WAND TOOL:

We use this tool much less today than we used to in the past (mostly thanks to the Quick Selection tool), but it's still handy when you have a solid color or similar colors in an area you want to select. For example, if you had a solid yellow wall and you wanted to select it so you could change its color (using the Hue slider in Photoshop's Hue/Saturation adjustment, found under the Image menu, under Adjustments), then the Magic Wand tool would be the tool that would usually select that entire wall in one click. In our example here, we want to select the green trees outside the arch in the background and use Levels to darken the shadows. So, take the Magic Wand tool (it's nested beneath the Quick Selection tool; press **Shift-W** until you have it) and click it once on the trees. It gets most, but not all of them, so press-and-hold the **Shift key** (to add to your current selection) and click it again over any areas it missed on the first click. You might have to do this a few times. Also, the Tolerance amount (up in the Options Bar) determines how many colors out it selects. The higher the number, the more colors it includes, so if it selects way too much, just enter in a lower number (I lowered it to 20).

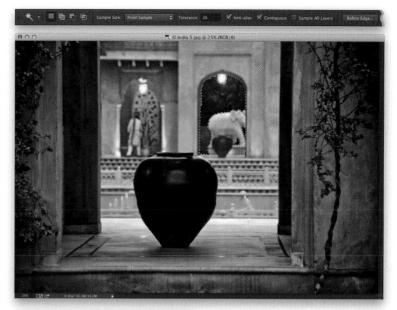

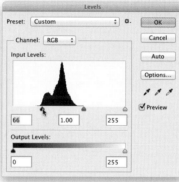

INVERSING A SELECTION:

A popular selection trick we use when making a tricky selection is to select something easy in an image (like the vase, here), and then go under the Select menu and choose **Inverse**. This inverses the selection, so everything *but* the original object we selected is now selected. So, for example, if we wanted everything in this photo to be black and white, except for the vase, we'd select the vase, choose Inverse, then go under the Image menu, under Adjustments, and choose **Desaturate**. I thought showing you this, here, might come in handy at some point.

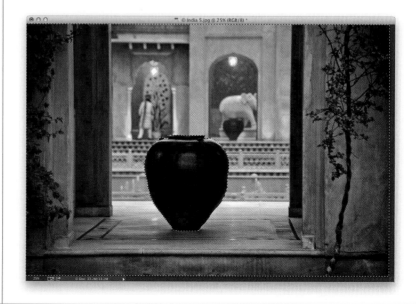

#4: CLONING AND THE PATCH TOOL

Lightroom's Spot Removal tool does have a Clone option, but it's...well...it ain't great (and that's being kind). However, Photoshop's Clone Stamp tool is incredible—it fixes, covers up, and removes all sorts of things in a way Lightroom just can't. For example, if you have a shot of a building with a broken window, you can paint a nearby window right over that broken one at a quality that no one would ever know it was fixed. But, that's just the tip of the iceberg of what it can do. Plus, there's also the Healing Brush (the more powerful cousin of the Clone Stamp tool [Spot Removal tool]), which we use for bigger repairs.

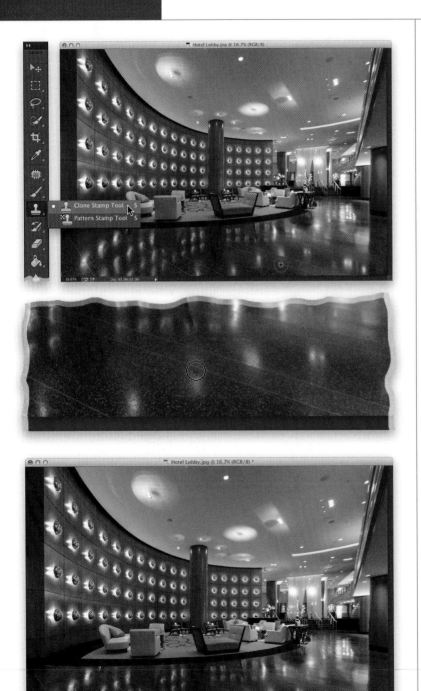

HOW TO CLONE:

In this image, we want to remove some extra reflections from the lighting in this hotel lobby, both on the ceiling (big jobs) and on the floor (small, but really tricky jobs because there are dividing lines between the tiles, so you can't just remove the reflections, you have to remove them and replace the lines). We'll start on the floor. Get the Clone Stamp tool **(S)** from the Toolbox, then press-and-hold the Option (PC: Alt) key and your cursor changes into a target. Click this target cursor right along one of the lines on the floor near where you want to remove a reflection (as seen circled here). Now, move your cursor up over the reflection, and you'll notice that you see a preview inside the round brush cursor itself of what you're about to clone. You can see the original line where you clicked in the brush cursor in the zoomed in view here, so you can line it up perfectly along the line in the tile, but it doesn't cover it all yet.

Now, just start painting and it clones the floor where you Option-clicked (PC: Alt-clicked) earlier right over that reflection. Since that area (called the "sampled" area) had that straight line, that line is cloned right over the reflection, and as you paint over it, and the area to the left of it, the reflection is gone, and the line is filled in right over it. Pretty amazing. So, that's how the tool works: you sample a clean nearby area by Option-clicking on an area, you move your cursor over the area you want to repair, and just click to clone the good area right over it.

THE PATCH TOOL:

While we could remove all the reflections, one-by-one, using the Clone Stamp tool, it would take quite a while, and you'd have to be pretty meticulous in your cloning because some of these reflections are pretty large. When the object you want to remove is large, that's when we reach for the Patch tool. It's also kind of like Lightroom's Spot Removal tool, if it was combined with Photoshop's Lasso tool. Here's how it works: Get the Patch tool from the Toolbox (it's nested beneath the Spot Healing Brush tool; press **Shift-J** until you have it) and draw a freehand selection around the object you want to remove (in our example, one of those big reflections on the ceiling, as seen here), just like you'd do with the Lasso tool. Once you're done, click inside the selection and drag it to a clean area of the ceiling (like you see here in the zoomed in view).

Once you drag your Patch tool selection to a clean spot (it shows you a preview within the selected area, just like the Clone Stamp tool shows you a preview inside its brush cursor), just let go of your mouse button and the selection snaps back to its original location and removes the reflection based on the texture, tone, and color from where you dragged the selection to (as seen here at the bottom, where the reflection is gone). Then, press **Command-D (PC: Ctrl-D)** to Deselect. If you need to do a little cleanup after using the Patch tool, just switch back to the Clone Stamp tool and use that to clean things up.

TIP: WHAT TO DO IF IT SMEARS

If the object you want to remove is near an edge in the image, chances are the Patch tool will leave a large smear when it patches the area. If that happens, press **Command-Z (PC: Ctrl-Z)** to Undo, then go up to the Options Bar and, from the Patch pop-up menu, choose **Content-Aware**, and try again. That will usually do the trick.

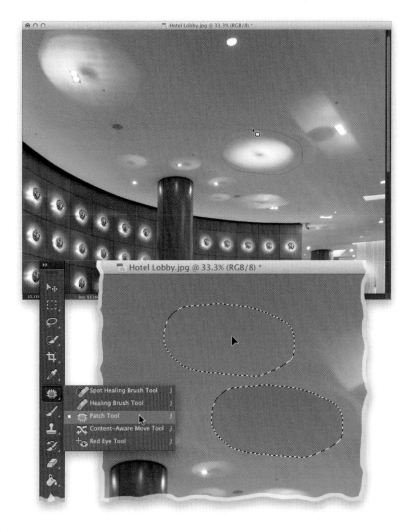

#5: WORKING WITH LAYERS

Layers are one of the main features we come over to Photoshop for because they do so much. A layer lets you add something on top of your image and position it wherever you'd like. For example, say you'd like to add a graphic or type to a wedding book page, or you'd like to blend two photos together for a fine art effect, you can do this with layers. Plus, we use layers for everything from portrait retouching (see Chapter 4) to special effects (see Chapter 6). Here are the basics on how layers work:

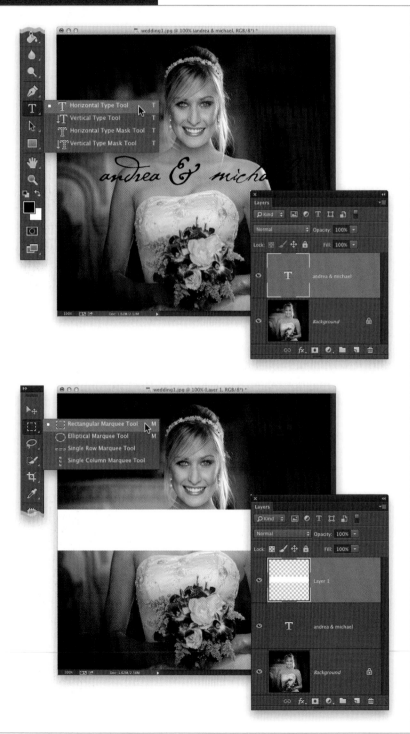

STEP ONE:
Open the image you want to edit in Photoshop and it will appear as the Background layer (meaning it's just a regular flat ol' image, just like in Lightroom). To add some text above your image, we'll use the Horizontal Type tool **(T)**. So, just click right on your image and start typing and it will type in whatever font and size you have selected in the Options Bar. If you want to change the font or size, highlight your type, then go up to the Options Bar and choose a new font from the font pop-up menu (I chose the font Cezanne Regular, but you can choose any font you like) and a large font size from the font size pop-up menu (I chose a size of 48 pt), then press **Command-Return (PC: Ctrl-Enter)** to set the type. You can reposition it anywhere you'd like using the Move tool (**V**; the topmost tool in the Toolbox).

STEP TWO:
If you look at the type in Step One, some of the black type is kinda hard to read (especially the last couple letters of Michael's name), so we're going to put a white bar behind the type so it all stands out. To add a new blank layer above your type layer, click on the Create a New Layer icon at the bottom of the Layers panel (it's the second icon from the right). Now, get the Rectangular Marquee tool **(M)** from the Toolbox and click-and-drag out a thin, wide rectangle from side to side (as seen here). Press the letter **D**, then **X** to set your Foreground color to white, and then press **Option-Delete (PC: Alt-Backspace)** to fill this selection with white (as seen here). Press **Command-D (PC: Ctrl-D)** to Deselect.

STEP THREE:

Unfortunately, this white bar now covers up our type when we actually want it behind our type. That's because layers are added to the stack from the bottom up. Take a look at the Layers panel in the previous step. There, we have the Background layer (that's on the bottom), and then on top of that we have a type layer. When it was only those two layers, you could see the type because it was stacked above the Background layer in the Layers panel. But once you added another layer on top, and filled it with white, it covered whatever was below it— the type layer and the photo of our bride. To get that white bar below our type layer, go to the Layers panel, and click-and-drag the white bar layer (Layer 1) down below the type layer (as seen here). The stacking order is now: the background image, then the white bar, and the type layer on top.

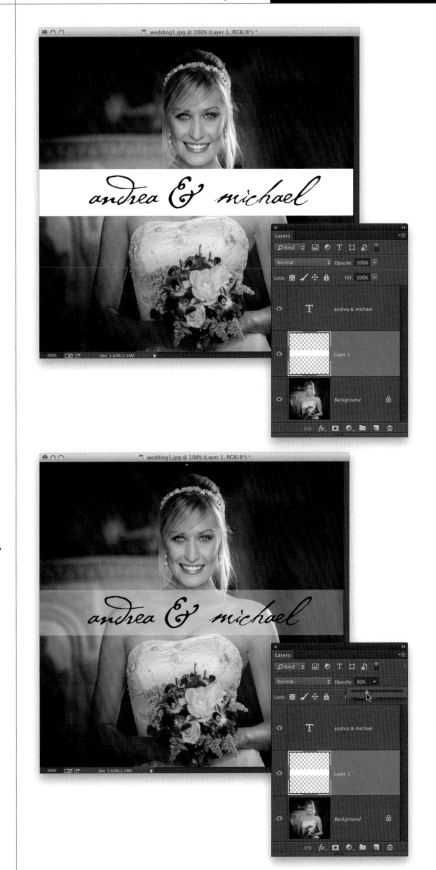

STEP FOUR:

Now, if you look at the image in Step Three, you can see that the solid white bar covers up part of the image of the bride. That's because it's a solid object and solid objects cover up what's below them in the Layers panel. However, layers all have an opacity setting, so if you want your object to be a little see-through, or a lot, you can lower the opacity amount for that layer. Make sure that layer is active (highlighted), then just go up to the Opacity field near the top right of the Layers panel (where it says 100%), click on the little down-facing arrow to its right, and the Opacity slider appears. Drag it down to around 30% (as shown here) and now you can see through to the bride on the Background layer.

Continued

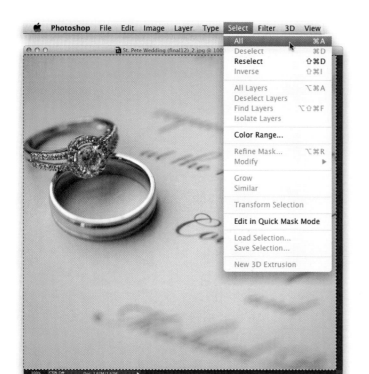

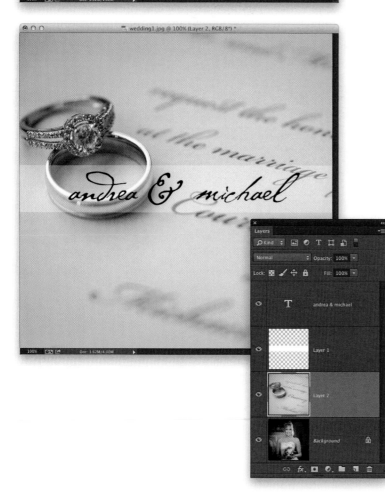

STEP FIVE:

Next, let's add another image here and we'll subtly blend them together. So, open another image in Photoshop (in this case, it's a wedding invitation with wedding rings on top). We'll need to select the entire image first, before we can copy it into memory, so go under the Select menu and choose **All** (or just press **Command-A [PC: Ctrl-A]**). Once you have a selection around the image, press **Command-C (PC: Ctrl-C)** to Copy the photo into Photoshop's memory.

TIP: DELETING LAYERS

To delete a layer, click on the layer in the Layers panel and (a) drag it onto the Trash icon at the bottom of the panel, (b) click on the Trash icon (but then it'll ask if you really want to delete the layer), or (c) hit the **Delete (PC: Backspace) key** on your keyboard.

STEP SIX:

Switch back to our photo of the bride and press **Command-V (PC: Ctrl-V)** to Paste the image in memory right into your document. It will appear on top of whatever your last active layer was. (*Note:* You may have to resize your pasted image, but we'll cover that in detail in #6.) In this case, the last layer we worked on was the white bar layer, so it appears in the stack of layers right above the white bar layer. However, we're going to want it to appear right above our photo of the bride (so we can blend the two photos together and still have the white bar and type layers above them). So, go the Layers panel, and click-and-drag this layer down in the layer stack right above the Background layer (as seen here). To get this image to blend with the bride photo on the layer below it, I could just lower the opacity of this layer, but it doesn't make for a very interesting blend. That's where the layer blend modes come in.

STEP SEVEN:

There are a whole bunch of layer blend modes (you can find them in the pop-up menu near the top left of the Layers panel—they're all seen here on the far right), and they determine how the current layer blends with the layer (or layers) below it. Some blend in a way that makes the combination of layers much brighter (like Screen mode) or much darker (like Multiply mode). So, which one is the "right" one for these two images? Who knows? That's why we use a keyboard shortcut to try them all out, and then we just stop when we find one that looks good to us. The shortcut is **Shift-+** (plus sign). Each time you press this, it changes to the next blend mode in the pop-up menu, so when you see one you like, stop. Yes, it's that easy. Here, I stopped at **Soft Light**, then lowered the opacity of this layer to 80% because the effect seemed too strong.

STEP EIGHT:

There's still a little problem, here, though. The invitation layer is making her face seem too yellow. I'd rather have her face appear like it does in the Background layer, but luckily we can choose which parts of our layers are visible by using layer masks. To add one, click on the Add Layer Mask icon at the bottom of the Layers panel (it's the third icon from the left), and it adds a white thumbnail mask to the right of your image thumbnail in the Layers panel. Since it's white, you'll paint in the opposite color—black. So, get the Brush tool **(B)** from the Toolbox, choose a large, soft-edged brush from the Brush Picker up in the Options Bar, and paint over her face (as shown here). It basically cuts a hole in the invitation layer, so you can see her original face on the layer below.

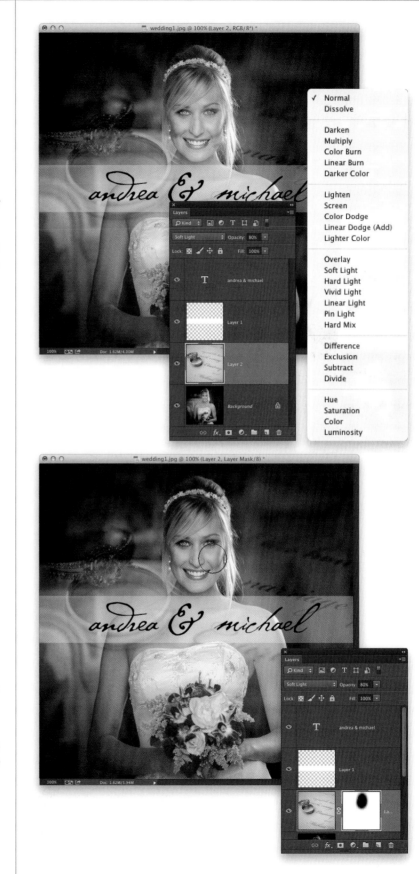

#6: RESIZING, ROTATING, AND TRANSFORMING

Since you'll be working with layers a lot, you're going to want to know how to resize things, because if you add something to a photo, like maybe a custom watermark or a logo or another photo (like we just did in #5), you might need to resize it to fit on your photo. Photoshop's feature for resizing is called "Free Transform," and the name fits because besides resizing, it lets you rotate, skew, flip, distort, and all sorts of other cool stuff. We'll cover a bunch of 'em here. You'll also want to know how to resize the entire image, so we'll do that, as well (at the very end).

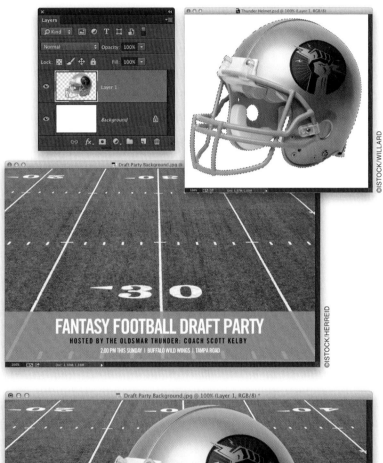

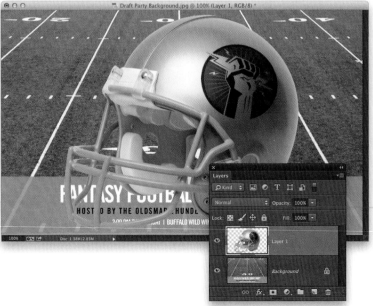

STEP ONE:
We'll start by opening the background image (this is an image from iStock that started in Lightroom. I took it over to Photoshop to add the three lines of text [I used the font Trade Gothic LT Std.], then I added that gray bar behind the text, and then lowered the opacity so it was a little transparent. We just covered how to do all this in #5). Then, we'll open another image— one of a football helmet on its own layer (with a transparent background). To get that helmet onto our football field background, press-and-hold the Command (PC: Ctrl) key, then go to the Layers panel and click directly on the thumbnail for the helmet layer. This puts a selection around everything on this layer (the helmet). Now, press **Command-C (PC: Ctrl-C)** to Copy that into memory.

STEP TWO:
Now, switch back to the football field background image and press **Command-V (PC: Ctrl-V)** to Paste the helmet you copied into this document. As you can see, it's a little big (this is why we need to know how to resize stuff within Photoshop). By the way, there are other ways to copy objects like this helmet between documents. Here's another way: Go back to the helmet image, then go under the Layer menu and choose **Duplicate Layer**. In the dialog that appears, from the Destination pop-up menu, choose the football field image.

STEP THREE:

To scale our image down in size, we'll use Free Transform. Its keyboard shortcut is **Command-T (PC: Ctrl-T)**, so it's easy to remember: T for Transform. When you press this, it puts a bounding box around whatever is on your active layer, with little handles in its four corners and at the center of all four sides. To resize something (like our helmet), all you have to do is press-and-hold the **Shift key** (this makes it resize proportionally, so your image looks the same, just smaller), then grab one of the corner handles (it doesn't matter which one) and drag inward to scale it down, as shown here (or drag outward to make it larger). When you're done resizing, press the **Return (PC: Enter) key** to lock in your transformation.

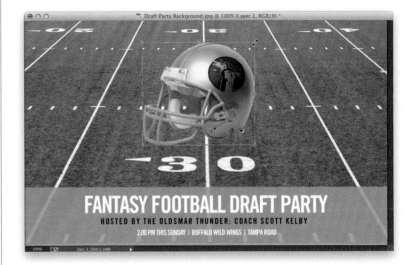

STEP FOUR:

Let's get the Free Transform bounding box again, but this time let's Right-click anywhere inside of it. This brings up a pop-up menu of all the transformations you could apply—everything from Rotate to Skew, Perspective to Rotate 180°, and everything in between. When you choose one of these options, and then use the handles, it automatically transforms based on the selected option. Here, we want to have Free Transform flip the helmet horizontally (we can get away with this because there's no text on the helmet. If there were text, it would read in reverse). So, Right-click within the bounding box, choose **Flip Horizontal**, and the helmet flips (as seen here).

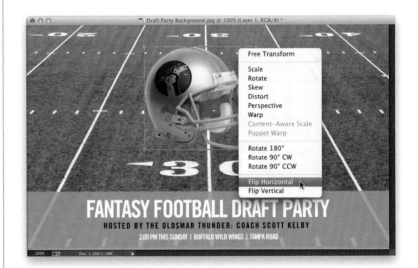

Continued

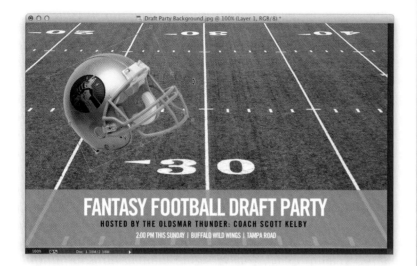

STEP FIVE:

Now, to rotate our flipped helmet, all you have to do is bring up Free Transform once again (if it's not still active), then move your cursor outside the bounding box, and you'll see that your cursor changes into a two-headed arrow. This lets you know you're ready to rotate. So, rotate the object by clicking-and-dragging up/down. Here, I placed my cursor outside the right side of the bounding box and rotated up. Then, I moved the helmet over to the left side—just move your cursor inside the bounding box and it changes into the solid Move arrow, so you can just click-and-drag it to the left. Press Return (PC: Enter) to lock in your transformation.

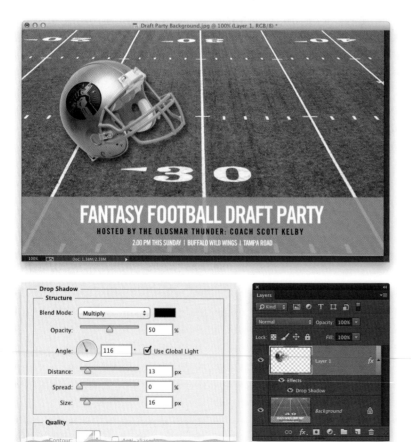

STEP SIX:

Okay, we're going to stray away from resizing for just a moment, so we can introduce layer styles. You use these to add drop shadows, glows, and stuff like that to a layer. So, to add a drop shadow behind our helmet, click on the Add a Layer Style icon at the bottom of the Layers panel (it's the second icon from the left) and choose **Drop Shadow**. This brings up the Layer Style dialog, which gives you access to all the layer styles (but, since we're just focusing on the Drop Shadow options here, I'm only showing that part of the dialog). There are just two sliders we need to worry about: (1) Size controls how soft the shadow is (I usually crank this up a bit), and (2) Opacity controls how dark the shadow is (I would probably lower it to 50%). There are controls for Angle and Distance, but it's easier to move your cursor outside the dialog, onto your image, and literally just click-and-drag the shadow where you want it. When you're done, click OK to close this dialog.

STEP SEVEN:

Next, let's make a copy of our helmet layer. The quickest way to duplicate a layer is to use the keyboard shortcut **Command-J (PC: Ctrl-J)**. This makes a duplicate of your active layer, so let's go ahead and do that now. Bring up Free Transform (you know the shortcut), press-and-hold the Shift key (to keep the helmets aligned), and then click-and-drag the duplicate helmet over to the right. Now, Right-click inside the bounding box and choose Flip Horizontal, so the helmets are facing off with each other (as seen here). Press Return (PC: Enter) to lock in your transformation. There's more to what Free Transform can do (and we'll look at it a little more later in the book), but that's what's so cool about Photoshop in general—there's always more you can do.

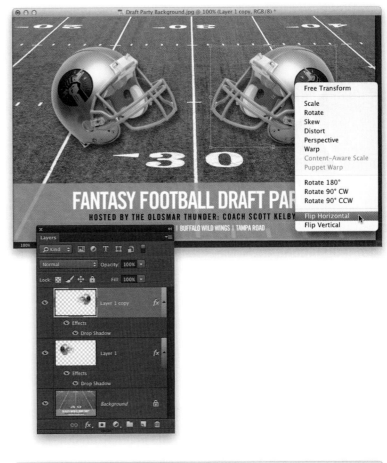

STEP EIGHT:

If you want to resize the entire image (not just a helmet), so it's smaller in physical size (and file size), making it easier to email to the people you want to invite to your fantasy football draft party, just go under the Image menu (up top) and choose **Image Size** (or just press **Command-Option-I [PC: Ctrl-Alt-I])**. This brings up the Image Size dialog. There's a preset pop-up menu of popular sizes near the top, but in our case, I just want to size it down from its original size of 1008 pixels wide (about 14") to just 610 pixels wide for emailing (that lowers my file size from 1.38MB to just 648KB, as seen at the very top of the dialog). When you're done, click OK and it physically resizes the image (as long as you have the Resample checkbox turned on, so make sure it's on). Also, Automatic resampling lets Photoshop use whichever mathematical algorithm it thinks will work best for resizing your image with the best results.

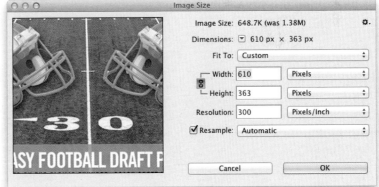

#7:
CAMERA RAW AS A FILTER (& ADJUSTMENT LAYERS)

When Adobe created Lightroom, they took their Camera Raw plug-in from Photoshop and added it to Lightroom (it has the same sliders, in the same order, that do the exact same things), but in Lightroom they call it the Develop module. Luckily, if you have Photoshop CC, you don't have to jump back to Lightroom to make any Develop module edits, because you can apply Camera Raw as a filter right within Photoshop. Also, while we're here, we'll cover adjustment layers, because they're pretty darn handy.

STEP ONE:

Open the image you want to edit in Photoshop. If you come to a point where you want to add a Develop module edit, but you're not ready to head back to Lightroom quite yet, just go under the Filter menu and right near the top you'll find **Camera Raw Filter** (as shown here). (*Note:* If you just looked for this, and you don't see it on the menu, that's because it's only available in Photoshop CC [the Creative Cloud version of Photoshop]. If you don't have CC, no worries, just skip over to Step Three.)

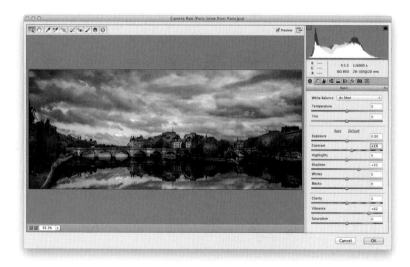

STEP TWO:

This brings up the Camera Raw window (it's generally just called "ACR" for short), and if you look on the right side of the window, you'll see all the same sliders, with the same names, that do the same thing as in Lightroom's Develop module, so this should all be familiar to ya. The functionality is the same, but things appear a little differently: for example, the toolbar (that includes the White Balance eyedropper tool) is in the top left, and instead of scrolling down to get to the other panels, they're in a row of horizontal icons near the top right—just hover your cursor over each icon to find what you're looking for. Anyway, you make your Develop module-like edits here, then click OK, and you're instantly back in regular Photoshop to pick up right where you left off. Easy enough.

STEP THREE:

Lightroom has unlimited undos, so if you make a mistake, you can just press Command-Z (PC: Ctrl-Z) until it's undone. Photoshop doesn't have unlimited undos, though, so we use adjustment layers instead. These layers are adjustments (like making things brighter or darker using Levels, or changing color with Hue/Saturation). Let's use one here, so you can see how they work: click on the Create New Adjustment Layer icon at the bottom of the Layers panel (it's the fourth icon from the left and it looks like a half-filled circle), and choose **Photo Filter** (as shown here). You can also choose adjustment layers by clicking on the icons in the Adjustments panel (seen here in the lower right). When you choose an adjustment, its options appear in the Properties panel (also seen here). I wanted more orange in this image, so I increased the Density to 40% (as shown here).

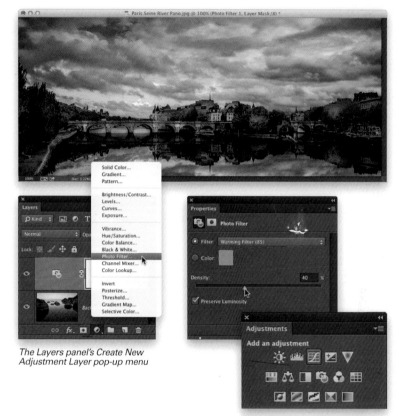

The Layers panel's Create New Adjustment Layer pop-up menu

The Adjustments panel, where you play the "What is that icon supposed to represent?" game

STEP FOUR:

Here's what's so awesome about an adjustment layer: (1) It adds the effect as a layer, so any layers below it get the effect added. (2) Since it's a layer, you can go back and adjust the amount anytime (even if you save and close the file—when you come back, as long as you didn't flatten the image, you can still change the effect). (3) It has a built-in layer mask, so if you wanted to remove the orange filter from just the buildings, bridge, and trees (but keep it in other areas), you'd just paint over those areas in black with the Brush tool (as shown here), and those areas are no longer affected. (4) If at some point you decide that you don't want this effect added after all, you can delete it by dragging that layer onto the Trash icon at the bottom of the Layers panel. And, (5) it has layer blend modes just like regular layers. Overall, they're incredibly handy (as you'll see later in the book).

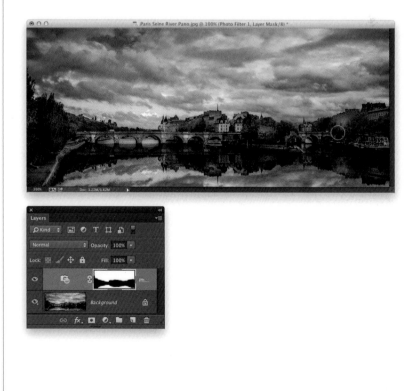

JUMP

JUMPING FROM LIGHTROOM TO PHOTOSHOP (AND BACK)

As soon I thought of jumping back and forth between Lightroom and Photoshop, I knew this chapter's title had to be "Jump" by Van Halen. And, by Van Halen, of course, I mean the "real" Van Halen with lead singer David Lee Roth, which to many of us is the only incarnation of Van Halen that will ever be "real," because when they replaced David Lee Roth with Sammy Hagar, they became something else— a great band with a really good guitar player…and Sammy Hagar singing. But, that my friends is not Van Halen. Honestly, at that point, I think they should have changed the band's name to Van Heusen. That way, fans would instantly know that: (a) this is not really Van Halen, and (b) this would make a great name for the world's best-selling dress shirt brand. By the way, since I mentioned Van Heusen, did you know that "Van Heusen has been associated with stylish, affordable, and high-quality shirts since introducing the patented soft-folding collar in 1921?" Well, it's true because I read it on the Internet, and as you know, the International Council That Ensures Everything You Read on the Internet Must Be True (or the ICTEEYROTIMBT, for short) stands 100% behind this assertion. Now, if you're thinking that mentioning Van Heusen is a sneaky way for me to somehow introduce paid product placements into my chapter openers, well that is just absurd (by the way, did you know that "Today, Van Heusen has grown into a 24/7 lifestyle brand known not only for dress shirts but for both men's and women's dresswear, sportswear and accessories"). This is clearly just another baseless charge probably concocted by marketing folks at Calvin Klein or Kenneth Cole or One Direction, who feel threatened by Van Heusen's "fit, fabric, finish and innovative fashion—at a fraction of the cost of luxury brands." Just preposterous! I would never stoop to such levels (www.vanheusen .com), and frankly I'm a bit taken aback by such baseless allegations. So much so, in fact, that I've done a bit of research, and I've uncovered an astonishing conflict of interest, which I believe is the real reason Sammy Hagar was kicked out of Van Halen and replaced by the original, and only true, lead singer of Van Halen, David Lee Roth. It seems that Mr. Hagar just happens to own a rather large company that makes men's slacks (www.haggar.com). Shocking! Well, at least finally, now, the truth is out!

CHOOSING HOW YOUR FILES ARE SENT TO PHOTOSHOP

When you move an image from Lightroom to any other program, it's called "external editing" since you're now editing the image outside of Lightroom. There's a set of External Editing preferences, so you can choose which programs to use for your external editing and exactly how (and in what format) those images are going to go over to that other program. Here's how to set things up your way from the start:

STEP ONE:
Press **Command-,** (comma; **PC: Ctrl-,**) to bring up Lightroom's preferences, and then click on the External Editing tab up top (seen here). If you have Photoshop installed on your computer (and I'm assuming if you bought this book you do), it automatically becomes the default choice as your External Editor, so you don't have to do anything to make that happen—it's good to go (if you have more than one version, it uses the latest version as the default, which in my case would be Photoshop CC; it's circled here in red). If, instead, you have Photoshop Elements installed, then that becomes the default External Editor.

STEP TWO:
Right below that, it shows you the default settings for what kind of file it's going to send over to Photoshop. By default, it sends a copy of the file over to Photoshop in TIFF format, embeds that file with the ProPhoto RGB color profile, sets the bit depth to 16 bits, and sets the resolution to 240 ppi. Let's start with the File Format choice: I change mine to go over to Photoshop as a PSD (Photoshop's native file format) rather than a TIFF, simply because its file size is often much smaller but without any loss of quality.

STEP THREE:

Next, you can choose the Bit Depth of the file going over to Photoshop. If your goal is to maintain the maximum quality, leave it set at 16 Bits/Component. The downside of 16-bit editing are: (1) some of Photoshop's filters and features will be disabled (stuff like all the filters in the Distort menu, and the Filter Gallery, and the Pixelate menu, but that's not too bad), and (2) the file size will be approximately double (so a 36-MB TIFF becomes a 72-MB TIFF). Neither may be an issue for you, but I thought you should know. By the way, I usually work in 8-bit mode myself.

STEP FOUR:

From the Color Space pop-up menu, you get to choose your file's color space. Adobe recommends ProPhoto RGB for the best color fidelity, and if you keep it at that, I'd go to Photoshop and change your Photoshop color space to ProPhoto RGB, as well—that way, both programs are using the same color space, so your color will be consistent as you move files back and forth. To change your Color Space to ProPhoto RGB in Photoshop, go under Photoshop's Edit menu, and choose **Color Settings**. In the dialog that appears, in the Working Spaces section, from the RGB pop-up menu, choose **ProPhoto RGB** (as shown here). Click OK, and Photoshop and Lightroom are now both using the same color space. (By the way, while you can change Photoshop's color space, Lightroom's working color space is set to ProPhoto RGB and you can't change it. So, although you can't change Lightroom's color space, you can change it for files leaving Lightroom.)

Adobe Photoshop's Color Settings dialog

Continued

STEP FIVE:
You also get to choose the resolution of the file you're sending over, but I leave mine set at the default of 240 ppi (so it's going over at the native resolution of the file). I've never found an occasion where I needed to change this resolution setting, so I just leave it alone.

STEP SIX:
If you want to use a second program to edit your photos, you can choose that in the Additional External Editor section. So, for example, if you wanted to send your image over to a separate plug-in or another image editing application (gasp!), this is where you'd choose it. Just click on the Choose button over there on the right, navigate your way to the program or plug-in you want to use, and then click the Choose (PC: Open) button, and that application or plug-in will now be displayed under Additional External Editor (shown circled here in red). To use this second editor (instead of Photoshop), go under Lightroom's Photo menu, under **Edit In**, and choose the other application (in this case, it would be DxO FilmPack 4), or press **Command-Option-E (PC: Ctrl-Alt-E)**. Next, there's a Stack With Original checkbox. I recommend leaving this on, because it puts the edited copy of your image (the one you sent over to Photoshop) right beside your original file back in Lightroom. That way, when you're working in Lightroom, it's easy to find the edited copy—it's right beside the original (as seen in the grid here).

STEP SEVEN:

At the bottom of the dialog, you can choose the name applied to photos you send over to Photoshop for editing. You have pretty much the same naming choices as you do in Lightroom's regular Import window, where hopefully you chose some sort of custom name because the default name of "IMG_0002" is pretty much meaningless. Here's what I recommend for your External Editing preferences: from the Template pop-up menu, choose **Filename** first, then go under that same menu again and choose **Edit** (as shown here).

STEP EIGHT:

This brings up the Filename Template Editor (shown here). You'll see that Filename is already chosen in the field up top. Click your cursor right after it and type in "-PSedit," but don't click Done yet. From the Preset pop-up menu up top, choose **Save Current Settings as New Preset** (as shown here at right) and save this setup, so you don't have to build it again—you can choose this naming preset anytime you want. Now, click Done, and your images edited in Photoshop will be named with their original filename + -PSedit (so a file named Paris-57.jpg in Lightroom and edited over in Photoshop will come back to Lightroom named "Paris-57-PSedit.psd," making it easy to identify at a glance). Okay, you're preferences are set; let's put them to work.

After Filename, type in "-PSedit"

Save this as a template

GOING FROM LIGHTROOM TO PHOTOSHOP (AND BACK)

Once you get to a point where there's something you need to jump over to Photoshop for, the process is really simple, and having that "edited in Photoshop" file come right back to Lightroom is just as easy. Here's how to make the round trip:

RAW PHOTOS:

To take a RAW image over to Photoshop, press **Command-E (PC: Ctrl-E)**. There's no dialog, no questions to answer—it just opens immediately in Photoshop. (*Note:* If Photoshop's not already open, it will launch it for you automatically.) By the way, you can also send your image over to Photoshop the slow way by going under Lightroom's Photo menu, under Edit In, and choosing **Edit in Adobe Photoshop** (as shown here), but I'd only do it that way if you're charging by the hour.

JPEG, TIFF, OR PSD PHOTOS:

If your images are JPEGs, TIFFs, or PSDs, then it's slightly different. It's the same keyboard shortcut (Command-E [PC: Ctrl-E]), but a dialog will appear asking you to choose how this image is going over. The three choices are: (1) Edit a Copy with Lightroom Adjustments (this is what I would normally choose, as I want anything I've done to the photo in Lightroom to still be there when it heads over to Photoshop). (2) Edit a Copy (I'm not sure I've ever chosen this one, because none of my changes would be included in the copy). Or, (3) Edit Original. I only choose this one in one very specific scenario: when I've taken an image over to Photoshop, then saved the file with all its layers still intact and let it go back to Lightroom. In Lightroom, if you want to reopen that same layered file in Photoshop again and have all those layers still intact, choose Edit Original, and when it opens back up in Photoshop, those layers will all still be there. Outside of that, I wouldn't risk messing up my original file, so I wouldn't advise Edit Original outside of that very specific scenario.

HOW TO GET IT BACK INTO LIGHTROOM:

Once your image is in Photoshop, you can do anything you'd like to it, just as if you didn't own Lightroom. When you're done editing in Photoshop, getting your image back to Lightroom is simple. Just do two things: (1) save the file (press **Command-S [PC: Ctrl-S]**), and then (2) simply close the file. The image automatically returns to Lightroom, and as long as you turned on that Stack with Original checkbox in the External Editing preferences (like we talked about two pages ago), the edited copy will appear right next to the original. That's it. Don't overthink it. Also, if you're working with a JPEG, TIFF, or PSD, and you choose Save As, rather than Save, rename the file, and save it somewhere else on your computer or hard drive, as long as you keep the format the same, it still sends the copy back to Lightroom.

NOT SENDING IT BACK TO LIGHTROOM:

If, after you send an image over to Photoshop, you decide you don't want to edit it after all, just click on the window's Close button (or press **Command-W [PC: Ctrl-W]**), and then when it asks if you want to save the document, choose Don't Save. Easy peasy.

GET SMART

PANOS, HDR & SMART OBJECTS

Okay, I named this chapter after the Smart Objects feature in Photoshop (which you can jump to directly from Lightroom), even though it's probably not the coolest thing in this chapter. I chose "Get Smart" because it's hard to find a movie or song title with either the acronym HDR or the word "pano" in it. Now, of course "pano" is short for "panorama" or "panoramic," both of which are derived from the popular Latin phrase, *panem et circenses*, which roughly translated means "I left my panini at the circus." Of course, the meaning behind the acronym HDR itself is one of the most misquoted of all, as I constantly see it referred to incorrectly as High Dynamic Range photography, when in fact its roots can be traced back to the Latin phase *Hominem Dictu Regnum*, which is a phrase used in ancient photographic literature representing the belief that any photo with large white glows around the edges, overly vibrant Harry Potter-like colors, and solid black clouds should be taken to the banks of a nearby river and beaten with a rock until it can no longer be determined to be of photographic origin. So, basically, you can see why I went with "Get Smart." However, this created quite a conundrum because now I had to decide whether it would be the one from the classic TV show *Get Smart* or the movie version of *Get Smart* (which was based on the TV show), even though my readers would never know which I had chosen when I wrote this (by the way, the word "conundrum," surprisingly, does not have a Latin origin. It's actually a phrase that was used in 15th century England to describe "a convict who can no longer play the drums." I don't know about you, but I find this stuff fascinatum!). Anyway, I hope that your not knowing which version of *Get Smart* I used doesn't *In necessariis unitas, in dubiis libertas, in omnibus caritas*, which roughly means "If it's necessary to fly United Airlines to Dubai, don't leave your seat while the snack cart is in the aisle."

KEEPING YOUR RAW IMAGE EDITABLE USING SMART OBJECTS

You're able to go back and re-edit your RAW image once you're in Photoshop by taking it over to Photoshop as a smart object. Once you do that, you can re-edit it using Photoshop's Camera Raw. (By the way, Camera Raw is built into Lightroom, Adobe just calls it something different: the Develop module. It's the same sliders, in the same order, and they do the same thing.)

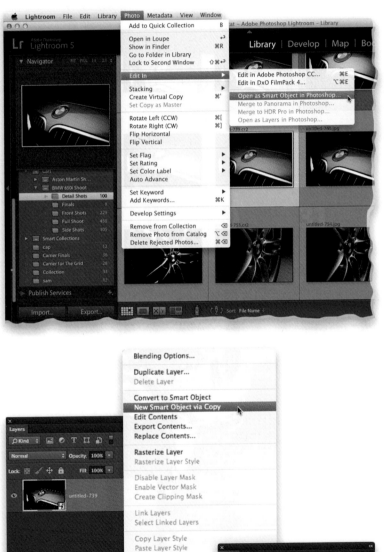

STEP ONE:
To take your image over to Photoshop as a re-editable RAW image, go under the Photo menu, under Edit In, and choose **Open as Smart Object in Photoshop** (as shown here). It appears in Photoshop like always, but you can tell it's a smart object by looking in the Layers panel—in the bottom-right corner of the layer thumbnail, you should see a little page icon, as you can see in the next step. We're going to use this re-editing ability to pull a cool little trick: we're going to combine the old Fill Light slider from Lightroom 3 with the Shadows slider that replaced it back in Lightroom 4 (and, of course, it's in Lightroom 5, as well).

STEP TWO:
To pull off this trick, we're going to need two smart object layers (in other words, we need two completely separate versions of the RAW image). But, we can't just duplicate the layer by dragging it onto the Create a New Layer icon (like we normally would), because when you do this, the two smart object layers would be linked to each other—if you re-edit one of the layers, the other layer automatically updates, too. So, we need to break that link when we duplicate the layer. Here's how: In the Layers panel, Right-click just above the layer's name and, from the pop-up menu that appears, choose **New Smart Object via Copy** (as shown here). This duplicates your RAW image layer, but it breaks the tie to it, so you can edit this copied layer independently from the original.

STEP THREE:

Now, double-click on the layer thumbnail for the original smart object layer and it opens in Camera Raw (as seen here). When it opens, you'll see the same sliders in the same order that they are in Lightroom's Develop module. In fact, the only real difference is that, in Lightroom, the background color is dark gray; here in Camera Raw, it's light gray. Now, the entire image is kind of dark in the shadow areas, so let's open things up a bit by dragging the Shadows slider to the right to +50 (as shown here). It's subtle, but it certainly helped. Click OK to save this change.

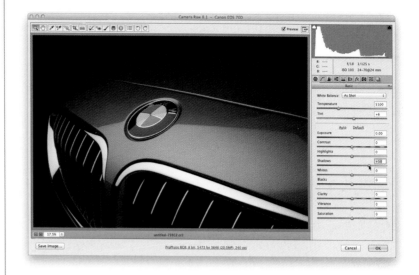

STEP FOUR:

Next, double-click on the top smart object layer, and then click on the Camera Calibration icon (the third from the right) near the top right of the Camera Raw window. At the top of this panel, you'll see the Process pop-up menu is set to 2012 (Current). That means you're using the current, most up-to-date processing version for your RAW image (and that's a good thing). The previous version was the 2010 process version (used in CS5)—that's the version that had the Fill Light slider. That slider was replaced in Photoshop CS6 (and Lightroom 4) with the Shadows slider, which is much more subtle in its effect, and overall looks more natural. But, if you do need to really open up those shadows, the old Fill Light slider would definitely do the trick (albeit, not as realistically as the new Shadows slider, but when you need lots of shadow-opening juice, nothing rocks a shadow like Fill Light). To make this slider re-appear in Camera Raw, from that Process pop-up menu, choose **2010** (as shown here).

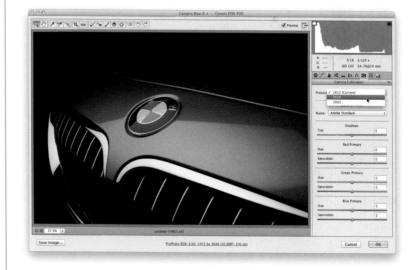

Continued

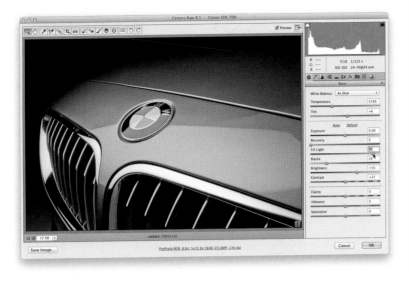

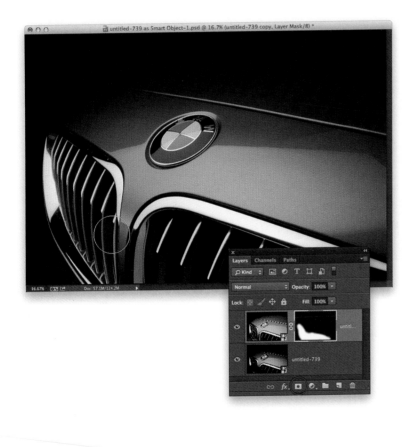

STEP FIVE:

Go back to the Basic panel (the first icon), and you'll see that the Fill Light slider now appears and the Shadows slider is gone. We're trying to open up those solid black areas at the bottom of the car's front grill, so drag that Fill Light slider way over to the right (as shown here), and it really opens up that area. Although this really did open up the shadows here, it also washed out the photo as well, so drag the Blacks slider a little to the right until the contrast comes back in the shadow areas, and click OK. It's way too bright overall in the shadows now (after all, we only wanted the bottom of the grill brighter), but we can fix that in the next step.

STEP SIX:

We only want the area at the bottom of the grill to have this opened-up shadows look, so **Option-click (PC: Alt-click)** on the Add Layer Mask icon at the bottom of the Layers panel (shown circled here in red) to hide this brightened smart object layer behind a black layer mask. Now your image looks like it did before we moved that Fill Light slider, but that's because that top layer is hidden behind that black mask. Our job is to reveal just part of that layer—the area at the bottom of the grill—and we're going to do that using the Brush tool to paint in that part of the grill. So, get the Brush tool **(B)** from the Toolbox and make sure your Foreground color is set to white. Now, paint over the bottom part of the grill (as shown here) and, as you do, it paints in the brighter version of the grill (you're now seeing the Fill Light layer showing through only where you paint).

STEP SEVEN:

The beauty is that if you want to re-turn to Camera Raw and tweak that Fill Light effect now, all you have to do is double-click on the thumbnail for that top layer, and it will re-open the RAW image in Camera Raw with your last settings intact. So, let's go ahead and lower the Fill Light amount down to 80 (as shown here) and lower the Exposure to –0.50. Click OK and Camera Raw updates your smart object layer automatically (you might see a progress bar appear onscreen for just a moment or two that says "Preparing Smart Object." That's it up-dating the layer).

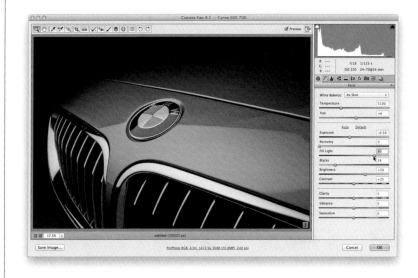

STEP EIGHT:

Now, let's tweak the bottom layer. In the Layers panel, click on the bottom layer, then double-click directly on its thumbnail and the original image we brought over from Lightroom opens in Camera Raw, and you'll see the standard sliders just like you do in Lightroom. This time, let's increase the Contrast a bit (I dragged it over to +18), then drag the Clarity slider over to +48 to increase the midtone contrast (I add Clarity when I want to enhance the texture in an image), and then drag the Shadows slider back to 0. Click OK and it applies your changes to give you the final image you see below. I hope this helped you see how keep-ing your RAW image re-editable might be really handy in some cases (like when you shoot a landscape where the ground is properly exposed, but since the foreground is right, the sky is way too bright. You can use this smart object trick to duplicate the original RAW image, darken the sky by lowering the Exposure amount, and then use the layer mask trick you just learned to paint the darker sky into the shot on the bottom layer that has the properly exposed foreground).

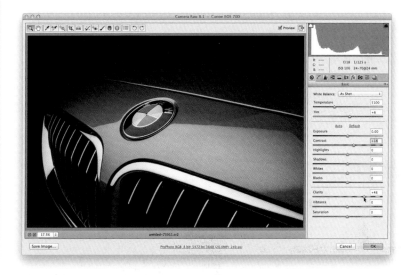

STITCHING PANORAMAS USING PHOTOSHOP

Lightroom doesn't have a panorama feature built-in (well, at this point anyway—hopefully one day), so we start in Lightroom, select the images we took to make our pano, then we jump over to Photoshop to seamlessly stitch all those photos into one single image.

STEP ONE:
In Lightroom's Grid view, Command-click (PC: Ctrl-click) on the photos you want to stitch together. Here, I've selected a series of five photos (images I shot in Vail, Colorado). When I shot them, I made sure each photo overlapped the next one by around 20%, because that's about how much overlap Photoshop needs between images to stitch them into a single panoramic image. At this point, the images are still 16-bit RAW files, but once we take them over to Photoshop and combine them, they won't be RAW files anymore (they'll be combined into one PSD, TIFF, or JPEG, depending on how you have your External Editing preferences set), so that's why it's better to tweak the images now, in Lightroom, while they're still individual RAW photos.

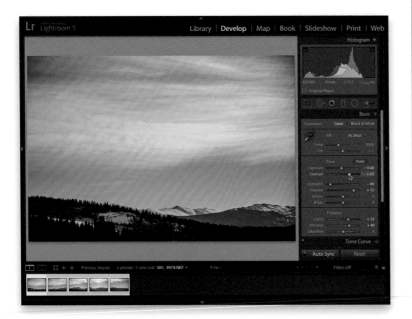

STEP TWO:
So, select all five images and go to the Develop module. Click on the little switch to the left of the Sync button (at the bottom of the right side Panels area) to turn on Auto Sync, so when we edit one photo, those changes are applied to all the rest. Now, let's increase the Contrast, lower the Exposure just a little (to make the sky a little darker), increase the Shadows amount (so we can see detail in the mountains), increase the Clarity (to enhance the texture in the trees and sky), and lastly, increase the Vibrance (to make the image more colorful; especially the sky).

STEP THREE:

Once the photos look good, go back to the Library module and, while all five are still selected, go under the Photo menu, under Edit In, and choose **Merge to Panorama in Photoshop** (as shown here).

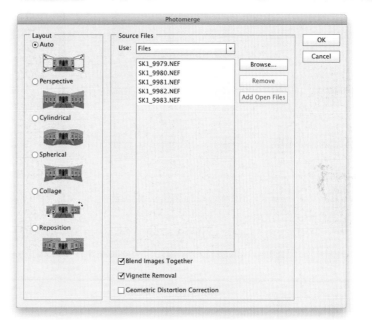

STEP FOUR:

In a few moments, you'll see Photoshop's Photomerge dialog (shown here), and in the center of the dialog, you'll see the names of the five images you selected in Lightroom. In the Layout section on the left side, leave it set to Auto, so Photomerge will automatically try to align and blend the images together for you. Also, these five photos have some edge vignetting (darkening in the corners), so turn on the Vignette Removal checkbox at the bottom of the dialog. It'll take a little longer to stitch your pano together, but your vignettes will already be removed, so overall it's a time and trouble saver. Click the OK button in the upper-right corner of the dialog to begin the stitching process.

STEP FIVE:

When Photoshop is done aligning and blending your photos, a new document will appear with your five images combined into a single panoramic image (as seen here). Parts of each photo wind up in this document as a separate layer (as you'll see in your Layers panel), so if you wanted to tweak the masks created by Photomerge, you could (but I don't). Let's go ahead and flatten the image by choosing **Flatten Image** from the Layers panel's flyout menu (the icon near the top-right corner of the panel). Now that we've flattened the image, let's crop it down to size a bit to get rid some of the white gaps that Photoshop left after stitching the image together (this pretty much always happens).

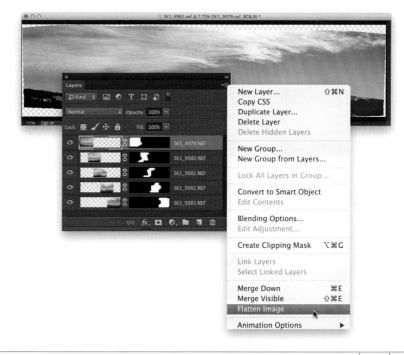

Continued

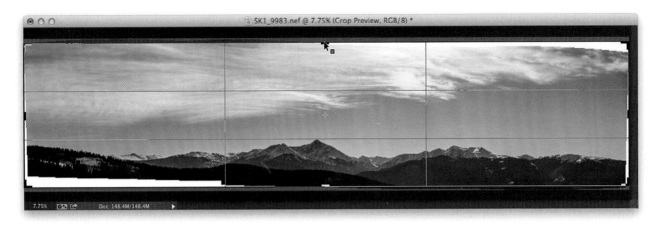

STEP SIX:
Press **C** to get the Crop tool and drag the top, bottom, left, and right center points inward a bit so most of those white gaps are gone (you don't have to crop them all away—we can have Photoshop fix some small gap areas for us). Once your cropping is in place (as seen here), press the **Return (PC: Enter) key** to apply the cropping to your pano.

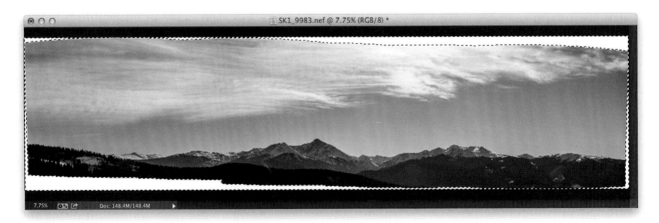

STEP SEVEN:
To fill in the small white gaps that remain along the top, bottom, left, and right sides, we use Content-Aware Fill, which tries to fill in the gaps intelligently (and actually does that pretty well most of the time). Start by getting the Magic Wand tool **(Shift-W)** from the Toolbox and click it once in one of the white gap areas. Since there are multiple areas with white gaps, just press-and-hold the **Shift key** and click on those areas, and it adds them to your current selection. Once your selection is in place, we do a trick to make Content-Aware Fill work better: we expand it out by a few pixels. So, go under the Select menu, under Modify, and choose **Expand**. When the dialog appears, enter 4 pixels and click OK.

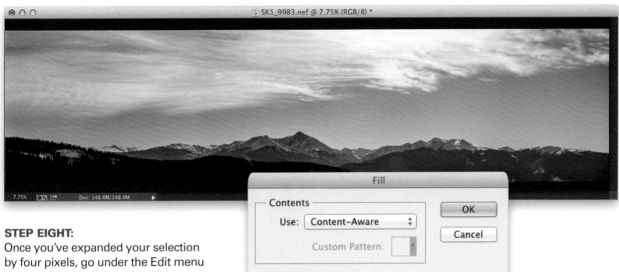

STEP EIGHT:

Once you've expanded your selection by four pixels, go under the Edit menu and choose **Fill**. When the dialog appears, choose **Content-Aware** from the Use pop-up menu (as seen here) and click OK. Press **Command-D (PC: Ctrl-D)** to Deselect. As you can see, it does a pretty amazing job.

STEP NINE:

Now that all the white gaps are filled in, go ahead and take a good look at the image. Here, you'll see three or four small areas where we have some lens flare (greenish spots or strokes on the image). Although we could wait to get rid of these later in Lightroom, honestly it's easier here in Photoshop. So, get the Healing Brush tool (press **Shift-J** until you have it) from the Toolbox and paint over the areas where you see lens flare to remove them (as shown here, where we're removing a streak of green lens flare on the left side of the image).

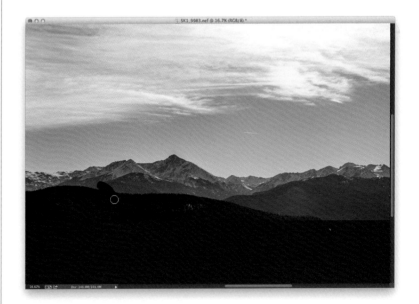

Continued

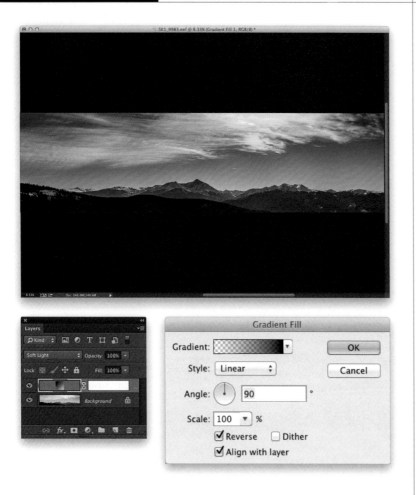

STEP 10:

Next, let's add a neutral density gradient effect (darkening the sky and then graduating down to transparent). First, press **D** to set your Foreground and Background colors to their defaults of black and white, respectively. At the bottom of the Layers panel, click on the Create New Adjustment Layer icon and choose **Gradient**. When the Gradient Fill dialog appears, it does the opposite of what we want—it darkens the ground instead of the sky. So, turn on the Reverse checkbox to fix that and click OK. Now, go to the Layers panel and change the layer's blend mode from Normal to **Soft Light**, and the effect blends in with the sky on the layer below it (as seen here). Go ahead and flatten the image and when you're done, to take your pano back to Lightroom, you do just two things: (1) save the file, and (2) close it. So, press **Command-S (PC: Ctrl-S)** to save it, then close the image window. When you go back to Lightroom, you'll see the pano appear in the Grid view, right after the images you used to create it.

HDR (High Dynamic Range) images (a series of shots of the same subject taken at different exposures to capture the full tonal range) have become really popular, and you can take the images you shot for HDR straight from Lightroom over to Photoshop's Merge to HDR Pro feature. You start by shooting bracketed on your camera. Here, I set up my camera to shoot three bracketed shots with two stops between each shot—one with the standard exposure, one two stops darker, and one two stops brighter (for three shots total).

CREATING HDR IMAGES IN PHOTOSHOP

STEP ONE:

In Lightroom, select your bracketed shots. Here, I've taken three bracketed shots (with a two-stop difference between each) and selected all three in the Library module by Command-clicking (PC: Ctrl-clicking) on each one. Once you've selected them, go under the Photo menu, under Edit In, and choose **Merge to HDR Pro in Photoshop** (as shown here).

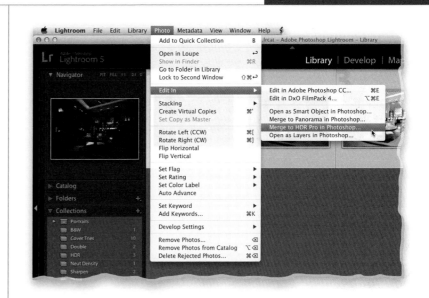

STEP TWO:

This launches Photoshop, and brings up the Merge to HDR Pro dialog (shown here), and it compiles your three images (or five images, or seven images—it just depends on how many bracketed shots you took) into one flat-looking image (as seen here), but that's just reflecting the default settings. There's a Preset menu in the top-right corner of the dialog with a group of presets that are...well...most are just about unusable. Adobe must have gotten tired of hearing me whine about them because when they launched CS5 they asked if they could include one of my own presets. Of course, I was happy to give them one, and it has been in HDR Pro ever since. It's called "Scott5."

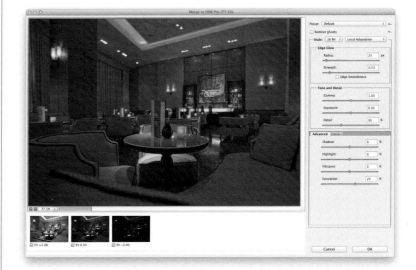

Continued

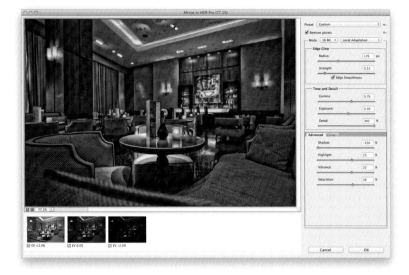

STEP THREE:

Go ahead and choose **Scott5** as it gives you that HDR-tonemapped look (I know, it looks bad right now, but it'll get better in just a moment). Back in Photoshop CS6, Adobe added an important new feature called Edge Smoothness, which makes your HDR effect less harsh, but the Scott 5 preset was created before Photoshop had this feature, so you have to add it. So, right after you choose Scott 5, turn on the Edge Smoothness checkbox. This softens the effect enough that you'll need to crank up the Strength a bit, so drag the Strength slider a little bit to the right to add more tonemapping (I increased it to 0.53). One more tweak: the Highlight slider on the Advanced tab controls the brightest whites (in this case, the lights in the room), so to brighten them up, drag it over to 23%.

STEP FOUR:

For now, let's save these tweaked settings as our own custom preset by going to the flyout menu to the right of the Preset pop-up menu and choosing **Save Preset** (as shown here). Then, give your preset a name. I named mine "Scott 6" (I know, big surprise). This preset works well as a starting place for most images—it is a bit over the top, but we'll deal with that soon enough. In the meantime, I want to note that I don't really touch any of the other sliders here with the exception of the Highlight slider, which affects the brightest areas of the image. So, if it were an HDR of a cathedral, it would control how bright the windows in the cathedral appear. In this case, it's the lighting in the room and the flicker of the candles. The Shadow slider is the other one I sometimes move to the right to open up the shadows, but I don't use it nearly as much as the Highlight slider.

STEP FIVE:

Go ahead and click OK in the Merge to HDR Pro dialog to open your now tonemapped image in Photoshop, as seen here. What we're looking to do here is come away with an image that has some of the good things about HDR (like the enhanced detail and opened-up shadow areas), but keep a more realistic look (so the image doesn't look obviously "HDR'd").

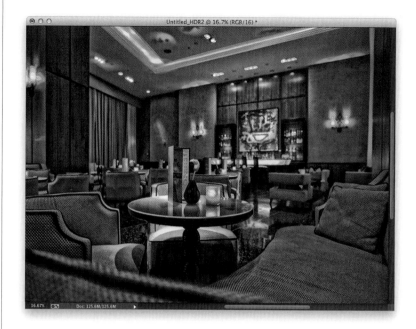

STEP SIX:

Now, go back to Lightroom to your three bracketed images. Press **Command-D (PC: Ctrl-D)** to deselect all three, and then click on the one that is the normal exposure. Press-**Command-E (PC: Ctrl-E)** to open this normal exposure image in Photoshop (or go under the Photo menu, under Edit In, and choose **Edit in Adobe Photoshop**, as shown here).

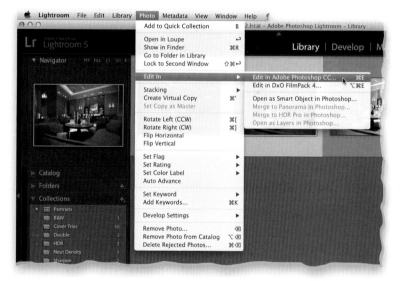

Continued

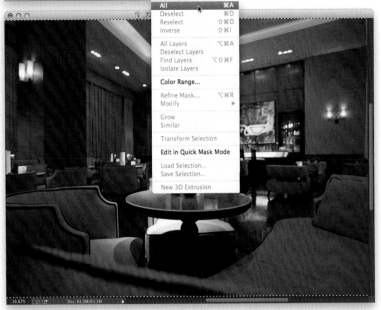

STEP SEVEN:

Once the image appears, press **Command-A (PC: Ctrl-A)** to put a selection around the entire image (or go under the Select menu and choose **All**, as shown here). Then, press **Command-C (PC: Ctrl-C)** to Copy the image into memory. Switch to your HDR image and press **Command-V (PC: Ctrl-V)** to Paste the normal exposure image right on top of your HDR image (it appears on its own separate layer, as seen in the next step).

STEP EIGHT:

In most cases, the two images will align absolutely perfectly, but in this case it's off by a few pixels (due to how Photoshop processed the HDR shot, since I didn't shoot it on a tripod), but Photoshop can fix the alignment problem for you. Start by going to the Layers panel and selecting both layers (click on the Background layer, then Command-click [PC: Ctrl-click] on the other layer), then go under the Edit menu and choose **Auto-Align Layers**, as shown here. Once the dialog opens, leave the Projection set to Perspective and click OK, and in just a few seconds, the images on your two layers are perfectly aligned. (*Note:* When it does this aligning, you'll usually have to go and crop the image just a tiny bit on all sides.) Next, in the Layers panel, click on the top layer (the normal exposure layer) to make it the active layer, then go to the bottom of the Layers panel and click on the Add Layer Mask icon (it's the third one from the left).

STEP NINE:

Adding a layer mask allows us to paint over areas of the normal photo where we want the HDR image to show through. This is important because areas of the photo that are out of focus from a shallow depth of field look really funky (in a bad way) when you add HDR toning. In this case, the area against the back wall is out-of-focus, so we want to keep that area untouched, so it doesn't have any effects on it. However, the area in the foreground, like the couch on the right, the tables, the marble floor, and the walls on the left side, would look great with the effect. So, press **X** to set your Foreground color to black, get the Brush tool **(B)** from the Toolbox, choose a medium-sized, soft-edged brush from the Brush Picker in the Options Bar, and then paint over just those areas (as shown here). These are the good parts of the HDR image, and now they're added to our normal image. If you make a mistake, press X again to switch your Foreground color to white and paint over those areas, then switch back to black. By the way, avoid the arm of the couch right at the very front edge of the image (the foreground) since it's very out of focus.

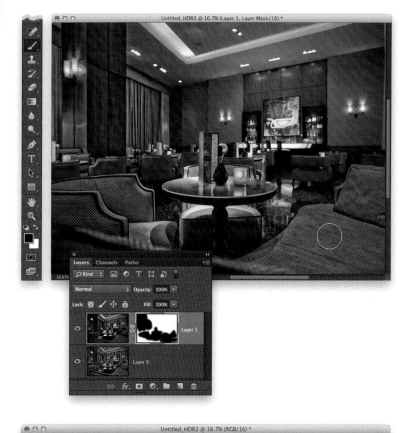

STEP 10:

At this point, I do some sharpening and then a couple of finishing moves that are popular for HDR images. We'll start with the sharpening, so let's go ahead and flatten the image (getting rid of the all the layers)—go to the Layers panel's flyout menu (at the top-right corner of the panel) and choose **Flatten Image**. Next, go under the Filter menu, under Sharpen, and choose **Unsharp Mask**. To add some nice punchy sharpening, enter Amount: 120%, Radius: 1.0, Threshold: 3, and then click OK to sharpen the image. Now, duplicate the Background layer by dragging it onto the Create a New Layer icon at the bottom of the Layers panel, or pressing **Command-J (PC: Ctrl-J)**.

Continued

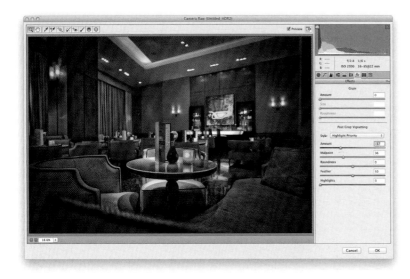

STEP 11:

Now for our finishing effects: One of the most popular is to add an edge vignette (darkening the edges of your image all the way around it). If you're using Photoshop CC, then go under the Filter menu and choose **Camera Raw Filter** to bring up the Camera Raw window (shown here), which is the same as Lightroom's Develop module. Click on the Effects icon, then in the Post Crop Vignetting section, drag the Amount slider to the left (I dragged over to –37) to darken the image, then drag the Midpoint slider to the left (I dragged over to 36) to make the darkening extend more toward the center of the image, and then click OK. If you don't have Photoshop CC, wait to add this vignette until your image is back in Lightroom, then in the Develop module go to the Effects panel and apply the same settings.

STEP 12:

Another popular finishing effect is to add a soft, contrasty glow to the entire image. So, go under the Filter menu, under Blur, and choose **Gaussian Blur**. Enter 50 pixels (which is enough to make this layer majorly blurry, as seen here) and click OK.

STEP 13:
Now we're going to change the blend mode of this blurry layer from Normal to **Soft Light** (in the pop-up menu at the top left of the Layers panel). This not only lets the blur blend in with the rest of the image (as seen here), it also adds a warm, contrasty look to the overall image. In fact, it's too warm and contrasty in most cases, so go to the Layers panel and lower the Opacity of this layer to 60% (as shown here), which gives you the warm contrast without overwhelming the image. I usually wind up at between 50% and 60% opacity on this layer.

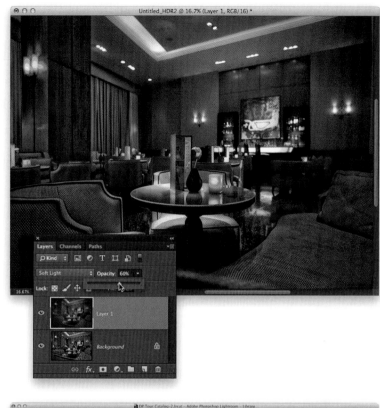

STEP 14:
So, all we need to do now to get this image back over to Lightroom is to: (1) flatten the image, (2) save the file, and (3) close it. So, from the Layers panel's flyout menu, choose Flatten Image, then press **Command-S (PC: Ctrl-S)** to Save it, and then close the image window. Go back to Lightroom and you'll find that your new HDR file appears right next to the original image files you used to create it (as seen here).

RE-TOUCH

RETOUCHING PORTRAITS

I had it made when it came to naming this chapter because when I typed the word "retouch" into the iTunes Store's Search Store field, I not only found songs named "Retouch," but it brought up an artist named "Re-touch," as well. So, I decided to go with that one, since it wasn't so obvious. Plus, once I previewed a few of his tracks, I realized there was no way he was paying his mortgage with income from his music career, so maybe this mention will give him some kind of boost. Okay, I'm just kidding, his music is actually pretty good—especially if you like bass drum. I mean, really, really like bass drum for long extended periods of time, and you like it followed by layering weird synthesizer sounds. If that sounds like a dig, it's not because there are a lot of remixes of Re-touch's tunes by everybody from Tom Novy to Goldie-Lox to Overnoise, which alone is pretty impressive (I have no idea who those people are, but it's only because I am very old and these tunes are probably played well after the Early Bird Special ends at Denny's, so I would've missed them, but I'm sure if they played these def tracks at Denny's around my dinner time [around 4:30 p.m.], there would be plenty of dentures just a-clackin' away. We call that "crack-a-lackin'," but that's just because we're so "street." Ball 'til ya fall, homies!). Anyway, just to circle back around for a moment, you can actually do some minor retouching right within Lightroom itself, and I cover that here at the start of this chapter, but for more serious stuff, you've got to jump over to Photoshop because it was born for this stuff. Now, Adobe has done a number of studies, using select focus groups across a wide range of demographics, and these studies have revealed that high-end professional retouchers using Photoshop can increase not only their productivity, but the realism of their retouching by putting on noise-canceling headphones and listening to a long bass drum track followed by layered weird synthesizer sounds, and then mentally picturing themselves at Denny's. I am not making this up. Google it. You'll see.

RETOUCHING IN LIGHTROOM

There are a lot of simple retouches we can do in Lightroom's Develop module, but they are usually about making something lighter or darker (like darkening your subject's eyebrows by painting over them with the Adjustment Brush with just the Exposure lowered) or removing something simple. I cover some of the most popular Lightroom retouches right here (including reducing wrinkles and slimming), but there's only so much you can do in Lightroom. That's okay, that's why there's Photoshop. But, first, a little Lightroom.

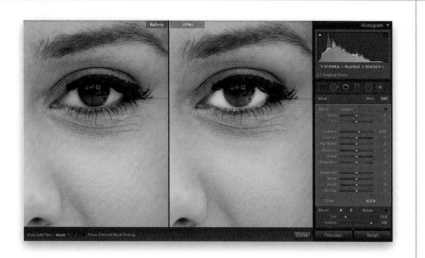

BRIGHTENING THE WHITES OF THE EYES:

For example, to brighten the whites of the eyes right within Lightroom, we click on the Adjustment Brush **(K)** in the toolbar at the top of the right-side panels, double-click on the word "Effect" to reset all the sliders to zero, then click-and-drag the Exposure slider to the right a little bit. Now, we zoom in tight on the eyes, and then paint over the whites to brighten them. Just be careful not to make them too white or it looks very obvious that they've been retouched.

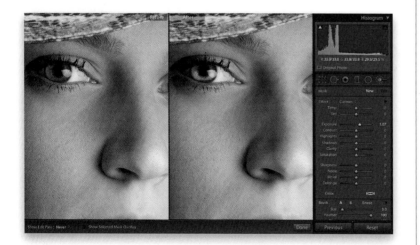

MAKING THE IRIS SPARKLE:

Another nice retouch to the eyes uses the same settings you just applied to the whites of eyes, but this time you're going to add a little "kicker" to the bottom of the iris. Click on the New button at the top of the Adjustment Brush options, and paint over just the bottom of each iris, avoiding the dark ring around the outside of them. Once you're done, you can decide how bright you want your subject's irises to be using the Exposure slider (it won't affect the whites of the eyes because you clicked the New button first).

SOFTENING SKIN:

Granted, it's not great skin softening because it pretty much blurs any skin texture, but it does help. Here's how it's done: Get the Adjustment Brush, double-click on the word "Effect" to reset all the sliders to zero, then click-and-drag the Clarity slider all the way to the left to –100. Now, paint over just the skin, avoiding any detail areas (like the eyes, eyebrows, lips, hair, nostrils, edges of the face, clothes, etc.), and those areas become very soft. Of course, we can do much better in Photoshop, but at least you can do some quick softening right in Lightroom, as long as your goal is speed over quality.

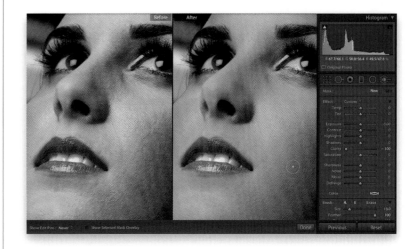

REDUCING WRINKLES:

If your subject is a little bit older, then you don't want to remove their wrinkles (it'll be a dead giveaway it was retouched, especially to their friends). Instead, you want to reduce their wrinkles, so they look 10 years younger (not 40 years younger). Get the Spot Removal tool **(Q)** from the toolbar and paint a stroke over an individual wrinkle, so it's totally gone. Then, go to the Spot Removal tool's options and lower the Opacity to bring back most, but not all, of the original wrinkle. That way, you reduce it, rather than remove it.

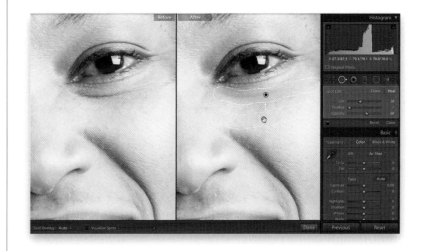

SLIMMING YOUR SUBJECT:

In Lightroom 5, Adobe added a lens correction feature we can use to instantly slim your subject, so they look 10 to 15 lbs. lighter. Go to the Lens Corrections panel, click on the Manual tab, and you'll see the last Transform slider is Aspect. Click-and-drag this slider to the right a little bit (here I dragged it over to +38) and, as you do, it squeezes the photo in from the sides proportionally, and—voilà—your subject is thinner (the farther you drag, the thinner they get). Now, just crop the photo, so the white areas on both sides are gone.

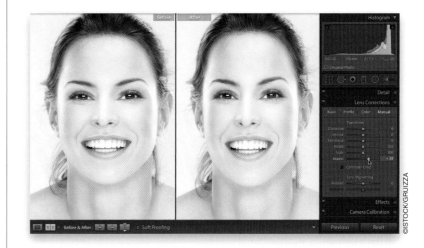

©ISTOCK/GRUIZZA

MAKING FACIAL FEATURES SYMMETRICAL

More often than not, the features on your subject's face won't be perfectly symmetrical (one eye might be higher than the other, or their nose might be a little crooked at the nostrils or the bridge, or one side of their smile might extend higher than the other, and so on). Luckily, you can bring all these misaligned features back into alignment using just a few tools, and some techniques you've already learned (but we do get to learn a helpful new tool this time, as well).

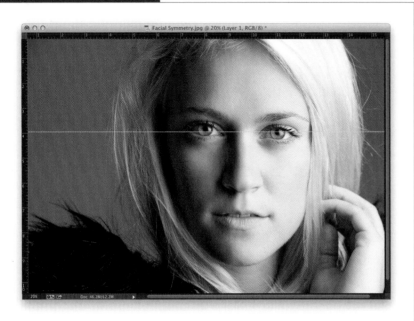

STEP ONE:
Here's the image we want to retouch, opened in Photoshop, and there's a very common problem here (well, when it comes to facial symmetry anyway), and that is our subject's eyes aren't lined up perfectly symmetrically (the eye on the left is up a little higher than the one on the right. I put a horizontal guide over the center of her pupil on the right to help you see the difference). There's a surprisingly easy fix, though. By the way, to get guides like this in Photoshop, you just have to make the rulers visible by pressing **Command-R (PC: Ctrl-R)**. Then, you can click-and-drag guides right out from the rulers themselves.

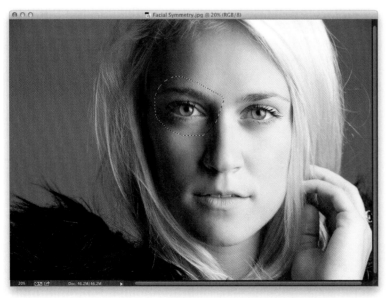

STEP TWO:
Get the Lasso tool **(L)** and make a very loose selection around both the eye and eyebrow on the left (as shown here), because we're going to need to move them together as a unit. Of course, at this point if we moved this selected area, you'd see a very hard edge (a dead giveaway), so we'll need to soften it by adding a feather to the edges that will help it blend right in. So, go under the Select menu, under Modify, and choose **Feather**. When the Feather Selection dialog appears, enter 10 pixels (as shown here) and click OK, and now you've softened the edges of your selection.

STEP THREE:

Press **Command-J (PC: Ctrl-J)** to copy your selected eye area (with its soft edges) up to its own separate layer. Here, I hid the Background layer, so you can see what just the eye area looks like. What's nice about seeing this view is that you can see the area you selected has soft edges, instead of sharp, harsh edges (the checkerboard pattern shows you which parts of this layer are transparent). By the way, to hide a layer (like the Background layer, in this case), go to the Layers panel and click on the Eye icon to the left of the layer's name. To see the Background layer again, click where that Eye icon used to be.

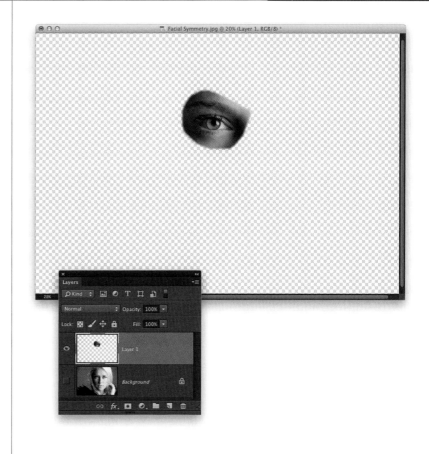

STEP FOUR:

Now, switch to the Move tool **(V)** and then press the **Down Arrow key** on your keyboard a few times until her eyes on both sides line up (as shown here). In this case, I had to hit the Down Arrow key seven times until they lined up. You might find it helpful to pull out a horizontal guide (drag it down from the top ruler) to help you align the two eyes right on the money, or you can just eye it. (Oh, come on. That one was pretty good. Get it? "Eye it." Seriously, that was pretty decent, ya gotta admit.)

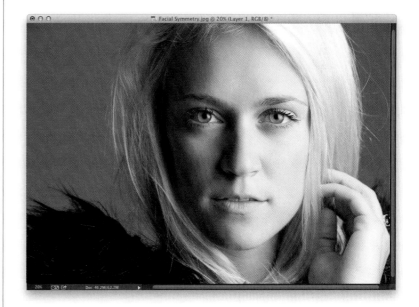

TRIMMING EYEBROWS

This retouch requires you to pick up one part of your image to cover up another part of it, and, of course, Lightroom doesn't have any way to do that. But, luckily, this is the stuff Photoshop is made for. This technique is actually very simple and very quick, but has a big impact when it comes to your subject having perfect eyebrows every time.

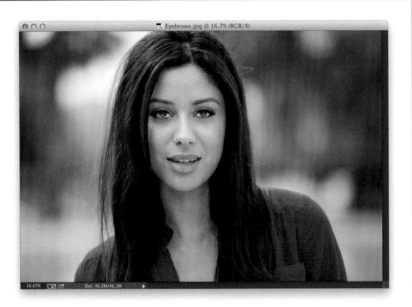

STEP ONE:
Once your image is open in Photoshop, start by getting the Lasso tool **(L)** and drawing a shape that kind of looks like an eyebrow itself. Draw this right above one of your subject's existing eyebrows (as shown in the next step).

STEP TWO:
You need to soften the edges of the selection just a little bit, so go under the Select menu, under Modify, and choose **Feather**. When the dialog appears, enter 5 pixels (just enough to add a little bit of edge softening), and click OK.

STEP THREE:

Now, press **Command-J (PC: Ctrl-J)** to place that selected area up on its own separate layer. Here, I turned off the Background layer (by clicking on the Eye icon to the left of the layer thumbnail), so you can see just the selected area with its feathered edge. Switch to the Move tool **(V)** and click-and-drag that shape straight down until it starts to cut off the top of the real eyebrow, and perfectly trims it. Then, go to the Layers panel, click on the Background layer, and do the exact same thing for the other eyebrow. A before and after is shown below.

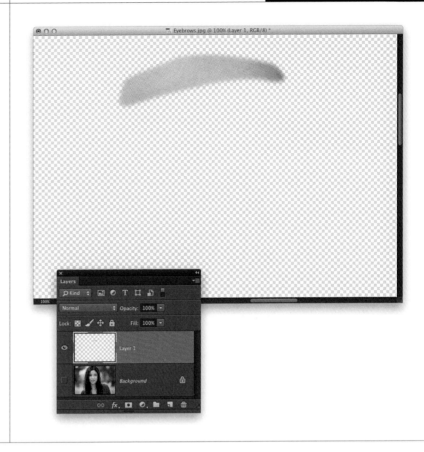

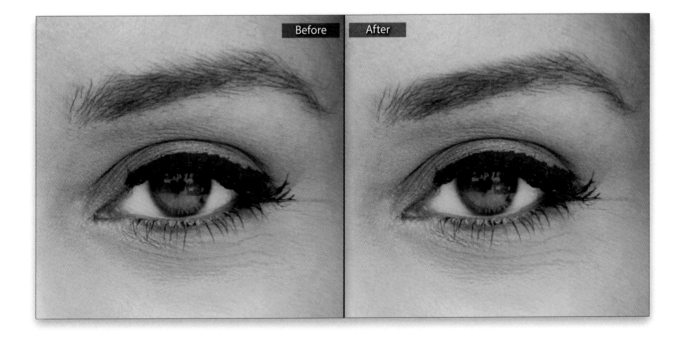

REMOVING EYE VEINS

Technically, you can remove some eye veins while you're still in Lightroom using the Spot Removal tool, but if you've ever tried it, it's pretty tricky and the results are…well… let's say there's a reason we almost always jump over to Photoshop for a retouch like this. The only time I'd consider doing it in Lightroom alone is if your subject had just one single red vein, and unfortunately that rarely happens, so it's handy to know this technique.

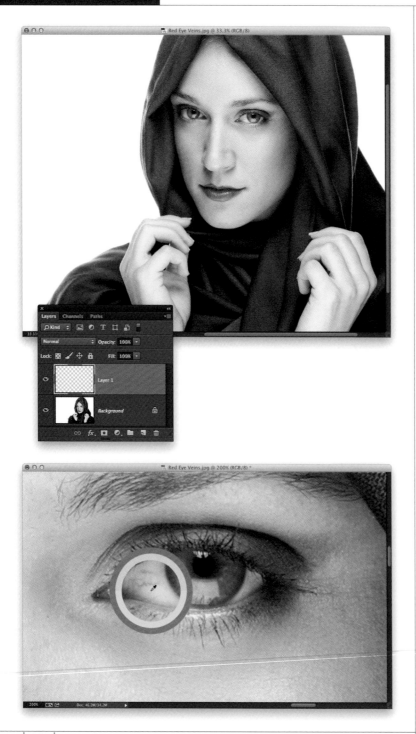

STEP ONE:

Here's the image we're going to retouch in Photoshop. We'll need to zoom in tight (to at least 100%) to really see what we're working on, so grab the Zoom tool (Z) and zoom in on the eye on the right (you can see this in the next step). Then, click on the Create a New Layer icon at the bottom of the Layers panel to create a new blank layer. We're going to do our retouching on this empty layer, so later we can add a filter on top of it that will add texture back into the areas we retouched to make them look more realistic.

STEP TWO:

You're going to remove these red veins using the Brush tool (with temporary help from the Eyedropper tool). So, get the Brush tool (B), then press-and-hold the Option (PC: Alt) key and your cursor will temporarily switch to the Eyedropper tool, so you can steal any color in your image and make it your Foreground color. You're going to want to click the Eyedropper tool right near the red vein you want to remove (as shown here, where I'm clicking it right below the vein I want to remove). A large circular ring appears around your Eyedropper tool when you click— the inside of the ring shows the exact color you just sampled and the outside of it is a neutral gray to help you see the color without being influenced by surrounding colors.

STEP THREE:

Let go of the Option (PC: Alt) key to return to the Brush tool, set your brush Opacity (up in the Options Bar) to 20%, and choose a small, soft-edged brush that's just a little bit larger than the vein you want to remove from the Brush Picker. Now, just start painting a few strokes right over the vein and, in just moments, it's gone! Remember, at 20% opacity, the paint builds up, giving you a lot of control as you build up your paint over the vein, so don't be afraid to go over the same stroke more than once. Since the eye itself is a sphere, the shading changes as you move across it, so be sure to sample again near what you're painting over as you're removing these veins to make sure the color and tone stay right on the money (I resampled about 10 or 12 times during this retouch).

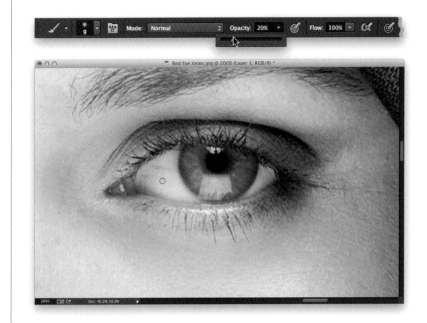

STEP FOUR:

Lastly, to keep the whites of the eyes from looking pasty after your retouch, we're going to add a tiny bit of noise to your retouch layer. So, go under the Filter menu, under Noise and choose **Add Noise**. When the filter dialog appears, choose an Amount of 1%, click on the Uniform radio button, and turn on the Monochromatic checkbox. Click OK to add this texture to your retouch. Although it's subtle, it does make a difference.

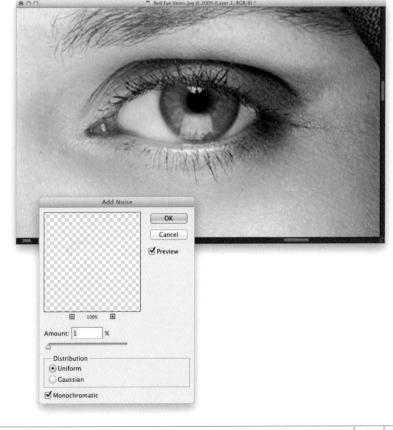

SHARPENING EYES

If there's one part of your image that is absolutely critical to have in sharp focus, it's the eyes. If the eyes aren't sharp, the whole photo's a bust, so we take extra steps to make sure we sharpen them. In this case, we're going to use the most advanced sharpening Photoshop has to offer: the Sharpen tool. By the way, it wasn't always this way. Adobe went and reworked the math behind the sharpening just a couple of years ago, and now we can apply more sharpening with fewer of the distracting halos and artifacts (junk) you'd get anytime you really sharpened something a bunch.

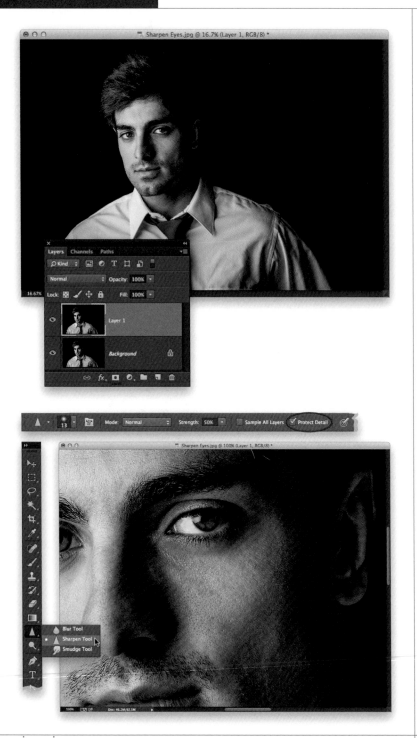

STEP ONE:
Open the image you want to retouch in Photoshop, and then press **Command-J (PC: Ctrl-J)** to duplicate the Background layer. I generally do this type of sharpening on a duplicate of the Background layer so (1) I can easily toggle the layer on/off to see a before/after while I'm sharpening, (2) I can lower the Opacity amount of the layer if I think I've over-sharpened the eyes, or (3) I can delete the layer altogether if I decide I don't want any sharpening at all.

STEP TWO:
Get the Zoom tool (**Z**; it looks like a magnifying glass) from the Toolbox, and then zoom in on the eyes. Also in the Toolbox, nested under the Blur tool, you'll find the Sharpen tool (seen here). It has been in Photoshop for many years, but was pretty much unusable because it was so harsh we avoided it all costs. But, in Photoshop CS5, Adobe's engineers decided to not only fix this tool, but to make it Photoshop's most advanced sharpening tool (I got that straight from one of Adobe's own Photoshop product managers). However, this new math is only turned on if the Protect Detail checkbox up in the Options Bar is turned on, so make darn sure that it is (as shown here, circled in red), or you'll be using the old version of the Sharpen tool (with the old results).

STEP THREE:

Also in the Options Bar, lower the Strength amount to 20% (as seen here). Using a lower amount like this gives you more control because the sharpening builds up each time you paint, rather than all at once. Then take the Sharpen tool, and paint a few times over an entire iris, including the outside edge of it (as shown here). Do the same thing with the other eye, and keep in mind that since you did this on a layer, if you need to, you can lower the layer's opacity, which lowers the amount of sharpening you've applied. Doing this much sharpening can sometimes sharpen random bits of noise or shift the colors in your image a bit, so change the top layer's blend mode from Normal to **Luminosity**, so it just sharpens the detail and not the color, and you're done. Now, flatten the layers (from the Layers panel's flyout menu) before you save the image and take it back to Lightroom.

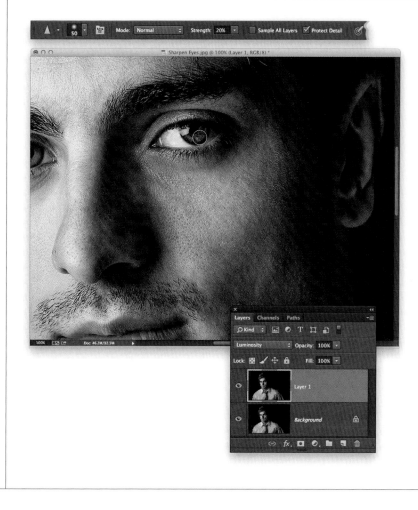

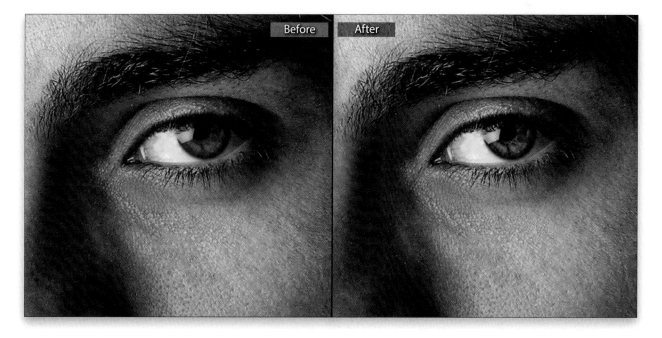

SOFTENING SKIN WHILE RETAINING TEXTURE

The problem with Lightroom's method for skin softening is that it pretty much obliterates the skin texture and your subject's skin winds up looking pretty plastic. That's why, when it comes to softening skin and keeping texture, we always head over to Photoshop. It does take a few steps, but it's really easy.

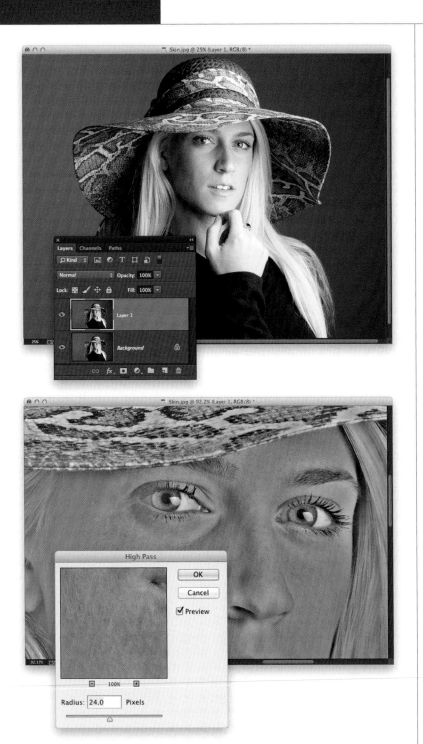

STEP ONE:
Select the image in Lightroom you want to retouch, then press **Command-E (PC: Ctrl-E)** to open it in Photoshop. Before we do any skin retouching, we always remove any large obvious blemishes first (you can do that in Lightroom using the Spot Removal tool before you even bring it over to Photoshop). It's hard to see at this zoomed out view, but she's got a nice skin texture we want to preserve, and this technique does a great job of that. So, start by pressing **Command-J (PC: Ctrl-J)** to duplicate the Background layer.

STEP TWO:
Go under the Filter menu, under Other, and choose **High Pass**. When the High Pass filter dialog appears, enter 24 pixels (as shown here) for images that are cropped in pretty tight like this. If it's more of a full-length or 3/4-length photo of your subject, where they're not so tightly cropped, use 18 pixels instead, then click OK. The image will turn mostly gray (like you see here) when you click OK in the High Pass filter (by the way, we normally use the High Pass filter when we need some really heavy sharpening. See page 134 for more on that technique).

STEP THREE:

Now, go under the Filter menu, under Blur, and choose **Gaussian Blur**. You're going to enter a number that is 1/3 of the number you entered in the High Pass filter. So, if you had a close-up image like we do here, you'd enter 8 pixels (1/3 of the 24 pixels you entered in the High Pass dialog). If instead your image was a 3/4-length shot or a full-length shot, then you'd enter just 6 pixels (1/3 of 18). Click OK to apply a blur to your High Pass gray layer (as seen here).

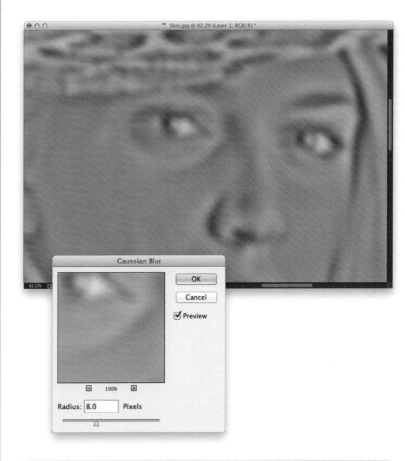

STEP FOUR:

Next, you're going to invert this High Pass layer by going under the Image menu, under Adjustments, and choosing **Invert**, or by just pressing **Command-I (PC: Ctrl-I)**. At this point, it still looks gray and pretty bad, but we're going to change the blend mode for this layer so it ignores the gray part. Go to the Layers panel and, from the pop-up menu near the top left, change the blend mode from Normal to **Linear Light** to give you the effect you see here. It's still a mess, but at least it's not gray, right? The problem is there are halos around everything. To get rid of all that haloing and stuff, go to the bottom of the Layers panel, click on the Add a Layer Style icon and, from the pop-up menu, choose **Blending Options**.

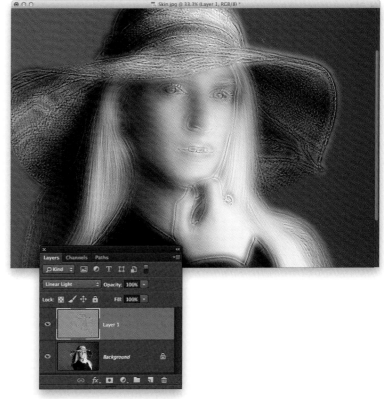

Continued

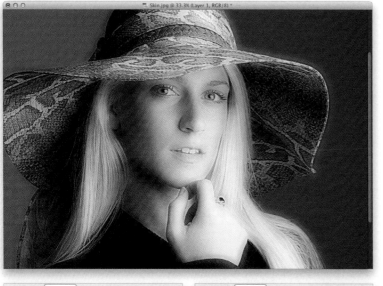

STEP FIVE:

When the dialog appears, go right to the bottom, where you'll see two gradients with little triangle-shaped sliders under them (shown below left). These are the Blend If sliders, and they are for controlling how the layer you're currently on blends with the layer(s) below it. If you drag those triangle sliders to the left or right, you'll see how harsh they make the blending. However, if instead you press-and-hold the Option (PC: Alt) key, and then drag the top-right slider (the one marked This Layer), it splits the slider in half and now it makes a very smooth blend. Drag it nearly all the way to left (as seen here at right), and some of those halos go away. Do the same thing with the top-left slider (press-and-hold the Option key and drag it nearly all the way to the other side), and the rest of the haloing junk goes away. Now click OK.

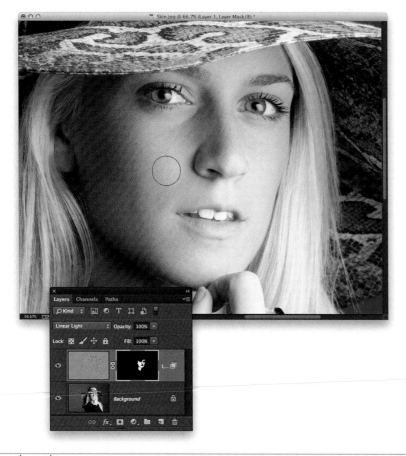

STEP SIX:

What you're seeing onscreen is what we're going to use for our skin texture, but it's also appearing over her eyes, lips, hair, hat, etc., so we need to hide this layer from view and then reveal just the parts we want. We do this by pressing-and-holding the **Option (PC: Alt) key**, then clicking on the Add Layer Mask icon at the bottom of the Layers panel (it's the third icon from the left). This hides your skin texture layer behind a black layer mask. Now, press **D** to set your Foreground color to white, get the Brush tool **(B)**, then in the Brush Picker in the Options Bar, choose a medium-sized, soft-edged brush and set its Opacity to 100%. Paint over just the skin areas (as shown here), avoiding all the detail areas, like the eyebrows, eyes, hair, nostrils, lips, teeth, and the edges of the face (avoid the edges of her face, or they will get softer). Notice how it's smoothing and removing the splotchy areas of skin, but it's actually enhancing the skin texture as you paint? Pretty cool, right?

STEP SEVEN:

At this point, you've applied the skin softening and texture at 100% (full power), but that's normally too much. So, go to the Layers panel and lower the Opacity to around 50% and things start to look more realistic. The lower the opacity, the less of the softening we see, so pick an opacity setting that looks good to you. Normally, I use something between 40% and 50%, but it depends on the person and their skin. There are times I've had to use 70%. It just depends on their skin.

TIP: SEEING IF YOU'VE MISSED ANY AREAS

In the Layers panel, Option-click (PC: Alt-click) directly on the black layer mask thumbnail (seen here). This shows you just the black-and-white mask. In this case, any areas that appear in black haven't been painted over yet, so if you see a gap that should be white, paint over it. When you're done, just Option-click on the thumbnail again.

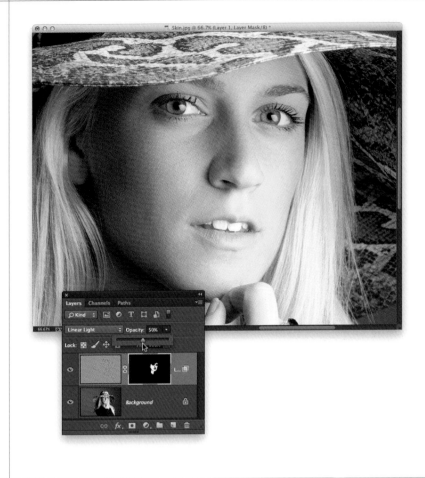

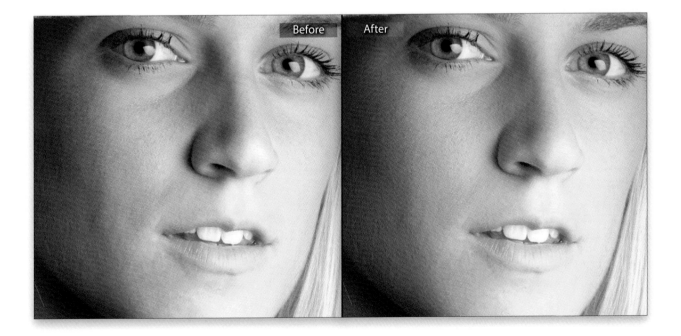

CREATING BEAUTIFUL TEETH

If someone is smiling in a photo I've taken, I always take a few moments to make sure their teeth line up nicely, without distracting gaps between teeth, or teeth that look too pointy, or too short compared to the teeth on either side, or anything that makes them not look perfectly beautiful. We use the Liquify filter for this because it lets you literally move the teeth around, tooth by tooth, as if they were made of a thick liquid. You can just kind of push and pull them in the direction you need them to go. Here's how it works.

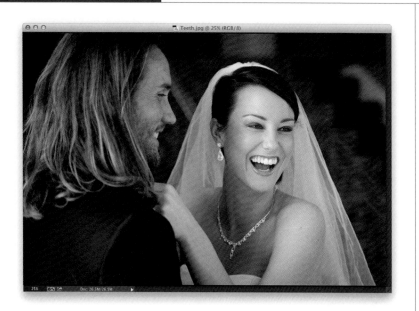

STEP ONE:

Open the image with teeth we want to retouch in Photoshop. First, let's evaluate what we need to do: I see that the two front teeth are a little too long compared to the rest of the other teeth (the front two should be a little longer than the surrounding others, but just a little). So, that's one thing to fix. Then, I would flatten the points on a few teeth and generally just try to even all the teeth out a bit. Her teeth are actually pretty nice, but the angle of this shot makes them look kind of crooked and uneven.

STEP TWO:

Go under the Filter menu and choose **Liquify**. When the Liquify dialog appears (shown here), start by zooming in tight (press **Command-+** [plus sign; **PC: Ctrl-+**] a few times). Then, make sure you have the first tool at the top of the Toolbox selected (on the left side of the dialog; it's called the Forward Warp tool, and it lets you nudge things around like they were made of molasses). The key to working with the Liquify filter is to make a number of very small moves—don't just get a big brush and push stuff around. Make your brush size (in the Brush Size field on the right) just a little larger than what you're retouching. Now, just gently nudge the teeth on the left side upward a few times each (as shown here) to shorten them and remove the pointiness (if that's even a word).

STEP THREE:

Now we're going to do more of the same. Let's work on the two teeth in the front center. Let's gently nudge them upward a bit to make them shorter, and then go over to that one tooth on the far right that's pointy and sticking down. Make your brush size very small (one of the big secrets of mastering retouching with Liquify is to make your brush just a tiny bit larger than what you're trying to move. If you get into trouble, it's probably because your brush is too big), then tuck up that pointy tooth (as shown here).

STEP FOUR:

So, that's basically the process: you'll move from tooth to tooth. To make a tooth longer, click inside it near the bottom of the tooth and nudge it down. If you need to close a gap, click on the side of the tooth with a very small brush and nudge it over. Here I'm flattening the tooth to the left of the front two teeth. My goal is to make everything pretty straight all the way across. A dentist would cringe if they saw what I did here, because it's not "dentically" correct (hey, I just coined another new term), but we don't have to worry about the teeth actually working to eat food, they just have to work in the context of our photo, which they do.

TIP: QUICK BEFORE AND AFTER

If you want to see a quick before and after of your retouch, just turn the Show Backdrop checkbox (near the bottom right of the dialog) on and off. If you don't see it, turn on the Advanced Mode checkbox near the top.

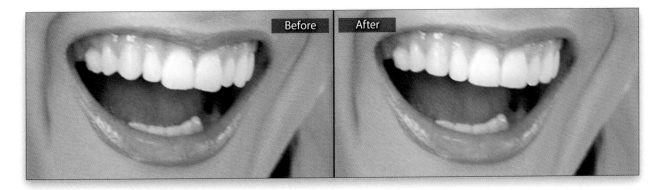

FOUR OTHER RETOUCHES WE USE LIQUIFY FOR

Liquify is an absolutely amazingly powerful tool unto itself, and here are four more instances where it literally comes to the rescue (while you'll find more reasons and ways to use it on your own, these are four situations you'll come across fairly often where it's the perfect tool for the job). Also, one thing you'll learn about retouching is that once you start to correct a certain problem, like ripples or folds in clothes, those problems start to stick out to you almost like they jump off the image, so you'll get really quick at identifying them and fixing them fast using Liquify.

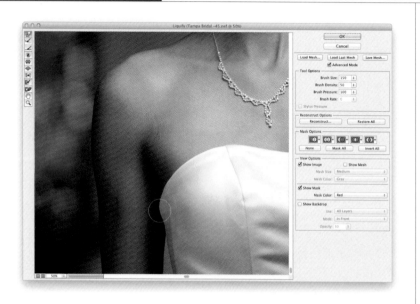

(1) FIXING RIPPLES OR FOLDS IN CLOTHES:

If you see a fold, or a ripple, or anything that needs a bit of tucking in, just tuck it in. You'll use the same Liquify tool we used for nudging teeth around—the Forward Warp tool (it's the first tool at the top of the Toolbox on the left). The same rules apply: make the brush slightly larger than the fold or material you want to move, then just gently nudge it over and it moves like you're moving a thick liquid (like molasses).

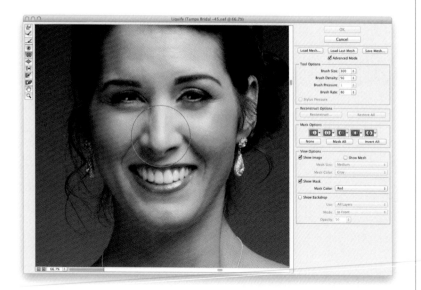

(2) SHRINKING NOSE SIZE:

Liquify has a special tool just for making things smaller. It's called the Pucker tool (it's the fifth tool down from the top in the Toolbox on the left) and to use it, just make the brush size a little larger than the area you want to make smaller (in this case, we're going to make our bride's nose smaller, even though it really doesn't need it), and then don't paint with it—just click. Each time you click, it shrinks the area inside your brush a bit more. If you go too far, just press **Command-Z (PC: Ctrl-Z)** and it undoes your last step. You can use this for reducing "bug eyes," as well.

(3) MAKING EYES LARGER:

A very popular retouch is to make your subject's eyes larger (ever-popular on magazine covers) and it's easy to do. You're going to use the cousin of the Pucker tool (which makes things smaller, right?). It's the Bloat tool, and it makes things bigger. It works the same way the Pucker tool does: you just move it over your subject's eye (just do one at a time), make it a little larger than the eye and eyelids, and then just click. Each time you click, the eye gets a little bigger. Remember, if you go too far, or it doesn't look right, use that keyboard shortcut I just mentioned to undo it.

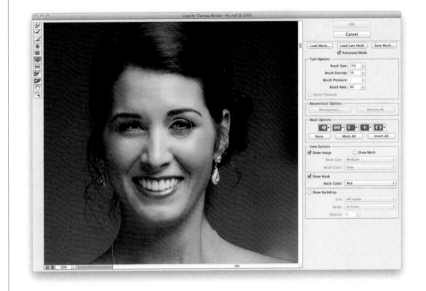

(4) SMOOTHING BODY PARTS:

This is another one I wind up doing quite a bit, especially when your subject has bare shoulders (and today's brides all seem to want strapless bridal gowns, so this is a good one to know). You're going to use the Forward Warp tool (like we do for fixing bumps or folds in clothes) and just gently nudge any bones sticking out along the shoulders (seen here) right back in.

TIP: FREEZING PARTS YOU DON'T WANT TO MOVE

If you're moving a large part of a person's face (like tucking in the sides), you always run the risk of moving things you don't want to move (like their eyes, or cheeks, or ears). You can lock down these areas in the center of their face, or their ears, by using the Freeze Mask tool (it's the fourth tool from the bottom in the Toolbox). Just paint over their eyes or cheeks and that area appears in a red tint, and now it will not move. When you're done, erase those red frozen areas with the Thaw Mask tool (it's right below the Freeze Mask tool).

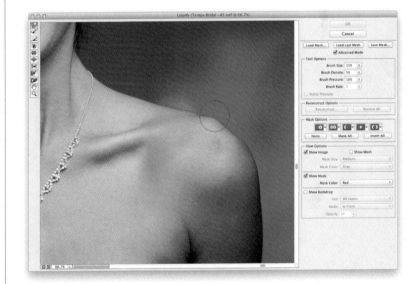

REDUCING JAWS AND JOWLS

This is a retouch you usually do when there's more than one person in the photo, but you want to slim just one of them. This is one of those techniques that, when you look at it, you think, "There's no way this is going to work." But, it actually works amazingly well, even though it only takes a few seconds. Go figure.

STEP ONE:
Click on the image in Lightroom you want to retouch and press **Command-E (PC: Ctrl-E)** to open it in Photoshop. Here, we're going to reduce his jaw area and jowls.

STEP TWO:
Get the Lasso tool **(L)** and draw a very loose selection around your subject's jaw and the lower part of the face on both sides (as shown here). Now, soften the edges of the selection by going under the Select menu, under Modify, and choosing **Feather**. When the Feather Selection dialog appears, enter 10 pixels and click OK.

STEP THREE:

Go under the Filter menu, under Distort, and choose **Pinch**. When the Pinch dialog appears, drag the slider to the right to the point where it reduces the area but without looking too obvious. You see a preview of how this affects your image in the filter dialog's little preview window as you drag the slider (I chose 35% here, but depending on your subject, you might need to use slightly more or less). To see a quick before and after of what the filter is doing, just take your cursor and click-and-hold right inside the preview window to see the before, then let go to see the after. Click OK, and the Pinch filter is applied to your selected area (a before/after is shown below). In some cases, applying the filter once just isn't enough (it's too subtle), so to apply the same filter again, using the exact same settings, press **Command-F (PC: Ctrl-F)**.

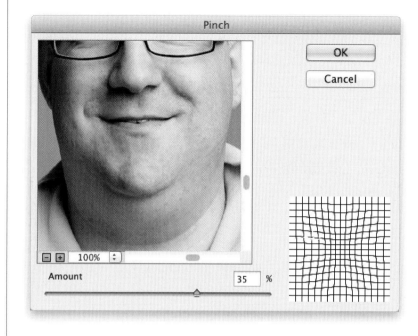

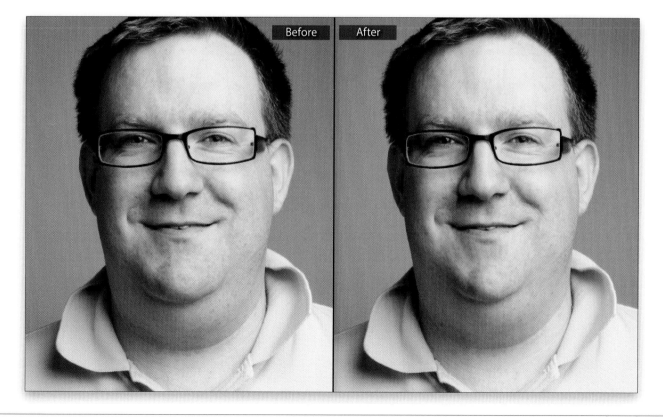

COMPOSITING: PUTTING YOUR SUBJECT ON A DIFFERENT BACKGROUND

Compositing has become really popular over the past few years, and I think one of the main reasons is Photoshop's Quick Selection tool paired with Photoshop's Refine Edge feature, which makes taking people off one background and putting them on another realistically, incredibly easy (even if their hair is blowing in the wind). Here's how it's done:

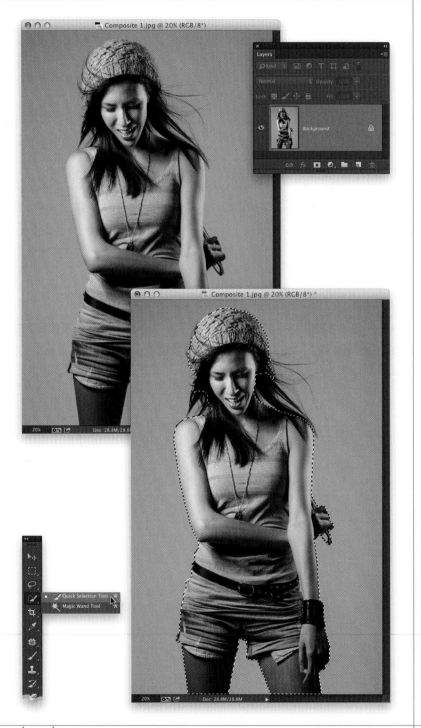

STEP ONE:

Start in Lightroom by choosing the photo of a subject you want to composite onto another background, and then press **Command-E (PC: Ctrl-E)** to take that image over to Photoshop (as seen here). Before we dive into the selection process, your job of selecting someone off the background is much easier if you photograph them on a light gray background (we use inexpensive white seamless paper and don't aim any lights at it, and the white background shows up as light gray on camera. Of course, you could just buy light gray seamless paper, but then you have to light it or it becomes dark gray).

STEP TWO:

We want to select as much of our subject as we can, including her "fly-away" hair. We do this in two steps: Start by getting the Quick Selection tool **(W)** from the Toolbox and start painting over your subject. As you paint, it starts making a selection. Here's an important tip: don't select the "hard-to-select" areas, like the outside edges of her hair—leave that for the next step. So, for now, just paint over a nice solid area of her hair to select it and avoid areas where you see the gray background peeking through altogether. If you look at my selection here, you can see I steered clear of those areas of hair at neck and chin level. Decrease your brush size to make it easier to select tighter areas by pressing the **[(Left Bracket) key** on your keyboard (it's to the right of the letter P). And, if you accidentally select too much, press-and-hold the **Option (PC: Alt) key** and paint over that area to deselect it.

STEP THREE:

There will probably be some areas that the Quick Selection tool didn't pick up, like noncontiguous areas between her arm and her clothes and, in this case, the areas inside the glasses she's holding—you can see solid gray through them (as seen here). I generally don't try to select those much smaller areas with the Quick Selection tool—it just doesn't work that well in those cases. For little areas like this, switch to the Magic Wand tool **(Shift-W)**. It works like a charm, especially since what you're doing will be subtracting from areas that are already selected (like the inside of her glasses). We actually need those areas to not be selected, so they're see-through.

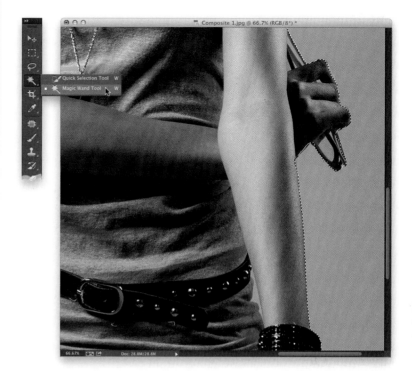

STEP FOUR:

Once you have the Magic Wand tool, press-and-hold the **Option (PC: Alt) key**, and then click the tool just once on those areas you want to be deselected, like on the lenses of her glasses (as shown here), and in that area between her arm and her belt, and anywhere else that shouldn't be selected. All it will usually take in each of these areas is one click. If it takes two, it takes two—no biggie. Now it's time to select the hair (don't worry—it's amazingly easy now), and that process starts by clicking on the Refine Edge button up in the Options Bar (also shown here).

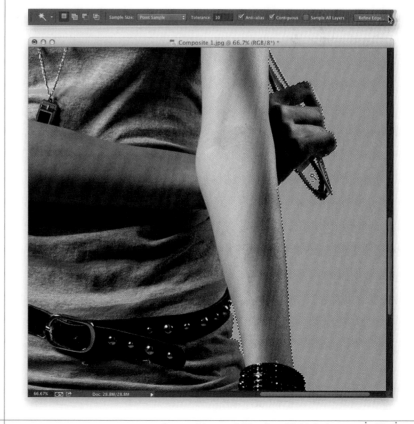

Continued

STEP FIVE:
This brings up the Refine Edge dialog, which is a miracle worker when it comes to selecting hair. Let's start at the top of the dialog and change to a view that makes selecting the hair easier to see as you do it. So, from the View pop-up menu, choose **Overlay**, and it puts a red overlay over all the areas that are *not* selected (as shown here). The areas that look normal are the areas that are okay—the ones already selected. What you can now see clearly are the areas of her hair which are still red. Our goal will be to paint over those areas (not quite yet though) with a special brush that focuses Photoshop's selection power on just that area, and it does an amazing job. But before we do that, we need to help the process along a little bit by turning on the smart selecting feature.

STEP SIX:
We do this by turning on the Smart Radius checkbox, and then we drag the Radius slider to the right a bit as a starting place (as shown here, where I dragged it over to 4.1). Okay, now we're ready to start selecting the hair, but don't worry, Photoshop will actually do all the "heavy lifting" for you— you just have to tell it which areas to focus on, and it'll pretty much do the rest. You tell Photoshop where to focus by painting with the Refine Radius Tool (shown circled here in red; it really should be called the Refine Radius brush, but that's another story).

STEP SEVEN:

Once you click on that tool to activate it, you then just paint over the tricky areas of her hair (as shown here, where I'm painting over her hair on the right side). By doing this, you're telling Photoshop "there is fine detail here you're missing," and it will re-evaluate that area and try to make a much more precise selection. It's not going to get every little stray thin sliver of wind-blown hair, but it'll get most of it.

STEP EIGHT:

Now take a look at her hair on the right side—it doesn't have all that red tint over it anymore because those areas are now added to our selection. But, if you look closely, it's not 100% solid. There's still a tiny bit of red tint over it, which means a lot of it is selected—most of it probably—but not all of it. So, some parts of her hair might be a little transparent, which isn't usually a great thing, but we can fix that in the next step.

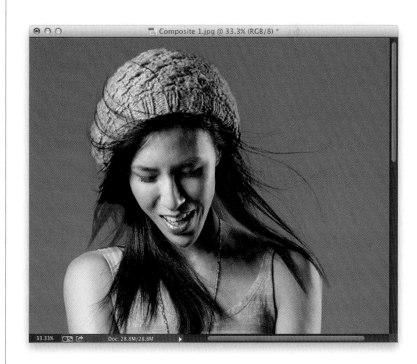

Continued

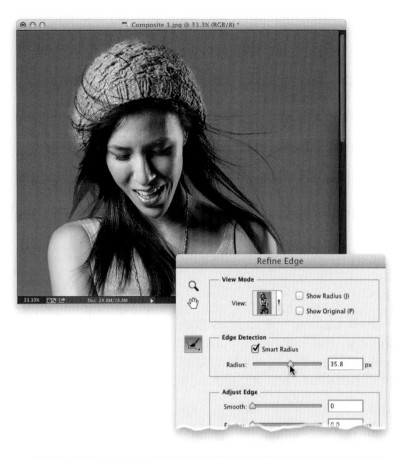

STEP NINE:

To have those slightly red-tinted areas go away (which means we've successfully added that fly-away hair to our selection), just drag the Radius slider to the right until those areas turn solid and the red goes away (as seen here). In this case, I dragged over to 35.8 and that area not only turned mostly solid, but it also picked up the hair against her neck and over her shoulder as a bonus. Unfortunately, you can't just crank the Radius slider way over to the right because it will actually begin to select too much. In fact, it already is a little bit—look at the top left side of her hat; it's starting to creep into that area a bit and the edges of her hat are starting to get a gray tint. For those areas, just press-and-hold the **Option (PC: Alt) key** and paint over them, and that removes the tint in those areas and returns it to more of a solid selection (as you'll see in the next step).

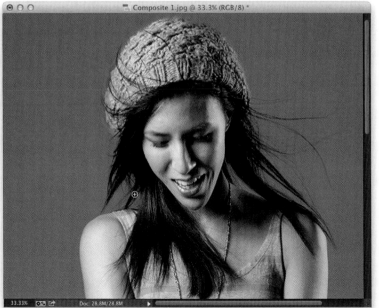

STEP 10:

For the hair on the left side, let's shrink the brush way down in size (press the **[(Left Bracket) key**). Then, paint right over those hair strands (as shown here). Now that we have our Radius set so high, don't paint big ol' brush strokes like we did on the other side—keep these nice and tight to the hair you want to keep, and it paints away the red tint and now that hair is added to our selection. If you start to see some gray areas appear, that's not good because it's selecting too much, so press **Command-Z (PC: Ctrl-Z)** to Undo your last brush stroke. If you need to undo multiple brush strokes, press-and-hold the Option (PC: Alt) key, again, and paint over those areas to deselect that gray junk, and then try painting over it again with a smaller brush.

STEP 11:

In the Output section, at the bottom of the Refine Edge dialog, from the Output To pop-up menu, choose **New Layer** (as shown here). Now, when you click the OK button, the Refine Edge dialog goes away, and your selected subject will appear on their own new layer with a transparent background (that checkerboard pattern you see in the background is Photoshop's way of showing you what's transparent on a layer). Now, if you look at her hair, you can see it's "pretty good," but it's a little transparent in places, right (you can kinda see through it on both sides)? But, don't worry—we're going to fix that fast!

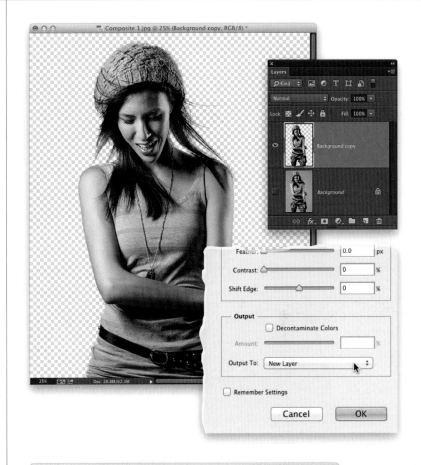

STEP 12:

The quick fix for this transparent hair is a trick I learned many years ago and it works like a charm: simply duplicate the layer. Yup. That's it. Press **Command-J (PC: Ctrl-J)** to duplicate the layer (as seen here). The pixels have a way of "filling in" behind the image, and now those areas that were "dropping out" are solid (take at look at the image now, compared to the one in the last step). I know, it sounds too easy, but it really works. In fact, if duplicating it once isn't enough, duplicate it again (although I've rarely had to do that). Now, once you've duplicated your layer, you really want them to be just one layer, so with your top layer active (the duplicate), press **Command-E (PC: Ctrl-E)**. This merges the two layers into one (this is the Merge Down command).

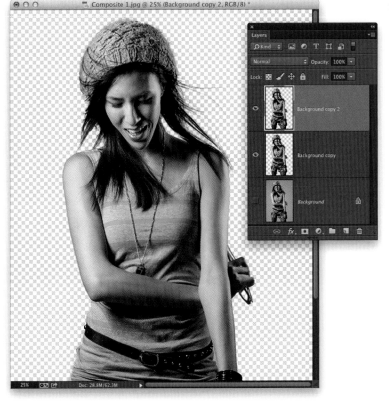

Continued

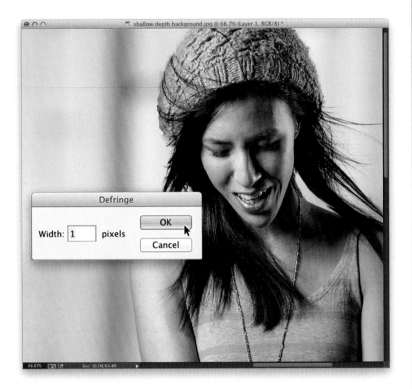

STEP 17:

One thing you're likely to see if you zoom in close is that your subject may have a thin white "fringe" around her—not so much in her hair, but more likely along her arms, clothes, etc. Sometimes it's really pronounced, and other times you hardly see it all, but if you do see it, here's what to do: Go under the Layer menu up at the top of the screen and scroll all the way to the bottom where you'll find a menu called "Matting." Go under Matting and choose **Defringe** to bring up the Defringe dialog you see here. Enter 1 pixel (as shown here), click OK, and that fringe is gone! If for any reason you don't like the way it looks, just press **Command-Z (PC: Ctrl-Z)** to Undo it.

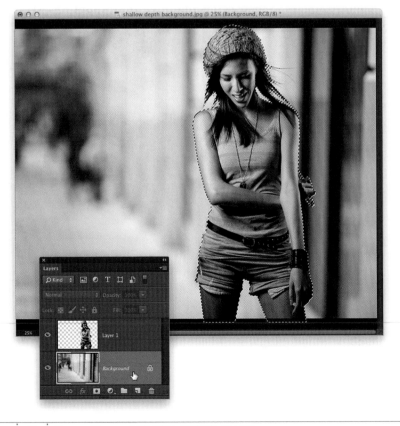

STEP 18:

Now we're going to make her over-all color match the lighting of the background shot to help "sell" the idea that she was really on this back-ground (this is really important for a convincing composite). To do that, we have to start by putting a selec-tion back around her, but you learned how to do that a few steps ago—just Command-click (PC: Ctrl-click) directly on the subject layer's thumbnail over in the Layers panel. This reloads the selection around her (as seen here). While the selection is still in place, in the Layers panel, click on the Back-ground layer (as shown here) to make it the active layer.

STEP 19:

Press **Command-J (PC: Ctrl-J)**, which makes a new layer in the shape of your subject, but it makes that layer out of the background (as seen here). So, it's like you took a cookie cutter and stamped out a shape from the background (I hid the other two layers from view here temporarily, just so you could see what this looks like. It's for example purposes only—you don't have to do this).

STEP 20:

In the Layers panel, click-and-drag this subject-shaped layer up to the top of the layer stack (as seen here; but, of course, make sure all your layers are visible). Now, you're going to have to reselect this layer again (yup, you have to do it again—same keyboard shortcut while clicking on the layer's thumbnail). Once it's subject shape is selected, we're going to use a special blur filter that creates a solid color that is an average of the colors in the shape of your subject. So, go under the Filter menu, under Blur, and choose **Average** (as shown here). This is going to create a solid color on this layer, but remember, that color is derived from the Background layer in the exact shape of your subject (the woman), and we're going to use that to help match her color to the color of her surroundings in the next step.

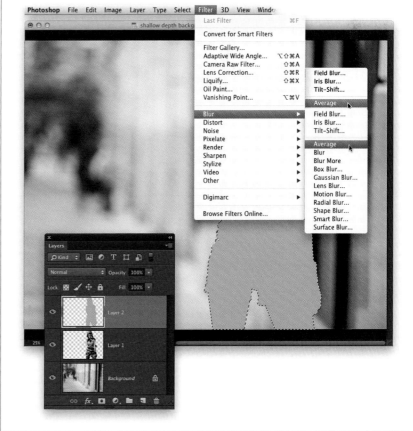

Continued

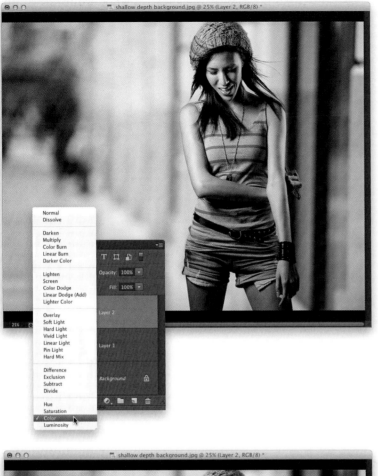

STEP 21:

To blend this solid color from the background onto our subject, first go to the Layers panel and change the blend mode of this layer from Normal to **Color** (as shown here). That ignores the solid fill and just brings in the color. So, now our subject looks like she has a grayish blue tint over her (that's okay, though, because we're not done yet).

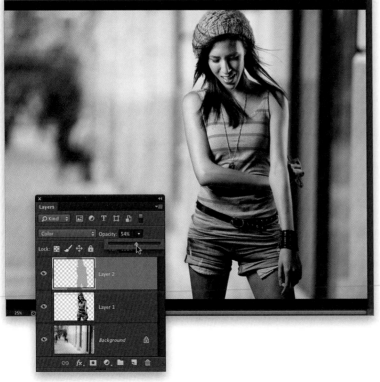

STEP 22:

You now just lower the opacity of this Color layer until some of her original color starts to come back, and keep lowering it until her color matches the color in the background (as shown here, where I lowered the Opacity to 54%). Now, the overall tone of the background and our subject is pretty much the same, which is a key aspect of successful compositing. If you go back to Step 16 and compare how warm her overall tone was to the tone you see here, you can really see how powerful this color-matching trick is. Let's go ahead and flatten the image (getting rid of the individual layers by flattening them down, so there's just the Background layer). To do this, go to the Layers panel's flyout menu (in the top-right corner) and choose **Flatten Image**.

STEP 23:

Another thing I like to do to finish off a composite is to apply some type of effect or tone or tint to the entire image (now that it's one single image), which tends to visually unify the image and make it look more like it was always just one image. One way is to add some contrast, tweak the white balance, and maybe desaturate the colors a bit using Camera Raw. You can do all of this back in Lightroom's Develop module (just hit **Command-S [PC: Ctrl-S]** to Save the image, then close it, and it will appear back in Lightroom next to the original. Then, go to the Develop module and drag the Temp slider over to +16, the Tint to +25, the Contrast to +35, and then the Vibrance down to –24). But, if you want to make those changes while you're still in Photoshop, and you have the latest version of it (Photoshop CC), you can go under the Filter menu and choose **Camera Raw Filter**, then enter those same settings in Camera Raw (as shown here), and then take the finished image back to Lightroom the same way (save and close). Below is the final image after making those final unifying visual tweaks in Camera Raw.

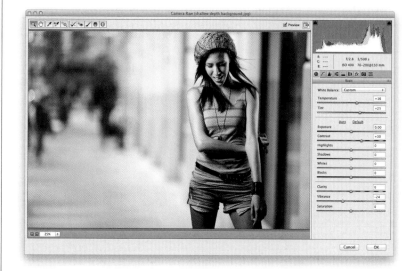

BLENDING TWO OR MORE IMAGES

Lightroom doesn't have a feature or function that lets you take one image and have it smoothly blend into another image (or multiple images), and these looks are very popular with everyone from fine art photographers to commercial photographers. The cool thing is that this is another one of those things that Photoshop was born for, so the process is incredibly easy and even lots of fun. It uses layer masking, and once you learn how to do it, it's hard to put the brush down (so to speak).

STEP ONE:
We'll start by opening the first image in Photoshop, so select it in Lightroom, and then press **Command-E (PC: Ctrl-E)** to take it over to Photoshop. This is the image we'll build our collage on top of.

STEP TWO:
Open the second image in Photoshop, as well. We're going to put a selection around this image, copy it into memory, and then we're going to paste it on top of the first image we opened. So, start by going under the Select menu and choosing **All** (or just press **Command-A [PC: Ctrl-A]**) to put a selection around the entire image. Then, go under the Edit menu and choose **Copy** (as shown here; or just press **Command-C [PC: Ctrl-C]**).

STEP THREE:
Now, click on the first image and press **Command-V (PC: Ctrl-V)** to Paste the image in memory on top of your first image (it will appear on its own separate layer). Get the Move tool (**V**; the first tool at the top of the Toolbox), and then drag this image over to the far right until the statue is over on the far-right side of the image window (as seen here).

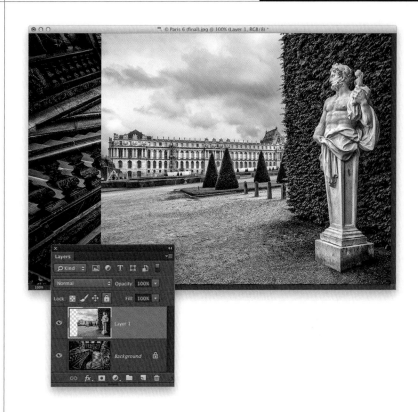

STEP FOUR:
To blend the two images, our first step is to click on the Add Layer Mask icon at the bottom of the Layers panel (it's the third icon from the left and shown circled here in red). This adds a white mask thumbnail to the right of your layer in the Layers panel.

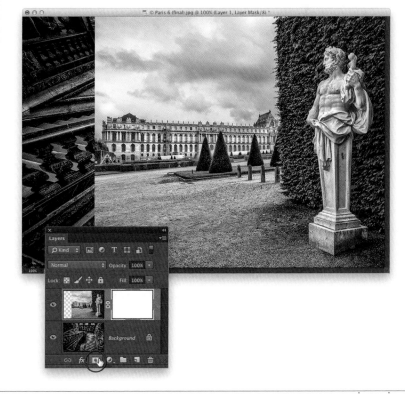

Continued

STEP FIVE:

Get the Gradient tool (G) from the Toolbox, and then click-and-drag it from just inside the left edge of your top image toward the statue (as shown here), but stop about an inch before you get to it. This blends the two images together (as seen here). By the way, the farther you drag the Gradient tool, the longer the transition between the solid part of the image and the transparent part. Also, if for any reason your blend looks…well… kinda weird, here's what to check: Go to the Options Bar up top and click on the down-facing arrow to the right of the Gradient thumbnail near the left. This brings up the Gradient Picker with a whole bunch of presets. You want the third one—the Black, White gradient. Click on that one and try again. If that doesn't do the trick, look back up in the Options Bar and you'll see five buttons to the right of that Gradient thumbnail you first clicked on. Click on the first one (that's the standard Linear Gradient, which is the one you want) and try again. That should fix whatever else was wrong.

STEP SIX:

Now that your blend is in place, you can actually edit it using the Brush tool. Just make sure your Foreground color is set to white (it's circled here in red), and then get the Brush tool (B) from the Toolbox and choose a large, soft-edged brush from the Brush Picker up in the Options Bar. The area I want to edit is a few feet to the left of the statue—it looks kinda weird where the stairs from the image on the bottom meet the ground from the image on top. So, take the brush, put it over that area (as shown here), and just click a few times. It erases those leftover stairs and reveals more of the top image. If you'd rather reveal more of the stairs image, press X to switch your Foreground color to black and paint over that area.

STEP SEVEN:

Okay, now let's add some text. Get the Horizontal Type tool **(T)** from the Toolbox, then up in the Options Bar, choose the font **Trajan Pro** (it comes with Photoshop, so you should already have it installed) from the font pop-up menu and set the font size to around 60 pt. Set your Foreground color to white and then type "THE PALACE OF." Now, let's duplicate this type layer since it already has the right font and size we want for our second line of type. The quickest way to duplicate a layer is to press **Command-J (PC: Ctrl-J)**. Get the Move tool from the Toolbox (don't use the shortcut; click on it), click directly on your type (your duplicate will be right on top of the original type layer), and drag this duplicate type layer straight down until it appears under your original line of text (as seen here).

STEP EIGHT:

Go over to the Layers panel and double-click directly on the "T" thumbnail for your top type layer—that's a shortcut that selects all the type on this layer for you—and type in "VERSAILLES" in all caps. To make the second line of type fit the same length as the top line, we'll use Free Transform to resize it, so click on the Move tool again, and then press **Command-T (PC: Ctrl-T)** to bring up Free Transform. Press-and-hold the Shift key (to keep it proportional), click on the bottom-right corner handle, and drag outward to scale this line of type up in size. When it matches the length of the top line, press the **Return (PC: Enter) key** to lock in your change.

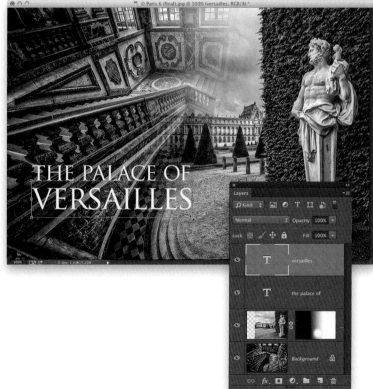

Continued

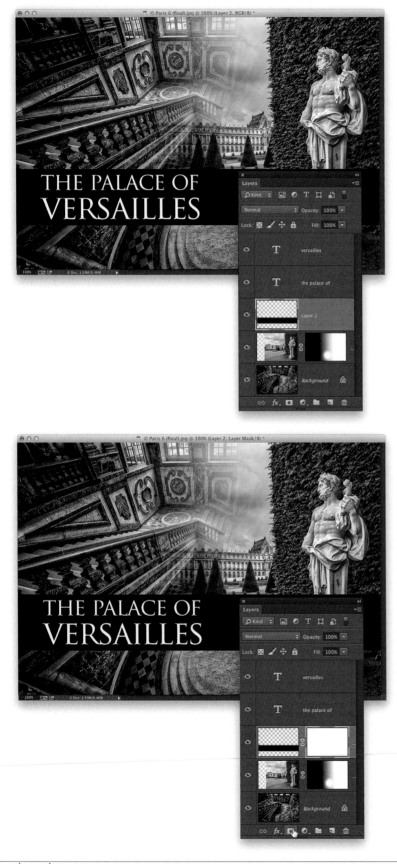

STEP NINE:
Let's now add a black bar behind our type. Start by creating a new blank layer under the type layers by clicking on Layer 1 (the top image layer with the gradient layer mask) in the Layers panel, and then clicking on the Create a New Layer icon at the bottom of the panel (it's the second icon from the right). Now, get the Rectangular Marquee tool **(M)** from the Toolbox and click-and-drag out a horizontal rectangular selection that's a little larger than your text. Press **D** to set your Foreground color to black, and then fill your selected rectangle with black (as seen here) by pressing **Option-Delete (PC: Alt-Backspace)**. You can deselect this black bar by pressing **Command-D (PC: Ctrl-D)**.

STEP 10:
Now, we're going to use the same blending technique we used with the images to fade this black bar. So, add another layer mask by clicking on the Add Layer Mask icon at the bottom of the Layers panel.

STEP 11:

Get the Gradient tool again, and click-and-drag it from around the middle of the black bar to the left, a little past the few last letters of your type (as shown here). The end of the black bar will now fade away (as seen here).

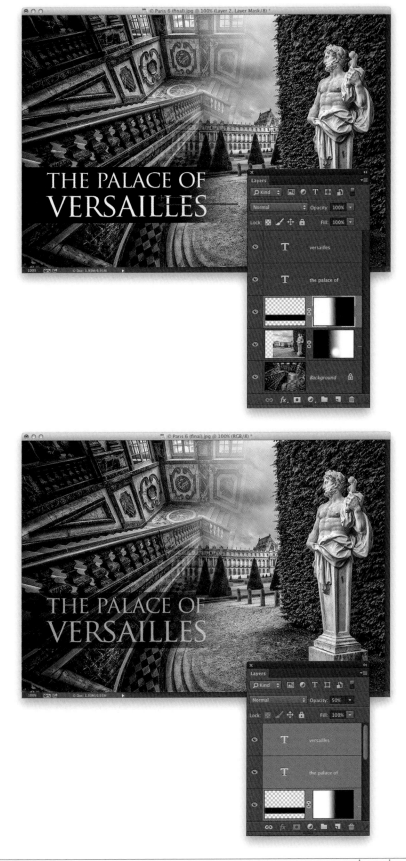

STEP 12:

To finish this collage off, we'll lower the Opacity of the black bar layer and both type layers to just 50%. So, go to the Layers panel and Command-click (PC: Ctrl-click) on both type layers, so both they and the black bar layer are selected. Then, drag the Opacity slider (at the top right of the panel) down to 50% to give you the finished image you see here.

PUTTING AN IMAGE INSIDE ANOTHER IMAGE

This is another popular form of compositing, where you paste one image inside another, so it looks like they're one. You see this pretty often with images placed on a television screen, or a computer screen, a tablet, a smartphone screen, or even billboards, signs, or buildings—there are dozens of examples. Luckily, it's a pretty quick and easy process.

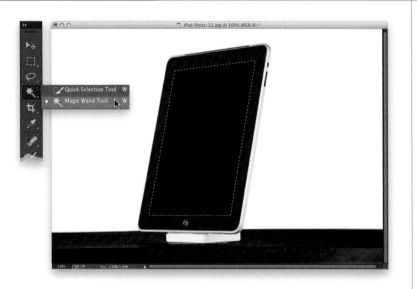

STEP ONE:

We'll start by opening the first image in Photoshop, so select it in Lightroom, then press **Command-E (PC: Ctrl-E)** to take it over to Photoshop. Here, we have a photo of an iPad and we want to add the cover of a tablet-based magazine inside the screen. What makes this a little bit tricky is the fact that the iPad is at an angle, so we'll have to tweak the perspective of the magazine cover, so it matches up and really looks like it's inside the screen. Start by getting the Magic Wand tool (**Shift-W**; we use it to select specific areas by their color) and click it once in the center of the iPad to select the darker screen area (as seen here).

STEP TWO:

Open the cover image in Photoshop, as well. We're going to put a selection around it, copy it into memory, and then we're going to paste it on top of our iPad image. So, start by going under the Select menu and choosing **All** to put a selection around the entire image. Then, go under the Edit menu and choose **Copy** or just press **Command-C (PC: Ctrl-C)**.

STEP THREE:

Now, go back to the iPad image, and you'll see your screen selection is still in place. Go under the Edit menu, under Paste Special, and choose **Paste Into** (as shown here).

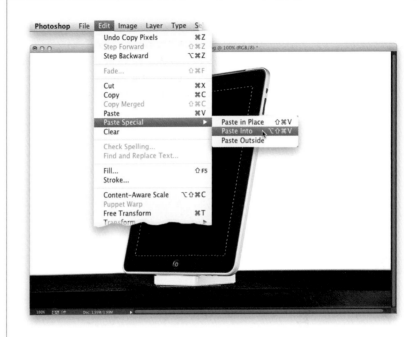

STEP FOUR:

This pastes the cover you copied into memory into your selected screen area (as seen here). The cover image is much larger in size than the area you selected, so when the cover appears, you'll only see a zoomed-in portion of it (we'll scale it down to fit in just a moment), and the cover will be flat (it doesn't automatically know the perspective doesn't match—we have to do that manually, as well, but doing both is easy).

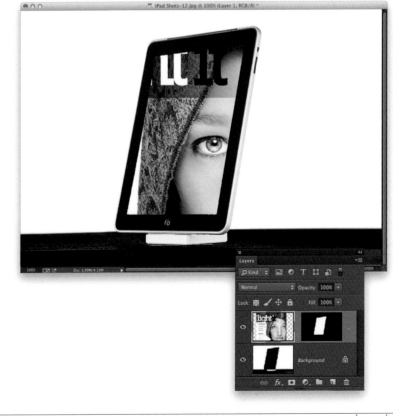

Continued

STEP FIVE:

Photoshop's Free Transform feature is what we use to scale, rotate, add perspective, skew, and all that type of stuff, and we need to do a few of those things to our image. So, press **Command-T (PC: Ctrl-T)** to bring up the Free Transform bounding box (it's a box with small transform handles in the corners and in the center of all the sides). The only problem is, when the image is this large, the transform handles appear way out at the edges of the pasted image, which extends off-screen. Luckily, there's a trick that lets us reach those handles: just press **Command-0** (zero; **PC: Ctrl-0**) and the document window automatically re-sizes, so you can reach all four handles.

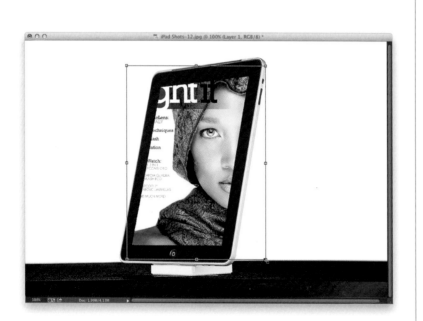

STEP SIX:

Click on one of the bottom corner handles, press-and-hold the Shift key (so your scaling stays proportional), and drag inward to scale your image down until it's just a little bigger than the size of the screen (as shown here). Place your cursor inside the bounding box and reposition the image, as needed. The image is still flat, but we're not done yet.

STEP SEVEN:

Now, you're going to match up the corner handles on the Free Transform bounding box to the corners of the screen on the iPad. You do this by pressing-and-holding the **Command (PC: Ctrl) key** and then just dragging each image corner until it meets the corner of the screen (as shown here, where I'm dragging the top-left corner handle over to the top-left corner of the screen). Holding that Command key lets you distort the image like this without any problem.

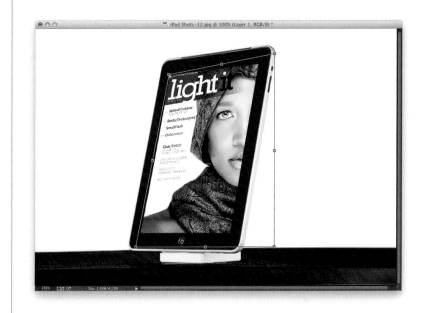

STEP EIGHT:

I will tell you this: it's going to look pretty bad as you put the first, second, and third corners in place. It doesn't look right (perspective-wise) until you get that final fourth corner handle in place, then it all comes together (as seen here). However, we're not done yet—we're going to add a glassy reflection to the iPad (kind of like you see on every photo of an iPad, smartphone, or anything with a glass screen these days). But, first, press **Return (PC: Enter)** to lock in your transformation. Then, let's flatten our image by choosing **Flatten Image** from the Layers panel's fly-out menu (at the top right of the panel).

Continued

REMOVING LARGE DISTRACTING THINGS

If I have a large distracting object in my image, the first thing I go looking for is another part of the image that I can copy-and-drag to cover that distracting object right up. Here, it's an entire wall of scaffolding that's ruining the shot. So, the plan is the same as always: find another part of the image we can copy to cover the bad part. In this case, since the walls are facing each other, we'll have to add another step to make it work.

STEP ONE:
We'll start by opening the image in Photoshop, so select it in Lightroom, and then press **Command-E (PC: Ctrl-E)** to take it over to Photoshop. You can see the huge towering scaffolding on the left side of the church interior, and that's what we're going to need to cover up with the opposite wall.

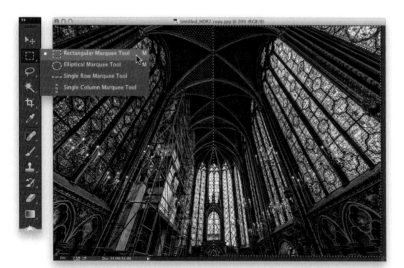

STEP TWO:
Get the Rectangular Marquee tool **(M)** from the Toolbox and drag it out over the entire right side of the church (as shown here). Split it right down the middle.

STEP THREE:

Press **Command-J (PC: Ctrl-J)** to put this selected area up on its own separate layer (you can see it here in the Layers panel). Once it's on its own layer, we're going to need to "flip it," so we can use it to cover the other side, and that means going to Free Transform. So, press **Command-T (PC: Ctrl-T)** to bring up the Free Transform bounding box. Once it appears, Right-click anywhere inside the bounding box and, from the pop-up menu that appears, choose **Flip Horizontal** (as shown here). Then, press **Return (PC: Enter)** to lock in your transformation.

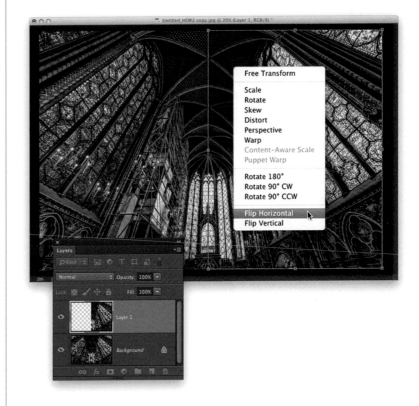

STEP FOUR:

This flips that half of the church, so it has the same perspective as the other side. But, of course, now you have two of the same side, side by side. We'll fix that next.

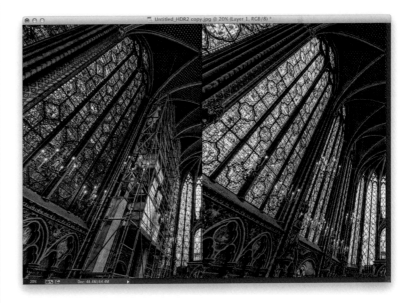

Continued

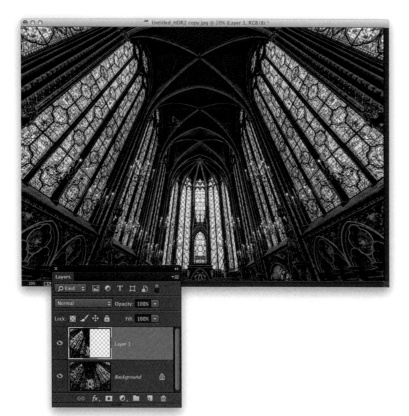

STEP FIVE:
Now, switch to the Move tool **(V)** and click-and-drag that flipped right side over to the left, so that it covers the scaffolding (as shown here). You might have to zoom in a bit (press **Command-+** [plus sign; **PC: Ctrl-+**] to zoom in a level or two) to make sure everything in the ceiling is lining up fairly decent (it might not be perfect, but that's okay—we're going to cover up some of that in a moment).

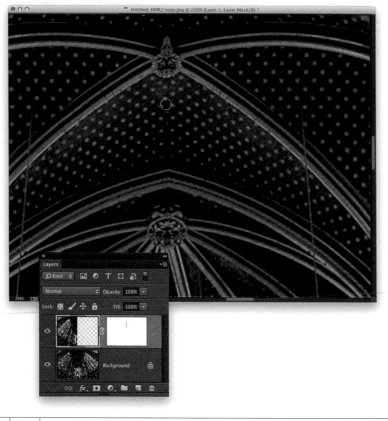

STEP SIX:
Press Command-+ (PC: Ctrl-+) a few more times to zoom in really tight and chances are you'll see a hard edge where you made your selection. We're going to selectively hide that hard edge by adding a layer mask and then painting that hard edge away from view. So, start by clicking on the Add Layer Mask icon at the bottom of the Layers panel (it's the third icon from the left). Then, with your Foreground color set to black, get the Brush tool **(B)** from the Toolbox, choose a medium-sized, soft-edged brush from the Brush Picker up in the Options Bar, and then paint over those hard edges to mask them away (as seen here).

STEP SEVEN:

Now, zoom back out for our final couple of moves. The first move is designed to help hide the fact that we just copied and flipped the right side to the left, and to do that we're going to darken the windows on the left side, so it looks like there's more sun on the right side (if the light through the windows looked exactly the same on both sides, that might tip someone off). So, click on the Create New Adjustment Layer icon at the bottom of the Layers panel (it's the fourth icon from the left) and choose **Levels**. When the Properties panel appears, click-and-drag the gray slider (beneath the graph) over to the right to darken the entire image. Now, press **Command-I (PC: Ctrl-I)** to hide that darker version of your image behind a black layer mask. With the Brush tool still active, press **X** to set your Foreground color to white, carefully paint over the windows on the left, and they'll paint in much darker (as shown here).

STEP EIGHT:

Let's go ahead and flatten down all the layers by going to the Layers panel's flyout menu at the top right of the panel and choosing **Flatten Image**. Lastly, let's apply some sharpening to finish this off. Go under the Filter menu, under Sharpen, and choose **Unsharp Mask**. When the dialog appears, let's enter some nice punchy settings—I used Amount: 120%, Radius: 1, Threshold: 3—then click OK to finish the image. Now, you can save and close the image to send it back to Lightroom where it will appear beside your original image.

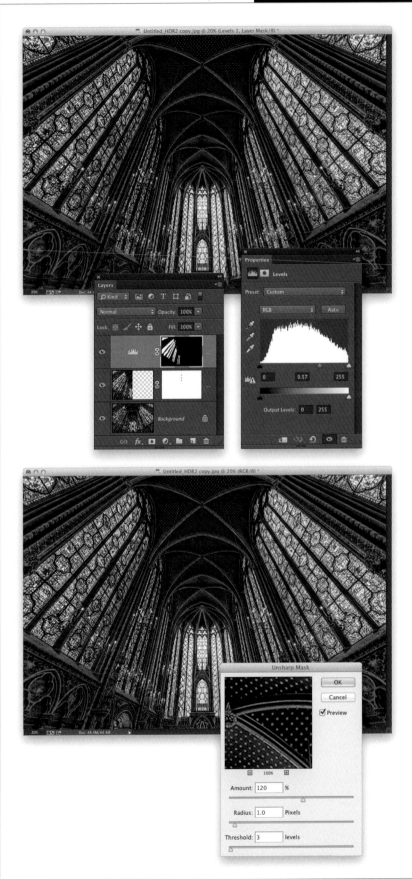

ADDING A LOGO OR ILLUSTRATION TO A PHOTO

If you have a logo or label you want to add to a product shot, or perhaps an illustration or graphic you want to add, there are two parts to the process: (1) scaling and positioning the graphic, and (2) doing a few finishing moves that help make it look like it was there in the photo all along. These have to do with everything from warping the image to fit a non-flat surface, to blending the graphic in with the photo you're putting it on top of.

STEP ONE:
We'll start by opening the first image in Photoshop (this one's a studio shot of my buddy Robert Vanelli), so select it in Lightroom, then press **Command-E (PC: Ctrl-E)** to take it over to Photoshop. We're going to put a Lightroom heart tattoo on his arm closet to the camera and have it bend and blend right in with this arm, so it looks like it's really there.

STEP TWO:
Next, open the image you want to use as your graphic. In our case, it's a heart tattoo illustration from iStock (www.istockphoto.com). Press **Command-A (PC: Ctrl-A)** to select the entire image, and then press **Command-C (PC: Ctrl-C)** to Copy it into memory. (By the way, I added the word "LIGHTROOM" in Photoshop, and I used the Warp transformation, along with one of its built-in presets called "Rise," to make the text fit inside that yellow scroll. You'll see how to warp things in a moment, but just so you know, the preset's default Bend amount wasn't steep enough to fit right on that scroll, so I increased the amount of Bend until it fit perfectly. This will make more sense in a few minutes when we get to the warping part.)

STEP THREE:

Now, switch back to the first image and press **Command-V (PC: Ctrl-V)** to Paste that tattoo into your image (it appears on its own layer). We're going to need to warp the tattoo image, so it bulges out like it would if it were really on his arm and he crossed his arms (like he is here). We'll start by going to Free Transform, so press **Command-T (PC: Ctrl-T)** to bring up the Free Transform bounding box. Once it appears, Right-click anywhere inside the bounding box and from the pop-up menu that appears, choose **Warp** (as shown here).

STEP FOUR:

Go up to the Warp pop-up menu in the left side of the Options Bar and chose **Arc** (as shown here). Of course, in our case, it over-arced the image, but luckily, you can easily control exactly how far the arc arcs.

Continued

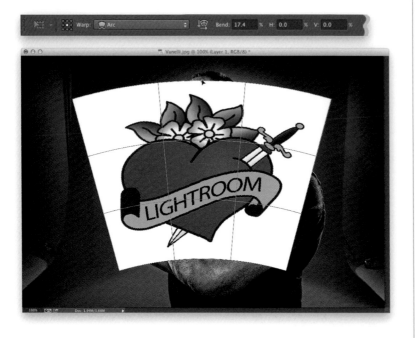

STEP FIVE:

At the top center of the arced image is a control handle. Click-and-drag that handle downward and as you do, it reduces the amount of the bend in the arc. You want it to bend a bit outward, but not nearly as far as the default setting. So, drag it to where it looks kinda like what you see here. Before we go on, let's jump back to how I warped that text along that yellow scroll: You see the Bend field up in the Options Bar (just to the right of that Warp pop-up menu)? I just increased that number until it bent upward enough that it fit. Easy enough. Okay, back to our tattoo. Once the bend looks right to you, press the **Return (PC: Enter) key** to lock in the transformation.

STEP SIX:

We need to bring up Free Transform again, so press Command-T (PC: Ctrl-T), then press-and-hold the Shift key (to keep things proportional), grab a corner handle, and drag inward to scale the tattoo down to where it's about the size that would fit on his arm (move your cursor inside the bounding box to move it into place on his arm). Just look at the actual tattoo graphic itself and ignore the white box around it when you're sizing it down, because you won't see the white box when we're done. Once the size is about right, you'll need to rotate it, so it fits properly on his arm. Move your cursor outside the Free Transform bounding box and it changes into a curved arrow. Just click-and-drag to the right until it's rotated into place (as shown here).

STEP SEVEN:
Once it looks right to you, press Return (PC: Enter) to lock in your transformation. Now, we have to get rid of the white background behind the tattoo. Luckily, that couldn't be easier because the layer blend mode Multiply ignores the color white. So, go to the Layers panel and, up at the top left, change the layer's blend mode from Normal to **Multiply**. It now blends in with his skin (as seen here), and the white background is gone. We're almost there, but there are two more little moves we need to make to finish this off. The first is to lower the Opacity of this tattoo graphic layer, so it's not so vibrant and perfect. Lower the Opacity of this layer to 80%, and now it blends in even better and looks more realistic.

STEP EIGHT:
The last step is to add a slight blur to the tattoo to, once again, make it look less perfect and less "added on in Photoshop." So, go under the Filter menu, under Blur, and choose **Gaussian Blur**. When the dialog appears, enter 0.3 (you can add less than a 1-pixel blur, and 0.3 is just a tiny amount of blur, but enough). Click OK and we're done. Now, go ahead and flatten down the layers by going to the Layers panel's flyout menu (at the top right of the panel) and choosing **Flatten Image**. Finally, save and close the image to send it back to Lightroom where it will appear beside your original image.

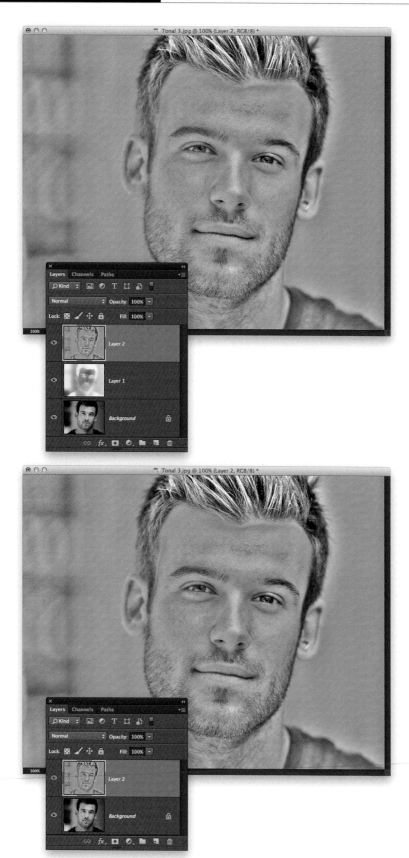

STEP FIVE:
We need to change the layer's blend mode one more time, but we can't change this layer's blend mode from Vivid Light or it will mess up the effect. So, instead, we're going to create a new layer at the top of the layer stack that looks like a flattened version of the image. That way, we can change its blend mode to get the effect we need. This is called "creating a merged layer," and you get this merged layer by pressing **Command-Option-Shift-E (PC: Ctrl-Alt-Shift-E)**. If you look at the Layers panel now, you'll see the Background layer (on the bottom, of course), then the Surface Blur layer, and then this new merged layer at the top of your layers stack in the Layers panel (as seen here).

STEP SIX:
Now that you have this new merged layer, you need to delete the middle layer (the one you ran the Surface Blur filter on), so click-and-drag it onto the Trash icon at the bottom of the Layers panel. We now have to deal with all the funky neon colors on this layer, and we do that by simply removing all the color. So, go under the Image menu, under Adjustments, and choose **Desaturate** to remove all the color (so now this layer is just gray).

STEP SEVEN:

Okay, we're almost done. Change the blend mode of your merged layer (the one named Layer 2) to **Overlay**, and now you can see the tonal contrast effect applied to your image. Unfortunately, we're experiencing a side effect of applying it—the white glow you see around his hair and shoulder on the right. There are two ways to fix this: (1) Click on the Add Layer Mask icon at the bottom of the Layers panel (the third icon from the left) to add a layer mask. Get the Brush tool **(B)**, choose a small, soft-edged brush from the Brush Picker up in the Options Bar, set black as your Foreground color and paint over the edge of his hair and shoulder, and it returns them to normal (you're hiding the effect in that area by masking it away). Or, (2) **Option-click (PC: Alt-click)** on the Add Layer Mask icon. That hides your tonal effect layer behind a black mask. Switch your Foreground color to white and paint in the effect over your subject's skin, but avoid the edge of his hair and shoulder. That's it.

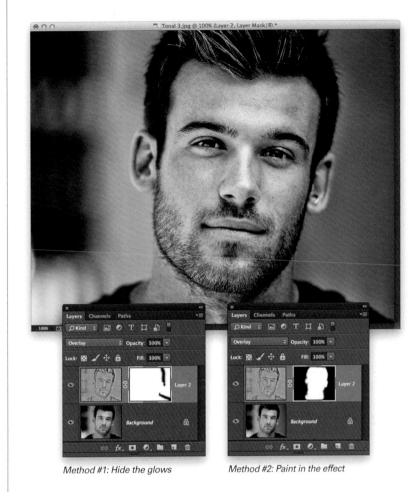

Method #1: Hide the glows *Method #2: Paint in the effect*

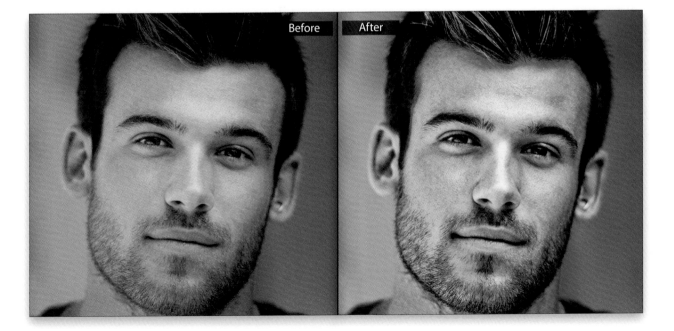

TURNING A PHOTO INTO AN OIL PAINTING IN ONE CLICK

This is a really popular effect for photographers who do portraits of babies, brides, pets, and anything really cute and cuddly. Also, it can look wonderful on landscapes, travel shots, and well…you just have to try it out on whatever image you'd like to see as an oil painting because it's so easy it's worth trying it out.

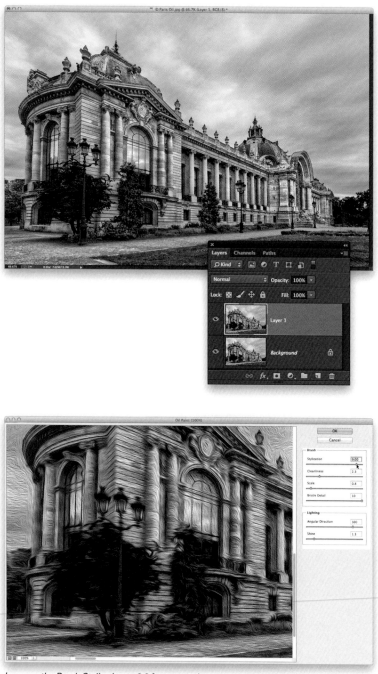

Increase the Brush Stylization to 9.0 for a smoother, more Van Gogh-esque look

STEP ONE:

Open an image in Photoshop that you want to turn into an oil painting. Here's a travel shot of the Petit Palais in Paris. I did a little HDR on this image (as if there was such a thing as a "little" HDR), but we're going to turn it into an oil painting in one click. For reasons I can't begin to understand, there is no Preview checkbox in the Oil Paint filter, so I usually start by duplicating the Background layer (press **Command-J [PC: Ctrl-J]**) so I can easily see a before/after by turning the top layer on/ off (by clicking on the Eye icon to the left of the layer in the Layers panel).

STEP TWO:

Go to the Filter menu and choose **Oil Paint**. Now, when you choose this filter, it immediately applies its default settings, so once you choose it—BANG!—you've got an oil painting. To really see the paint effect, you'll need to zoom in to 100%, and you can see it does a pretty amazing job of keeping detail while looking very painterly. Of course, at this point, you can just click OK and be done with it, but you actually have quite a bit of control over how your oil painting looks. Let's start with the first slider: Stylization. Technically, this controls the style of the brush it paints with, and the farther you drag this slider to the right, the more intense the effect becomes because the brush strokes get longer and the effect looks smoother (at lower numbers, it paints with small, hard brush strokes). If you drag this slider all the way to the left, the oil paint look pretty much goes away and it just looks like you put a canvas texture over your image.

STEP THREE:

The next slider down, Cleanliness, controls the detail (in fact, they could have named it the Detail slider and saved us a lot of grief). If you want the brush to paint your image with a cleaner, more detailed look (more realistic), keep this slider closer to the left, and for a softer, more painterly look (seen here), drag the slider to the right (I dragged it over to around 8.2).

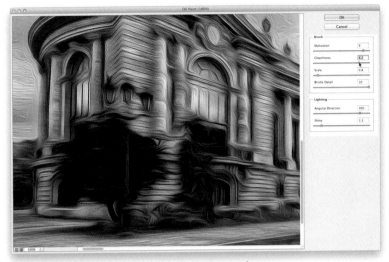

Cleanliness controls detail. Drag to the right to create a softer, more painterly look

STEP FOUR:

The Scale slider controls the size of your brush, so dragging it way over to the left paints your image with a very thin brush and dragging it all the way over to the right paints it with very thick strokes, and that definitely creates a different look.

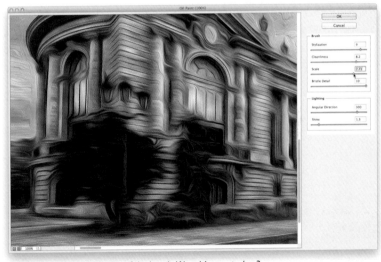

Scale controls the thickness of the brush. Want bigger strokes? Drag to the right

Continued

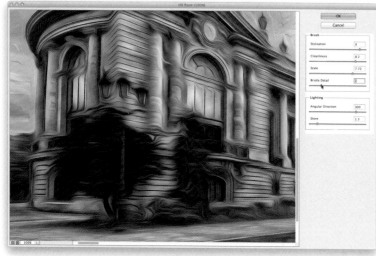

Bristle Detail controls the overall sharpness. Drag to the right for a sharper look

STEP FIVE:

Okay, a better name for the Bristle Detail slider would be the Sharpness slider. It makes the overall image look sharper or softer with how it affects the brush. Dragging it to the left takes away the detail of the brush bristles, so it's very soft, smooth, and undefined. Dragging to the right gives it a harder, more detailed look that makes the image look sharper, as you really see the bristles in the stroke now.

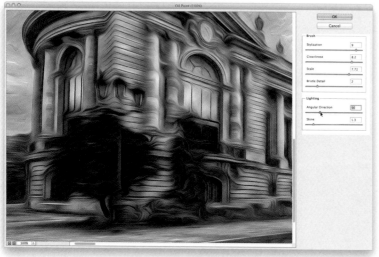

The Angular Direction lets you choose the direction of the light hitting the paint

STEP SIX:

In the Lighting section below the brush controls, the Angular Direction controls the angle of the light hitting your painting, and the light changes as you drag from 0 to 360 degrees.

TIP: GETTING GOOD RESULTS

I hate to be the guy that says, "Just drag the sliders around until it looks good to you." But, I can tell you that I've used this filter enough to know that it looks so different depending on the subject, that if you just drag each slider back and forth a couple of times, you'll find a sweet spot where it looks good for that particular photo, and you just stop there. It sounds like a cop-out, but honestly, that's how I use it.

STEP SEVEN:

The last control in this dialog is the Shine amount, and it controls how the light reflects: dragging it to the left makes your image very flat-looking, and dragging over to the right (as shown here) adds contrast to the highlights and shadows and kind of makes the paint look thicker, almost like it's embossed. Below are the settings for the final image (labeled After) that I came up with based on the technique I mentioned in the tip on the previous page.

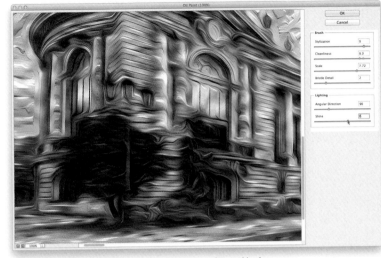

Dragging the Shine slider to the right gives an embossed look to the paint strokes

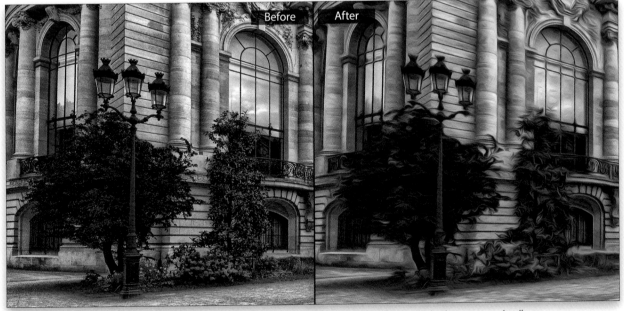

Before

After: Note the effect on the bushes, grass, and walkway

TILT SHIFT EFFECT (THE ARCHITECTURAL MODEL LOOK)

The tilt shift effect, where you miniaturize a scene and make it look like a small architectural model, has become huge in the past couple of years, with Flickr groups, and meetups, and the whole nine yards. The Photoshop part is easy as long as you have a photo where the view is from above, looking down onto the scene. That's because that's the angle you would actually view a real architectural model. If you've got a shot like that, the rest is easy.

STEP ONE:
Open the image you want to apply the effect to in Photoshop (remember to read the intro above to make sure you use the right type of image, or this effect will look pretty lame. Of course, as always, you can download the image I'm using here from the book's downloads page mentioned in the book's introduction). Now, go under the Filter menu, under Blur, and choose **Tilt-Shift**.

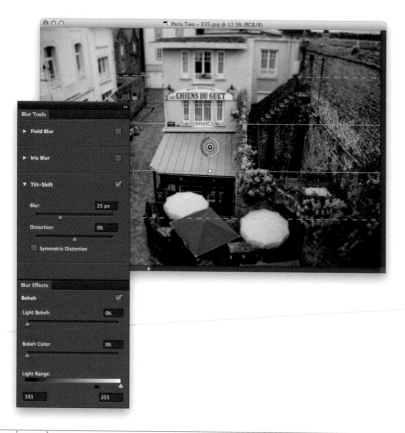

STEP TWO:
When you use this filter, you don't get a regular filter dialog or window, instead you get an onscreen interface (Adobe introduced this in Photoshop CS6 as a more interactive way to edit your images) with a column of panels on the right side of the screen. Anyway, when you choose this filter, it places a round pin in the center of your image, and outside of that are two solid lines, and outside of those are two dotted lines. The area inside the solid lines is the area that will remain in focus (the focus area), and the area between each solid line and dotted line is a transition area, where it fades from sharp to blurry. The wider the distance between the solid and dotted lines, the longer it takes to go from sharp (inside the solid line) to totally blurry (outside the dotted line). You can change the distance between any of these lines by just clicking-and-dragging directly on them. *Note:* To remove a pin, just click on it and hit the Delete (PC: Backspace) key on your keyboard.

STEP THREE:

You control the amount of blur by clicking on that gray ring around the pin and dragging around the ring. As you drag, the ring turns white to show you how far you've gone, and the actual amount of blur appears in a little pop-up display at the top of the ring (as seen here). If you don't like working with that tiny circle to choose your blur amount, there is a Tilt-Shift section in the Blur Tools panel on the right, and you'll see a Blur slider over there you can use instead. In our example, I clicked-and-dragged the ring over to 51. While we're here, look inside the two horizontal solid lines. See how that area is sharp and in focus? Okay, now look at the area outside those lines, until you reach the dotted lines, to see how it transitions to the blurry area.

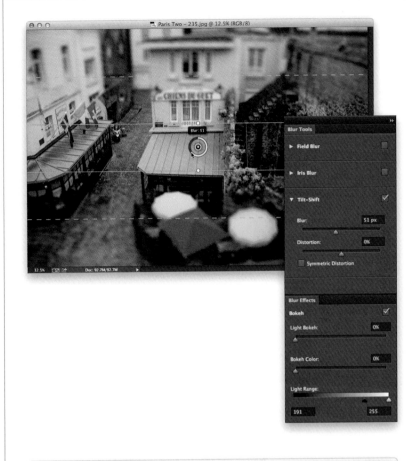

STEP FOUR:

When I do these tilt shift effects, I pretty much use the same formula every time: (1) I drag the two solid lines closer to the center to make the focus area smaller, (2) I increase the blur quite a bit, (3) I rotate the entire blur a bit to the left, so it doesn't look so intentional, by moving my cursor just outside the white dot in the center of a solid line. That changes your cursor into a double-headed arrow, and you can just click-and drag to rotate the whole effect. (4) When I'm done, I click the blue OK button in the Options Bar, and (5) lastly, I bump up the color to make the model look more colorful. You can do this when the image comes back to Lightroom by going to the Develop module and dragging the Vibrance slider quite a ways over to the right (I dragged to +52), or if you have Photoshop CC, go under the Filter menu and choose **Camera Raw Filter** and drag the Vibrance slider there (as seen here).

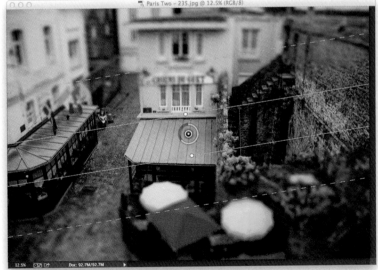

Continued

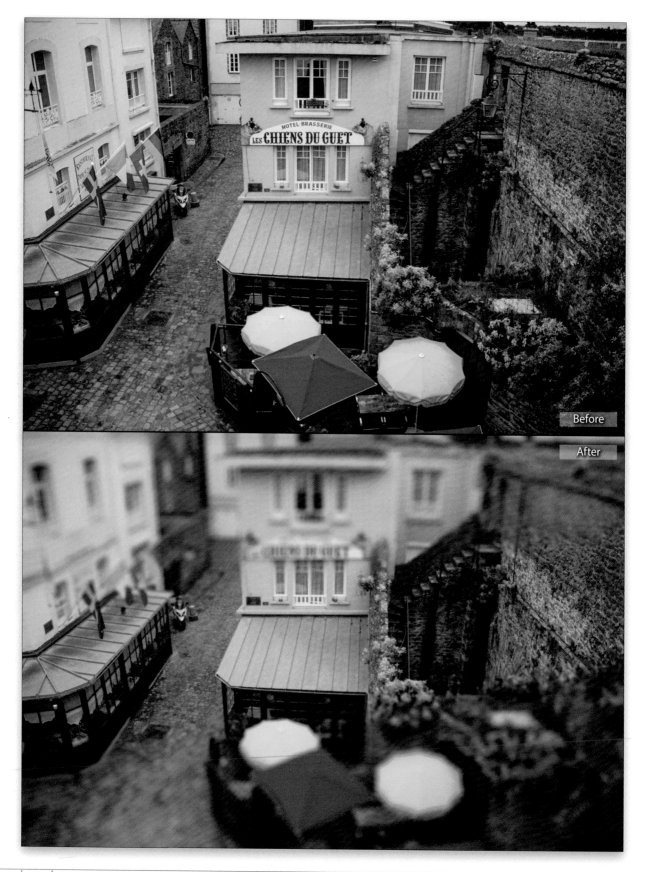

Before

After

Nothing kills a shot like choppy water. I include it in my "Seven Deadly Sins of Landscape Photography," and it's pretty deadly for travel shots. Here's a quick technique that gives you an absolutely still water, glassy reflection, and you can end the technique right there—many people do—or you can take it one step further and bring a little more realism to the look. The choice is yours (and it does depend on the image. Sometimes the mirror look looks best).

STEP ONE:
We'll start by opening the image in Photoshop, so select it in Lightroom then press **Command-E (PC: Ctrl-E)** to take it over to Photoshop. In this case, we have a photo of San Giorgio Maggiore (just across the Grand Canal from Venice's St. Mark's Basilica), and the water is very choppy (it usually is—the Grand Canal is a very busy waterway, especially when huge cruise ships move through the canal headed out to sea). Get the Rectangular Marquee tool **(M)** and make a selection from the horizon line at the base of the buildings all the way up to the top of the sky (as shown here).

STEP TWO:
Now press **Command-J (PC: Ctrl-J)** to copy that selected buildings-and-sky area up onto its own separate layer. Once it's there, it's time to flip it upside down, so press **Command-T (PC: Ctrl-T)** to bring up Free Transform, then Right-click anywhere inside the Free Transform bounding box (which will appear around your buildings-and-sky layer). From the pop-up menu that appears, choose **Flip Vertical** (as seen here) to flip this layer upside down. Press **Return (PC: Enter)** to lock in your transformation.

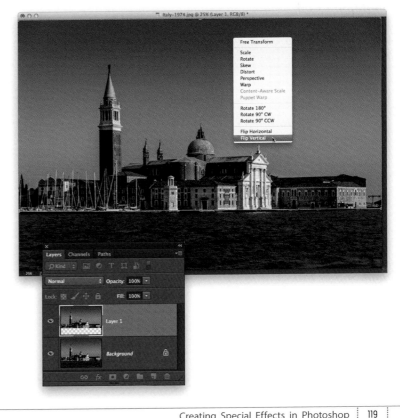

Continued

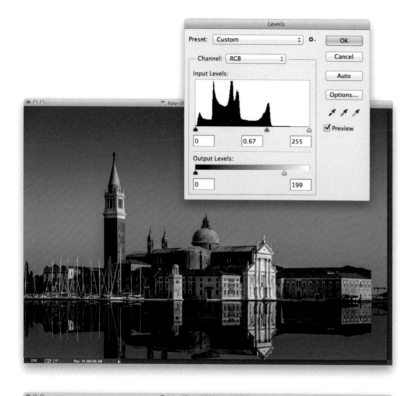

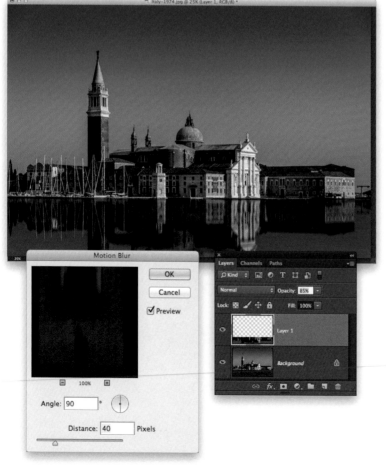

STEP THREE:

Now get the Move tool **(V),** press-and-hold the Shift key, and drag straight downward until the bottom of the flipped image touches the bottom of the buildings (as shown here). The reason we hold the Shift key as we drag is that it keeps the image lined up as you drag—it keeps it from sliding over to the right or the left—so it goes straight down, which is what we need to make everything perfectly match up. Now, you can end right here, and it would look good. However, I do take it another couple of moves further and whether you do (just for the sake of realism) is up to you. The first thing I do is darken the flipped reflection so it stands out from the original image, and I do this using Levels (press **Command-L [PC: Ctrl-L]**). When the Levels dialog appears, I drag the center Input Levels midtones slider to the right and the bottom-right Output Levels slider to the left to darken the overall flipped reflection (as seen here).

STEP FOUR:

The last two moves (which are, again, totally optional) are to first apply a bit of vertical motion blur. That way, the water still reflects, but it's not that absolute mirror reflection, and looks more like what a real reflection looks like in many cases (although it is possible to get a true mirror-like reflection in real life…just probably not along the Grand Canal). Go under the Filter menu, under Blur, and choose **Motion Blur**. When the dialog appears (shown here), set the Angle to 90° (straight up and down), and then drag the Distance slider over to the right until it looks good to you (in other words, it looks imperfect). My final step is to lower the layer's Opacity for this reflection by about 15% (to 85%) to let just a tiny bit of the original water peek through, again to help it look more realistic. Here's the final image.

This is yet another form of compositing, but it's kind of "reverse compositing" because, instead of selecting a person or an object and placing it on another background, we're going to select the background (sky) and replace it with a better one. This is a handy thing to know because nothing kills a travel or landscape shot like a dull, gray, cloudless sky, like the sky was on the day I took this photo of the National Centre for the Performing Arts in Beijing.

SWAPPING OUT FOR A BETTER SKY

STEP ONE:
We'll start by opening the first image in Photoshop, so select it in Lightroom then press **Command-E (PC: Ctrl-E)** to take it over to Photoshop. This photo has it all—it was taken in boring light, with choppy water, under a dull, cloudless sky. I'm amazed I'm letting anyone see it at all, but it's only because I have a feeling it's about to look somewhat better. Since our goal is to fix the sky (by replacing it with a better sky), we need to put a selection around the current sky.

STEP TWO:
Since the sky is made up of very similar colors, either the Magic Wand tool (shown here) or the Quick Selection tool will select that sky in all of two seconds (I tested both and the Quick Selection is faster for this particular image), but choose whichever you feel more comfortable with. If you chose the Magic Wand tool **(Shift-W)**, click it once anywhere in the sky, then press-and-hold the **Shift key** and click in any places it missed until the entire sky is selected (as seen here). If you chose the Quick Selection tool **(W)**, paint a stroke from left to right across the sky and it'll select it for you. Once it's selected, let's "dig in" to the edges a bit so there are no little white pixels showing up later. Go under the Select menu, under Modify, and choose **Expand**. When the dialog appears, enter 2 pixels (your selection will grow outward by 2 pixels), and click OK.

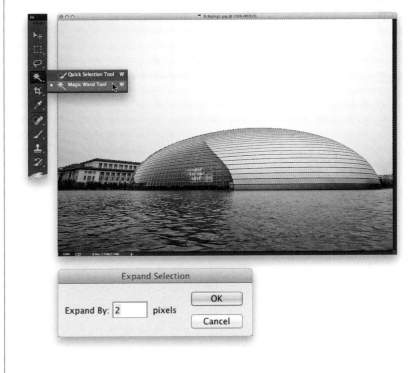

Continued

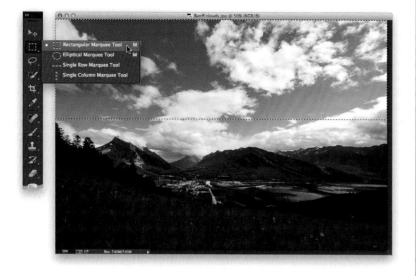

STEP THREE:
Now you'll need to open an image that has some nice clouds in it. I chose an image taken up on a hill in Banff National Park in Canada. (Hey, there are direct flights from Canada to Beijing every single day, so I felt it was okay to use Canadian clouds. Okay, I'm stretching here, so don't overthink this one.) Once you find a shot with good clouds, select as much of the sky as you can, using the Rectangular Marquee tool (**M**; as shown here, where I selected all of the sky from just above the trees on the left). Once you've got just the sky selected, you'll need to copy that sky into memory by pressing **Command-C (PC: Ctrl-C)**.

STEP FOUR:
Next, switch back to your original image (the selection you made of the sky should still be in place). Then, go under the Edit menu, under Paste Special, and choose **Paste Into** (as shown here). This will paste the clouds you copied into memory into your image (as seen in the next step).

STEP FIVE:
Here's the sky image pasted into our selection. By the way, when you paste into a selection like this, it automatically deselects your selection and adds a layer mask to the pasted image (as seen here). That way, if you need to edit the edges (maybe you see some white or something that doesn't look right along the edges where the sky meets the original photo), you can paint in white, with a very small brush, on that layer mask to help cover up any problems (but, our "digging in" of 2 pixels, like we did in Step Two, usually helps avoid that). You can also reposition the sky by using the Move tool (**V**) to click-and-drag right on the sky itself. If you need to resize the sky, press **Command-T (PC: Ctrl-T)** to bring up the Free Transform bounding box (see page 18). If you can't see the Free Transform handles, just press **Command-0** (zero; **PC: Ctrl-0**) and the document window automatically resizes, so you can reach all four handles. Just remember to press-and-hold the Shift key to keep things proportional as you scale up or down by dragging the corner handles.

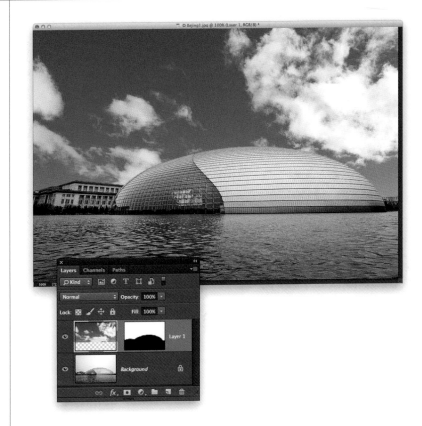

STEP SIX:
There is one more thing I would do to finish this one off: The water looks a little greenish to be under such a rich blue sky, so if you have Photoshop CC, click on the Background layer, put a rectangular selection around the water, and then go under the Filter menu and choose **Camera Raw Filter**. When the ACR window appears, drag the Temperature slider (near the top of the Basic panel) to the left a bit until the water becomes more blue (it will only affect the water since you made a selection before you chose the Camera Raw filter). If you don't have Photoshop CC, then wait until you take the image back to Lightroom, and paint over the water with the Adjustment Brush, using the same bluish Temperature setting.

WEDDING BOOK AND TYPE EFFECTS

There are as many wedding book Photoshop techniques as there are wedding books, so what I wanted to do here was show you a pretty typical one—one that you'd need to jump over to Photoshop to do because it adds effects (like a drop shadow and an inner glow) that we can't achieve in Lightroom. We also get to unlock a very powerful, yet seldom shown, type technique that will definitely help you stand out from the crowd.

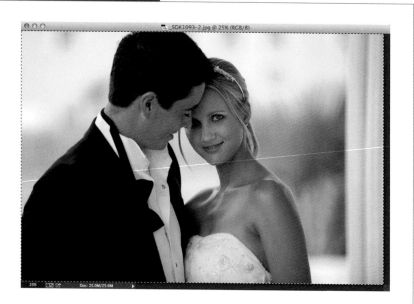

STEP ONE:

We'll start by opening the image in Photoshop, so select it in Lightroom then press **Command-E (PC: Ctrl-E)**. Once the image is open, go ahead and put a selection around the entire image by pressing **Command-A (PC: Ctrl-A)**—that's the shortcut for Select All. Now, copy that image into memory by pressing **Command-C (PC: Ctrl-C)**. Let's switch to the blank wedding book cover. In this case, our wedding book is square, so create a new document that is square (as seen in the next step) by going under the File menu and choosing **New**. When the dialog appears, just type in the dimensions you want, type in the resolution (we'll go with 300 ppi), and click OK.

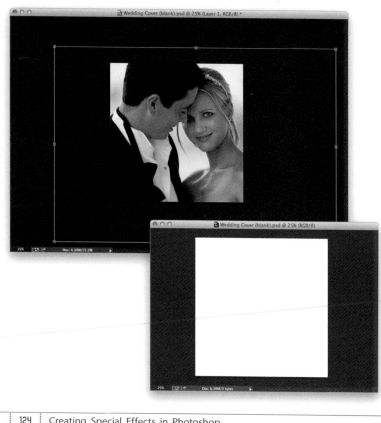

STEP TWO:

Now, press **Command-V (PC: Ctrl-V)** to Paste the image we copied in Step One into this square document. We're going to have to scale the image down because it's much larger than the document we pasted it into, so press **Command-T (PC: Ctrl-T)** to bring up the Free Transform bounding box (see page 18). If you can't reach the handles, press **Command-0** (zero; **PC: Ctrl-0**) and the window will resize so you can reach them all. Press-and-hold the Shift key, grab a corner handle, and drag inward to scale the image down so it kinda looks like the cropping you see here, then press the **Return (PC: Enter) key** to lock in your transformation.

STEP THREE:

Go to the Layers panel and click on the Create a New Layer icon (it's the second icon from the right) to create a new blank layer above your wedding couple layer. Press the letter **D**, then **X**, to set your Foreground color to white. (Pressing D sets your Foreground and Background colors to their defaults of black and white, respectively. The letter X then swaps them, so white is the Foreground color. It's a handy little trick.) Now we want to fill this entire layer with white by pressing **Option-Delete (PC: Alt-Backspace)**. Of course, this white layer completely covers up the bride and groom. But, what we want to create is a backscreened effect (very popular in wedding albums), so just lower the Opacity of this layer to around 75%, and now you can see through the white layer to the couple layer below it. This 75% number might be showing them a bit too much, but we can't really tell until we add the type later on. So, for now, we'll leave it at 75% and roll on.

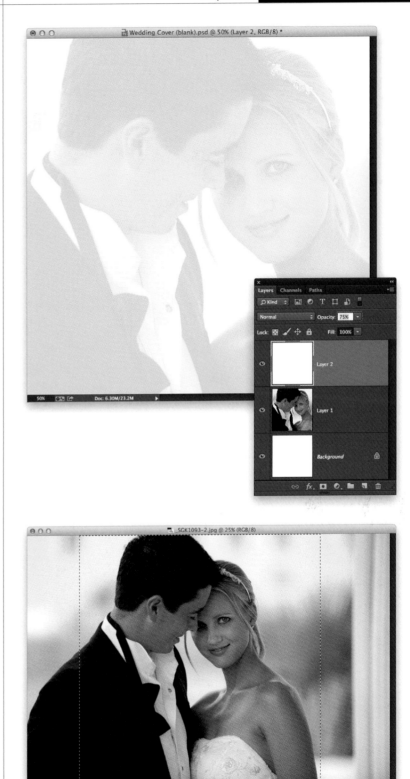

STEP FOUR:

Next, switch back to your original image, and get the Rectangular Marquee tool **(M)**, because we're going to make a perfectly square selection nice and tight on the wedding couple. To make a square selection, press-and-hold the Shift key first, then click-and-drag out a selection and it's constrained to a perfect square (as seen here). Now, press Command-C (PC: Ctrl-C) to copy that square selected area into memory.

Continued

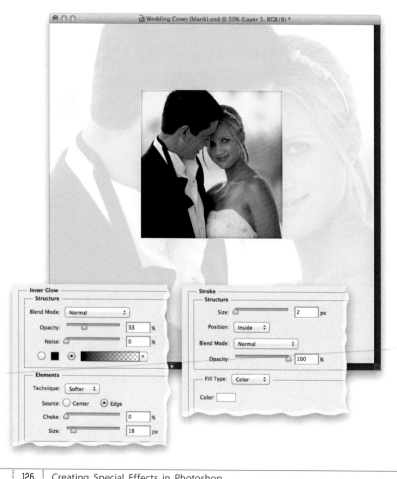

STEP FIVE:

Switch back to your wedding book document and press Command-V (PC: Ctrl-V) to Paste that square selected version of the couple into your document. Of course, it will be too large, so you'll have to do the whole Free Transform thing again (press Command-T [PC: Ctrl-T]) to scale the image down to the size you see here, and position it just above center in the document (you may want to click on the original couple layer and use the Move tool to nudge it over a little, as I did here). Don't forget to press-and-hold the Shift key when you click-and-drag that corner handle inward to keep things proportional as you scale it or things will look really wonky. When you're done resizing it, press Return [PC: Enter]) to lock in your resizing. Next, we're going to add an effect to the inside of this photo (and to the outside) to give the impression that this smaller image is cut into the image behind it.

STEP SIX:

Click on the Add a Layer Style icon (the second icon from the left) at the bottom of the Layers panel and choose **Inner Glow** from the pop-up menu. This places a glow inside the edges of your image, but the default settings are very subtle, so we'll have to tweak them quite a bit. First, change the Blend Mode (up top) from Screen to **Normal**, or you won't be able to see your glow when we change the color. Then, click on the light yellow color swatch to bring up the Color Picker, choose black, and then click OK. The Size slider controls the amount of glow—we need to increase that to 18 to make the glow big enough to be seen with this image. And, finally, lower the Opacity down to 33%, so it doesn't look so dark and obvious. While you're still in that dialog, on the left side is a list of all the layer styles. Click on Stroke, and this adds a black stroke around your image. Click on the color swatch and change your stroke color to white, then from the Position pop-up menu, choose **Inside** (so the corners stay square, not rounded), and lastly, lower the stroke Size to just 2, then click OK.

STEP SEVEN:

Get the Horizontal Type tool **(T)** from the Toolbox, and then type "Always and forever" using the font Bickham Script Pro (it should already be installed on your system—it's an OpenType font from Adobe and that OpenType thing means it has special powers). Highlight the capital "A" in "Always," then press **Command-T (PC: Ctrl-T)** to bring up the Character panel (this is where all the main type controls are). From the panel's flyout menu (in the top-right corner of the panel), go to OpenType, and then choose **Swash**. This replaces your regular capital "A" with a beautiful stylized capital "A." If you then go under that same menu again, and choose **Stylistic Alternates**, it gives you an even bigger, more beautiful "A" (as seen here). Although only capital letters have that Swash feature, you can get stylized lowercase letters by highlighting a letter and choosing just Stylistic Alternates (that's what I did here to get that gorgeous "f" for the word "forever"). Use the Move tool (click on it in the Toolbox) to center the text better after you add the stylistic alternates.

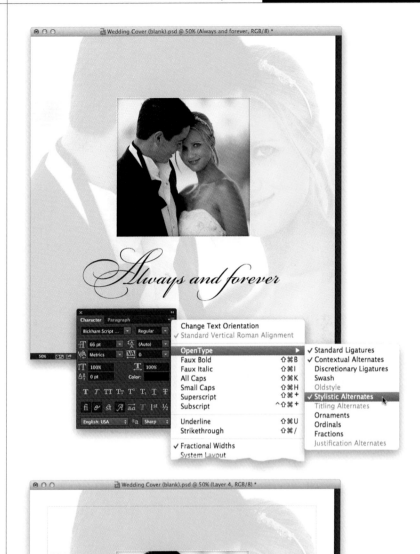

STEP EIGHT:

Let's finish things off by adding a drop shadow to our type, and a thin inner border to the page. Click on the Add a Layer Style icon again, but this time choose **Drop Shadow**. Move your cursor outside the dialog, click directly on your type in the image itself, and drag the drop shadow down and to the right, so it's a little bit away from the type (as seen here). Now, in the dialog, lower the Opacity to just 15% for a nice subtle shadow. For the final touch, add a new blank layer, then get the Rectangular Marquee tool and make a large, square selection about ½" inside the edges of the image. Then, go under the Edit menu and choose **Stroke**. When the dialog appears, enter a Width of 1 px, for Location choose Center, and click OK to add a black stroke around your selection. Deselect by pressing **Command-D (PC: Ctrl-D)**. The final step is to make the stroke look very thin by lowering the Opacity of this layer to just 40%. Voilà!

SHARPEN

SHARPENING AND DEALING WITH PROBLEMS

How cool is this?! I found a 2011 movie short named *Sharpen*, so—BAM—that's the title. Done. Boom. It's too perfect. Now, I must admit, it doesn't sound incredibly compelling, as IMDb simply describes it like this: "A boy talks about his family and recounts a traumatic event." Snore! Every boy has a traumatic family story and, while I didn't see the movie short, I'll bet my traumatic childhood story is much more traumatic than this kid's, so I thought I'd share it here: When I was a young boy, I always dreamed of taking a jet plane flight. I didn't even care where the plane was going. The whole idea was just so amazing, and being a passenger on a commercial flight was about the best thing this little boy could imagine. My older brother Jeff got to take a number of flights, but I was always left behind. But one year, on my birthday, my mother and father surprised me—the three of us would fly on a big jet to the "Big Apple." Finally, my dream would come true. The night before the flight, I couldn't sleep. I kept picturing the free snacks, and the soft drinks, and how polite I would be to the flight attendants (more polite than any little kid on any jet had ever been). I'd ask if I could go up front and take a peek inside the cockpit at all those instruments and dials, and if they gave me a pin-on pair of wings, I would probably just black out and be in the fetal position on the floor of the plane—I was that excited. But when we got to the airport, and they started to board the flight, I noticed we didn't board right away. So, I asked my mother if everything was okay since we weren't boarding, and she got down on one knee, looked me in the eyes, and said, "Honey, we're flying Southwest Airlines. There is no First Class." I started to tear up, but I stayed strong, I looked over at my dad and said, "Dad, we're at least in Business Class with lie-flat sleeper seats, right? We're at least in Business Class, right Daddy?" They chuckled and my mom said, "Dear, there is no Business Class on Southwest. We're in coach like everybody else." Well, I burst into tears, and I started screaming and cussing, and began kicking her in the shins, and she was sobbing and her shins were bleeding, and right then a TSA agent came up and Tasered us both. Coach class. Really?! I haven't spoken with either of them since. Take that, *Sharpen* kid with the "traumatic event."

THE SHARPENING FILTERS

Seeing as Lightroom has sharpening available in the Develop module, why do people love to sharpen in Photoshop so much? Well, the main reason is: we can see the sharpening in Photoshop much better than we see it in Lightroom. I'm sure there's some legitimate reason why, but whatever it is, the sharpening (at all magnifications) is just easier to see in Photoshop. Plus, you have more ways to sharpen (from subtle to over-the-top). Here are my four favorite ways:

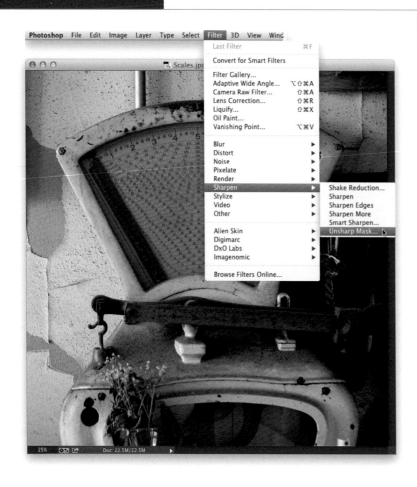

#1 UNSHARP MASK

STEP ONE:
The most popular tool for sharpening in Photoshop is the Unsharp Mask filter (don't let the name throw you—it's a holdover from the traditional darkroom days). Go under the Filter menu, under Sharpen, and choose **Unsharp Mas**k (as shown here).

STEP TWO:

There are three sliders in this dialog. The Amount slider determines the amount of sharpening applied to the photo; the Radius slider determines how many pixels out from the edge the sharpening will affect; and Threshold determines how different a pixel must be from the surrounding area before it's considered an edge pixel and sharpened by the filter (by the way, the Threshold slider works the opposite way of what you might think—the lower the number, the more intense the sharpening effect). So what numbers do you enter? I'll share the three settings I use the most these days: The first one produces a nice punchy sharpening and, of the three, it's the one I use most. The next one I use for sports shots, landscapes, cityscapes, or things with lots of textures. The last one, web sharpening, is one I use if I'm working with a low-resolution file (like a photo taken with a cell phone), or any image that's small in physical dimensions.

Standard sharpening

Heavy sharpening

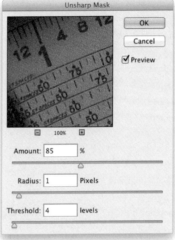

Web sharpening

STEP THREE:

When you use the Unsharp Mask filter, you get two previews of your sharpening: (1) you see the effects right on-screen as you drag the sliders, and (2) you see a zoomed-in preview of how the sharpening is affecting your image in the small preview window inside the Unsharp Mask filter dialog itself. If you click-and-hold inside this preview, it gives you a "before" (unsharpened) view of your image, and when you release the mouse button, you see the after again. You can see a full before/after here at right where I added the heavy sharpening settings from the previous step (Amount: 100%, Radius: 1.5, and Threshold: 0). They work great here, since this is a photo with a lot of texture and metal (stuff that looks great when you add a lot of sharpening). By the way, Photoshop doesn't do side-by-side before-and-afters like Lightroom. I had to duplicate the file, apply the sharpening to the image on the right, then leave the image on the left unsharpened.

Continued

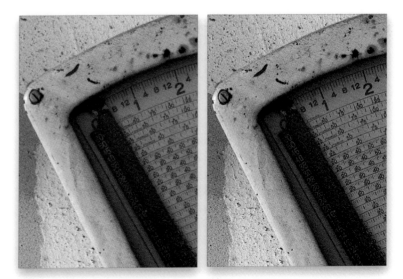

Before *After*

#2 SMART SHARPEN

STEP ONE:

This one is aptly named—it's a sharpening filter using a better mathematical algorithm than Unsharp Mask (which, by the way, has been in Photoshop since version 1.0) that lets you apply more sharpening with less of the bad stuff associated with sharpening (increased noise, halos that appear around the edges of objects, or little specks or artifacts in the sharpened image). You find it right near where you find the Unsharp Mask filter. Go under the Filter menu, under Sharpen, and choose **Smart Sharpen** to bring up the dialog you see here.

STEP TWO:

One of the downsides of sharpening has always been that if you apply a lot of sharpening, the edges start to get "halos" around them, but Smart Sharpen's new algorithm lets you apply a higher amount of sharpening before halos start to appear. So, how do you know how far you can push the sharpening? Adobe recommends that you start by increasing the Amount slider to at least 300%, then start dragging the Radius slider to the right until you start to see halos appear around edges. When they appear, back the slider off by just a bit (until the halos go away). By the way, did I mention that the Smart Sharpen window is resizable? Yup, just click-and-drag the bottom-right corner out as large as you'd like (as seen in the next step).

STEP THREE:

Now you've got your Radius amount set correctly, so go back to the Amount slider and start dragging it to the right (above 300%), until the sharpening looks good to you (or haloing appears, but you'd have to crank it quite a bit before that happens). I ended up leaving mine at 300%. Also, do you see that Remove pop-up menu? Make sure it's set to **Lens Blur** (it's the only good one). The top choice (Gaussian) basically gives you the same math as Unsharp Mask, so you're not getting the advantage of the "new math." The bottom choice (Motion Blur) is for those one-in-a-million times where you can determine the exact angle of the motion blur and try to counteract it by entering the angle of the blur in degrees. I have never been able to do either. Stick to the Lens Blur option and you'll be all right.

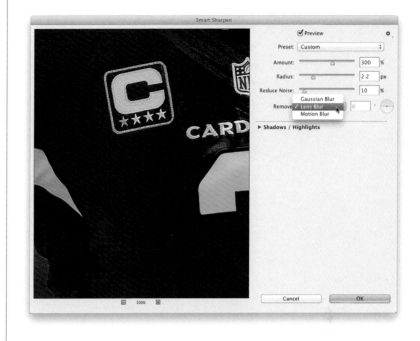

STEP FOUR:

Sharpening (in general) tends to make any noise already in your photo more visible, which is why the Smart Sharpen filter has a Reduce Noise slider (added back in Photoshop CS6). The goal with this slider is not to decrease noise; it's to let you add a lot of sharpening without increasing the noise, so after you apply your sharpening, then you'll drag this slider to the right until the noise in the photo looks about like it did before you sharpened the image, which is what I did here in the before/after of the original unsharpened image, and the Smart Sharpened version on the right.

TIP: SAVE YOUR SETTINGS AS A PRESET

If you find a set of settings you really like, you can save them as a preset by going to the Preset pop-up menu at the top and choosing **Save Preset**. Give it a name, and click Save, and now your settings preset will appear in that pop-up menu. Pretty handy.

Continued

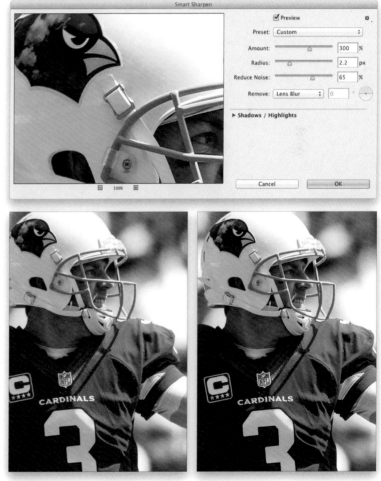

Before *After*

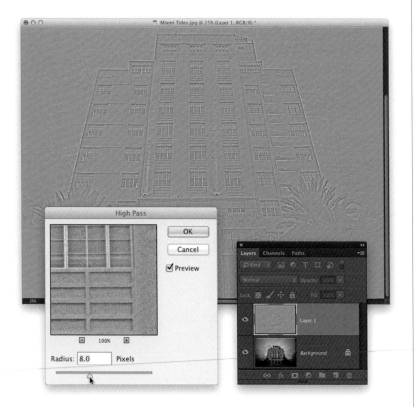

#3 HIGH PASS SHARPENING

STEP ONE:

This is a very high level of sharpening that's really popular with photographers who create HDR images or high-contrast effects, because it accentuates all the edges in the photo, and making those edges stand out can really give the impression of mega-sharpening. You start by duplicating the Background layer by pressing **Command-J (PC: Ctrl-J)**, then go under the Filter menu, under Other, and choose **High Pass** (as shown here).

STEP TWO:

Start here by dragging the Radius slider all the way to the left (everything turns gray onscreen), then drag it over to the right until you start seeing the edges of objects in the image clearly appear. The farther you drag, the more intense the sharpening will be, but if you drag too far, you start to get these huge glows and the effect starts to fall apart, so don't get carried away. For non-HDR images, go easy on the Radius amount—just drag until you see the edges clearly appear, then stop. Click OK.

STEP THREE:

Go to the Layers panel, and change the blend mode of this layer from Normal to **Hard Light**. This removes the gray color from the layer, but leaves the edges accentuated, making the entire photo appear much sharper (as seen below). If the sharpening seems too intense, you can control the amount of the effect by lowering the layer's Opacity in the Layers panel, or try changing the blend mode to Overlay (which makes the sharpening less intense) or Soft Light (even more so).

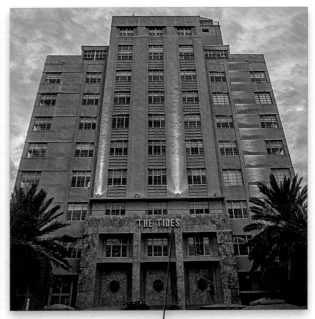

Continued

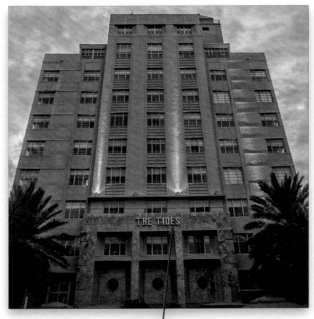

Before

After

#4: SHAKE REDUCTION

STEP ONE:
The Shake Reduction filter was introduced in Photoshop CC (so if you don't have CC, you can skip this) and is designed to remove blurriness that was caused by shooting hand-held with a slow shutter speed or a long lens. It only works if you moved the camera or lens while shooting. It doesn't work if what made your photo blurry was your subject moving. Just so ya know. Also, this filter works best on images that don't have a lot of noise, have a pretty decent overall exposure, and where you didn't use flash. So, while it doesn't work on every image, when it does, it's pretty jaw-dropping. Here's a shot I took in low light, handheld, and it is not sharp by any means.

STEP TWO:
Go under the Filter menu, under Sharpen, and choose **Shake Reduction** to bring up the dialog you see here. When the filter opens, it immediately begins analyzing the image, starting in the middle (where most blurring occurs) and searching outward from there. You'll see a little progress bar appear (as it's thinking) near the bottom of the small preview on the right side of the dialog (it's called the Detail Loupe). Once it's done doing the math, it shows you its automated blur correction and, as you can see here, it did a pretty amazing job of saving the shot. It's not perfectly 100% sharp, but the original was unusable. At least now, if I wanted to put it on Facebook or Twitter at web resolution, it would be totally passable, which I think is saying a lot. For most of us, this is all you'll need to do: open the filter, let it do its thing, and you're done.

Back in Photoshop CS6, Adobe introduced a filter called Adaptive Wide Angle that was invented for situations when you've got serious distortion or bending in an image from using a super-wide or fisheye lens. However, there are three things you need to know about this filter: (1) you're not going to use it very often, (2) you're either going to have to crop pretty massively after using it or use Content-Aware Fill to fill in the gaps, and (3) it actually does a pretty darn good job when you do need it.

FIXING WIDE-ANGLE DISTORTION

STEP ONE:
Open the photo that has a wide-angle lens issue you want to fix. In this case, it's a fisheye shot of the Georgia Dome taken from up high in the stands well before the game. Obviously, I wanted the rounded fisheye look, and it looks great on the stands and roof, but seeing the field bowing like it does here just looks weird. Ideally, the lines on the field would still be flat, and that's where the Adaptive Wide Angle filter shines. Go under the Filter menu and choose **Adaptive Wide Angle**.

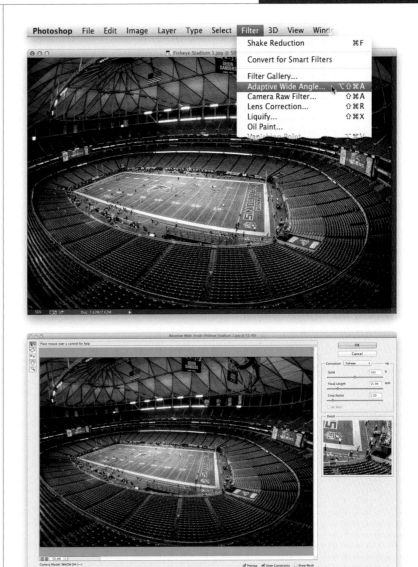

STEP TWO:
When the Adaptive Wide Angle dialog opens (shown here), it reads the lens data embedded into the photo by your camera (see the bottom-left corner of the dialog) and tries to apply an auto correction. Sometimes it does a pretty good job, but in this case, it's so subtle that the field is still really bent, so we'll have to help the filter out. With the Constraint tool (the first tool in the toolbox on the left), click at the base of the object you want straightened (the left corner of the field, here), and then as you move your cursor over to the right corner of the field, the aqua line you're dragging literally bends (it does this automatically because it knows the lens you used, and what kind of problems you're dealing with). You get a zoomed-in close-up of where you cursor is currently located in the Detail preview on the right (as seen here). If you mess up this Constraint line, Option-click (PC: Alt-click) once on it, and it's gone.

Continued

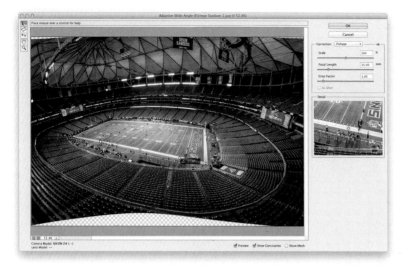

STEP THREE:

When you drag out that line, it immediately straightens that area (as seen here), and you'll see a thin circle with two handles (white dots) appear. Those handles let you fine-tune the angle of that line after you've laid it down, so if it's off a little (or a lot), you can grab one of them and literally rotate it to change the angle of the fix (as shown here). You may have more than one area that needs to be straightened, so you can draw more than one line if you need it. You'll also see gaps where it had to warp the image to do this straightening, so your image will have to be cropped down a bit when all this is over. Okay, that's the basic plan: you take the tool and drag it over parts of your image that need to be straightened and it does its thing.

TIP: IF YOUR LINE DOESN'T BEND

If Photoshop recognized your lens and has a profile for it, then the lines will bend automatically, but if not, then it's up to you to make the bend manually. Get the Constraint tool, click it on one side, then click at the end to complete your straight line. Then, go to the line, click on the center point, and bend the line so it fits.

STEP FOUR:

Once you click OK, you can see all the gaps that will need to be cropped away, so get the Crop tool **(C)** and click-and-drag in the bottom and top until most of the gaps are cropped away. Once you've cropped it, your image now appears as a layer, so you should flatten your image before you take it back to Lightroom.

TIP: STRAIGHTENING RECTANGLES

If you need to quickly fix something like a doorway or window (a rectangle), then use the Polygonal Constraint Tool (the second tool down), which works like the Polygonal Lasso tool: just trace around your rectangle and it straightens it.

Group shots are always a challenge because, without a doubt, somebody in the group will be totally hammered (at least, that's been the experience with my family. You know I'm kidding, right?). Okay, the real problem is that in group photos there's always one or more people who blinked at just the wrong time, or forgot to smile, or weren't looking at the camera, etc. Of course, you could just take their expression from another frame and combine it with this one, but that takes a lot of work. Well, at least it did before the Auto Blend feature. This thing rocks!

STEP ONE:
Here's a group shot where all three of our subjects are in nice sharp focus, and I like the facial expressions on both women. But the guy in this shot was blinking when the shot was taken, so we'll need to find another shot from that same shoot where he wasn't blinking (this is why we never take just one or two shots of a group).

STEP TWO:
Here's another shot taken just a few moments later. The guy looks great here, and he and the woman beside him are both in nice sharp focus, but the woman in the back moved a few inches back between frames, and now she's out of focus (take a look at where I zoomed in on her face, and you can see it is quite soft focus-wise). So, the idea is to take the guy on the right from this shot and combine him with the previous photo to make one single group photo where they're all in focus and his eyes are open.

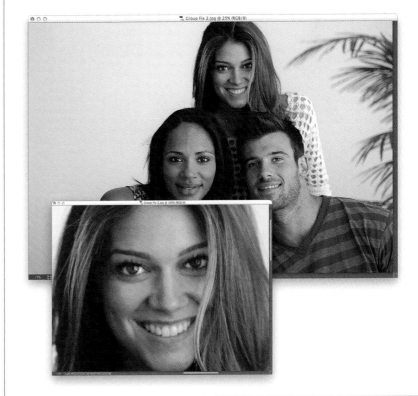

Continued

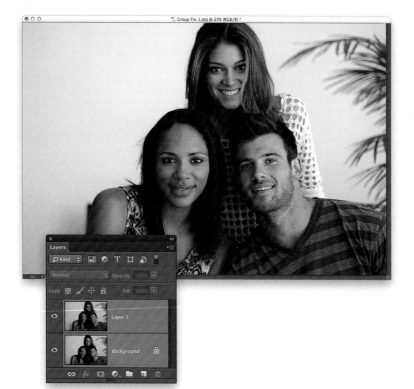

STEP THREE:

First, we need to get the two photos into the same document. So, click on the image where the guy's expression looks good and press **Command-A (PC: Ctrl-A)** to put a selection around the entire image, then press **Command-C (PC: Ctrl-C)** to Copy that image into memory. Now, switch to the photo where the guy's eyes are almost closed and press **Command-V (PC: Ctrl-V)** to Paste the image in memory right on top of it. The pasted image will appear on its own separate layer (as seen in the Layers panel here), but if any of our subjects moved even a tiny bit between frames (and we know they did, since the woman in the back is out of focus in the second shot), then the two photos won't be perfectly aligned. Luckily, Photoshop can do the layer alignment for us. Start by going to the Layers panel and, with the top layer already selected, Command-click (PC: Ctrl-click) on the Background layer, so both layers are selected (as seen here).

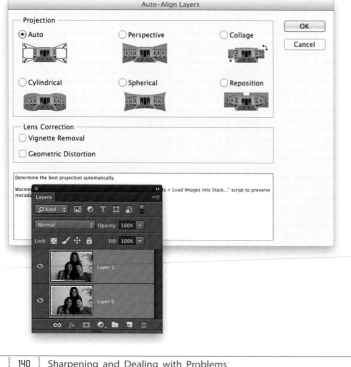

STEP FOUR:

Now, go under the Edit menu and choose **Auto-Align Layers**. When the Auto-Align Layers dialog appears, click on the Auto radio button (if it's not already selected), and then click OK to have Photoshop align the two layers for you (and it usually does a pretty darn amazing job at it, too!). However, to make two photos align where people moved a little during the shoot requires it to slightly resize and tweak the photos a bit to make that happen, which generally leaves a gap around the outside edges of the image (seen in the Layers panel here—look at the outside edges in the thumbnails). So, you'll have to get the Crop tool **(C)** and crop the photo just a tiny bit, so you don't see those gaps along the outer border (you'll see that I cropped the image in the next step).

STEP FIVE:

Now that they're aligned, click on the top layer to select just that layer, then press-and-hold the **Option (PC: Alt) key** and click on the Add Layer Mask icon (the third icon from the left) at the bottom of the Layers panel to hide the top layer (with the guy's eyes fully open) behind a black layer mask. Next, get the Brush tool **(B)**, choose a medium-sized, soft-edged brush from the Brush Picker in the Options Bar and, with your Foreground color set to white, paint over the guy's eyes and nose (that general area). As you do, it reveals the good version of him on the top layer (as shown here). In this case, the alignment worked so well that all I had to paint in was the area at the top of his face. But, depending on the image, sometimes you might have to paint more (like an entire face, or some hair, etc.), so don't be afraid to reveal more of the good shot if you need to. Finally, go ahead and flatten the layers (from the Layers panel's flyout menu). The original images and the final fixed image are shown below.

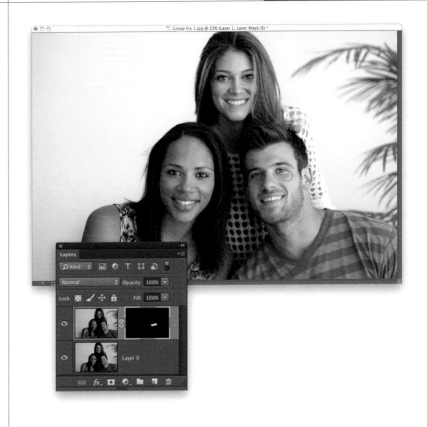

Before: The guy's eyes are almost closed in this shot

Before: Here, his eyes are open, but the woman in the back is out of focus

After: Parts of the two photos are combined to make one perfect group shot, where everyone's eyes are open, and everyone is in sharp, perfect focus

FIXING REFLECTIONS IN GLASSES

I get more requests for how to fix this problem than probably all the rest combined. The reason is it's so darn hard to fix. If you're lucky, you get to spend an hour or more desperately cloning. In many cases, you're just stuck with it. However, if you're smart, you'll invest an extra 30 seconds while shooting to take one shot with the glasses off (or ideally, one "glasses off" shot for each new pose). Do that, and Photoshop will make this fix absolutely simple. If this sounds like a pain, then you've never spent an hour desperately cloning away a reflection.

STEP ONE:

Before we get into this, make sure you read the short intro up top here first, or you're going to wonder what's going on in Step Two. Okay, here's a photo of our subject with her glasses on and you can see the reflection in her glasses (pretty bad on the left side, not quite as bad on the right, but it definitely needs fixing). The ideal situation is to tell your subject that after you take the shot, they need to freeze for just a moment while you (or a friend, assistant, etc.) walk over and remove their glasses (that way they don't change their pose, which they absolutely will if they take their own glasses off), then take a second shot. Luckily, I did that here.

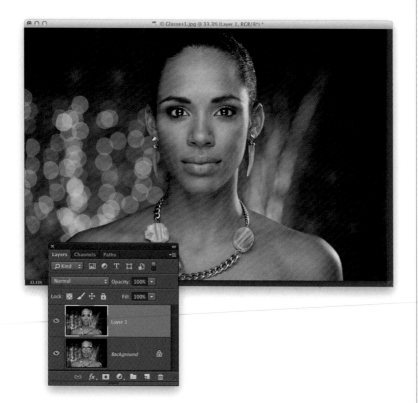

STEP TWO:

Since I could see there was a reflection in her glasses, I had someone remove them, and then I took another shot (her head moved slightly, but we'll be able to line the two shots up pretty easily). With the second shot also opened in Photoshop, get the Move tool (**V**) and, with both images visible (floating), press-and-hold the Shift key and click-and-drag the "no glasses" photo on top of the "glasses" photo, so they appear in the same document (as seen here in the Layers panel).

STEP THREE:

Now, holding the Shift key will help align the photos, but it's still off a little because she moved slightly between the shots. So, we'll get Photoshop to align them perfectly for us. Start by Command-clicking (PC: Ctrl-clicking) on each layer in the Layers panel to select them both, then go under the Edit menu and choose **Auto-Align Layers**. When the dialog appears (seen here), leave the Projection set to Auto and click OK. Once it's done, you'll probably end up with some transparent areas around the edges of your image, where Photoshop rotated the images while aligning them (also seen here), but we'll take care of those later.

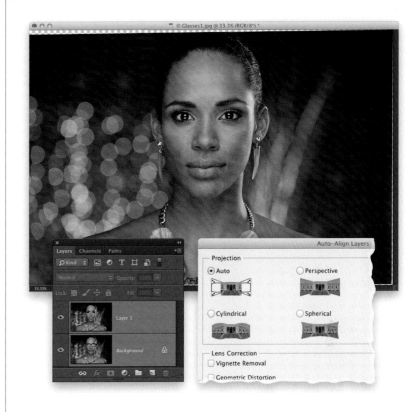

STEP FOUR:

Click on the top layer to make just that layer active, and then **Option-click (PC: Alt-click)** on the Add Layer Mask icon (the third icon from the left) at the bottom of the Layers panel to hide the top layer behind a black layer mask. You should now see the "glasses on" image, but in the Layers panel, you'll see that the black layer mask on the "glasses off" layer is active (it has a white frame around it).

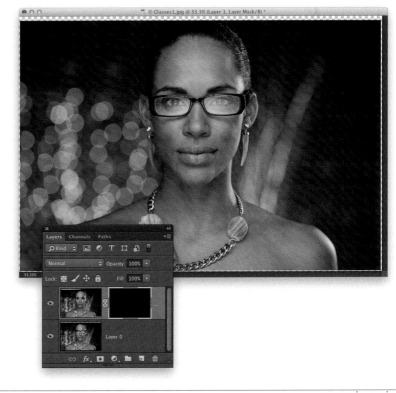

Continued

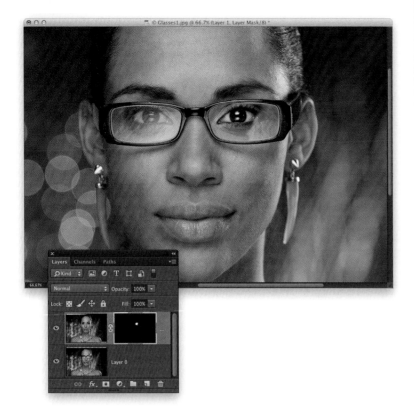

STEP FIVE:

Use the Zoom tool **(Z)** to zoom in on her eyes, make sure your Foreground color is set to white, get the Brush tool **(B)**, and choose a small, soft-edged brush from the Brush Picker up in the Options Bar. Then, simply start painting over the inside of the frame on the right, and it reveals the version of her eyes without the glasses on (as seen here). What you're doing is revealing the top layer, but just where you want it. Once the eye on the right is done, do the same thing for the eye on the left. Make sure you use a small brush and be careful not to accidentally erase any of the frames. If you do make a mistake, no biggie—just press **X** to switch your Foreground color to black and paint the frames back in.

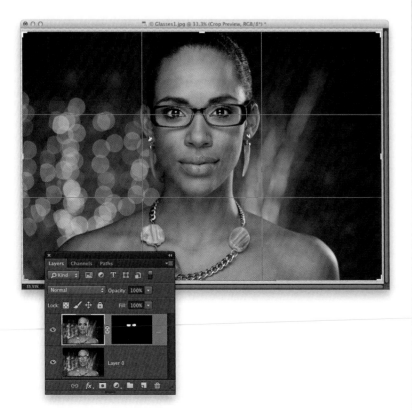

STEP SIX:

Once you're finished, zoom back out so we can fix the transparent edges. Grab the Crop tool **(C)**, drag the cropping borders in to the edges of the photo, and then press **Return (PC: Enter)** to complete your crop. Finally, you can go ahead and flatten your layers by choosing **Flatten Image** from the Layers panel's flyout menu (at the top right of the panel). You can see a before/after on the next page.

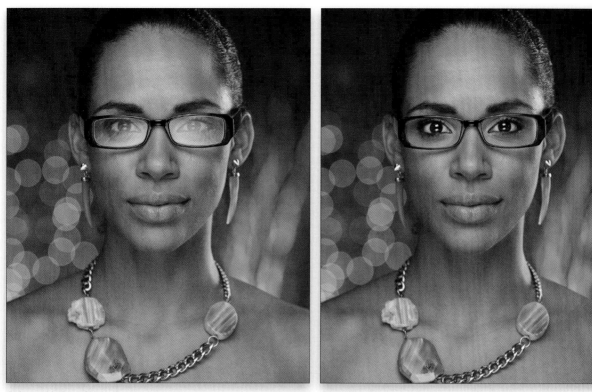

Before: with the softbox reflecting in her glasses *After: the reflections are gone*

REMOVING STUFF USING CONTENT-AWARE FILL

Photoshop's Healing Brush (a version of which is in Lightroom, called the Spot Removal tool) is great for removing spots, specks, wrinkles, and stuff like that. Its cousin, the Patch tool, is great for removing larger problems. But, there are lots of times when you need a different tool to take care of white gaps you get on the edges of your image, like when you've done a lens correction, or stitched together a pano, or in our case, rotated an image. Content-Aware Fill is perfect for this because it's faster, easier, and cleaner.

STEP ONE:
In this case, we rotated the image so the doorway behind the car is straight (the street is actually at an angle), but once we rotated the image, it left those white gaps in the corners. Of course, you could crop in tight until you've cropped all the white corners away, but then you've changed the composition of the photo, making the car's front bumper very tight to the edge of the image (and generally, you wouldn't want it that close because it would make the car look crowded). That's the wonderful thing about Content-Aware Fill: you keep the same composition, but it fills in the blanks (so to speak).

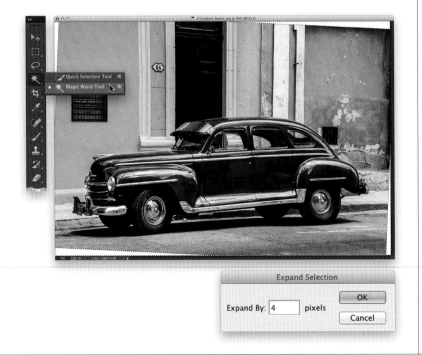

STEP TWO:
You start by selecting the white gap areas. When it's a solid color like this, the Magic Wand tool **(Shift-W)** is usually your best bet: just click it once in one of those gap areas, then Shift-click on another area (holding the Shift key adds the second area to your first selection). Keep holding that Shift key down and click on the other white areas, until they're all selected (as seen here). Once your selection is in place, you can help Content-Aware Fill do its thing by expanding that selection outward. So, go under the Select menu, under Modify, and choose **Expand**. When the Expand Selection dialog appears, enter 4 pixels and click OK, and your selection grows outward by that much.

STEP THREE:

Next, go under the Edit menu and choose **Fill**. When the Fill dialog appears, choose **Content-Aware** from the Use pop-up menu (shown here). Now, just click OK, sit back, and prepare to be amazed (and then go ahead and Deselect by pressing **Command-D [PC: Ctrl-D]**).

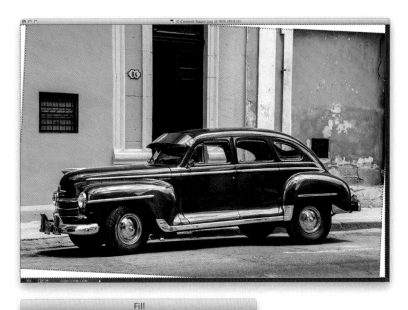

STEP FOUR:

Not only are the white gaps gone, but look how it extended the white columns on the top right, and the sidewalk on the right behind the car. (That's why it's called "Content-Aware" Fill. It's aware of what is around the object you're removing and it intelligently fills it all in.) The more I use it, the more it amazes me, but part of using this effectively is learning its weaknesses (like the strange effect on the blue wall in the top right), and how to get around them when possible. I do want to mention that while Content-Aware Fill often does a perfect job, just about as often, it doesn't work at all. It constantly surprises me in that it works brilliantly more times than I think it will, but in some cases, depending on the image and what you're trying to remove or fill, it either doesn't work at all or it fixes just part of the problem. If the results are just awful, press **Command-Z (PC: Ctrl-Z)** to Undo it. But, if it doesn't look great, ask yourself this: "Did it at least fix part of it, or even most of it?" If it even fixes some of the problem, then you have that much less work to do with the Healing Brush and Clone Stamp tool, like in this image.

DON'T MOVE

12 THINGS YOU'D THINK YOU'D NEED PHOTOSHOP FOR, BUT YA DON'T

I thought it would be really helpful to wrap up the book with a special bonus chapter to keep you from jumping over to Photoshop for things you can actually do as well, or maybe even better, right within Lightroom. The reason this is called a "bonus" chapter is that I wasn't even planning on having this chapter at all until I was about ¾ of the way through writing the book, and then I realized that if I added a few more pages to the book, even if they're blank pages with nothing on them, it would sell more copies, and if it sells more copies, then I get a cash bonus from my publisher, so…welcome to my bonus chapter. Okay, none of that is true. Well, the first part is (the part about doing more stuff in Lightroom), but in reality, the only way I get a cash bonus from my publisher is if I'm able to work a few naughty words into the book, because then the book can get an R rating from the NTSB, and book publishers know from decades of highly biased research that teens will buy any book with an R rating because there's a good chance that if they remove 75% of the "clean" words, what's left over is actually the entire lyrics to a rap song. Now all they have to do is put a drum track behind those lyrics, with enough bass response that it loosens the bolt holding your intake manifold in place (which can mess with your air/fuel ratio, which by the way wouldn't be a bad name for a band) and, before you know it, they're up on stage twerking like a boss with that guy you got to sing the chorus because you're just a rapper and not a singer (but of course, that's a best case scenario. Your mileage may vary). Anyway, I'm surprised you let me go this long without asking about where the title came from for this chapter. It's actually from the 2004 Italian flick *Don't Move*, starring Penelope Cruz, which I thought kinda fit since I'm telling you when not to move to Photoshop. Now, this movie is unrated, as best as I can tell, because it looks like it was only released in theaters in Italy, but I gotta believe a lot of Italian teens went to see it anyway because even though Penelope and co-star Sergio Castellitto aren't doing anything particularly naughty on the movie poster, it looks like they're about to, and for most teens, just the intent is enough.

12 THINGS YOU'D THINK YOU'D NEED PHOTOSHOP FOR, BUT YA DON'T

A lot of times, when I talk to Lightroom users and they tell me why they want Photoshop, it's actually for things that they didn't realize Lightroom could either already do, or actually does better. So, I thought I'd include this bonus chapter on the top 12 things you might think you need to jump over to Photoshop for, but you can do right in Lightroom. Hope you find these helpful. By the way, they're in no particular order.

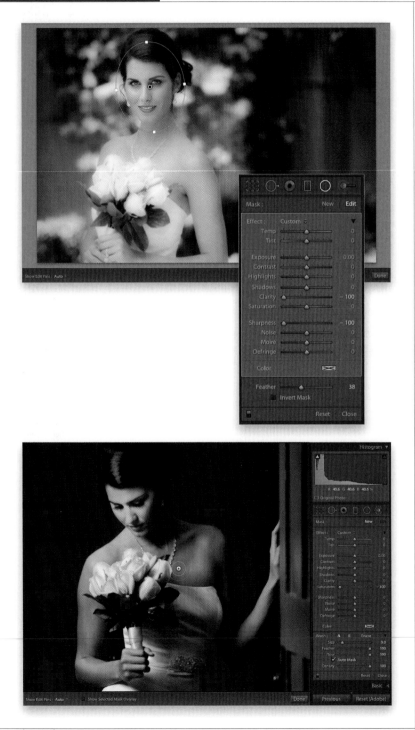

#1: CREATING AN IRIS BLUR EFFECT

Photoshop's popular Iris Blur filter enables you to pick one part of your image to be in focus (a circular or oval area), and then it gradually (or quickly) turns into an out-of-focus look. You can get a similar look in Lightroom's Develop module: Get the Radial Filter (Shift-M), drag it out over the area you want to remain in focus, turn off the Invert Mask checkbox, then lower the Clarity to –100 and the Sharpness to –100. The Feather slider controls the transition between the sharp in-focus area inside the oval and the out-of-focus background—the higher the Feather amount, the softer the transition. So, if it doesn't look sharp enough in the center of the oval, lower the amount.

#2: ADDING SELECTIVE COLOR EFFECTS

This is where the entire image is in black and white, except for one area (for example, a photo of a bride where everything is black and white, except her bouquet). In Photoshop, you'd duplicate the Background layer, convert the photo to black and white, add a layer mask, and paint the color back, or convert the image to black and white and use the History Brush to bring the color back. In Lightroom, go to the Develop module, get the Adjustment Brush (K), double-click on the word "Effect" to reset all the sliders to zero, and turn off the Auto Mask checkbox. Then, set the Saturation to –100 and paint over everything except the area you want to appear in color—stay clear of it by ½" or so. Now, turn the Auto Mask checkbox back on and paint right up to the edge of the area you want to remain in color—just keep the + (plus sign) crosshair in the center of the brush from crossing onto that area.

#3: CREATING A BACKSCREENED EFFECT

This is an effect often seen in wedding albums where an image appears faintly in the background, so you can put easily readable text over that image. We did this in Photoshop in Chapter 6 so we could place another image and some text over it, and add a couple layer styles. But, you can create this look in Lightroom by going to the Tone Curve panel (in the Develop module) and dragging the bottom-left corner point straight upward along the left side of the grid. The higher you drag, the more your image is backscreened.

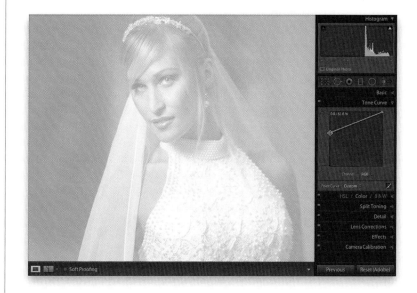

#4: FIXING AN OVER-LIT SHOT

If you have a portrait that has been evenly lit, but you want the image to appear as though the subject's face is nicely lit and then the light falls off gradually darker, in Photoshop you'd add a Gradient adjustment layer, choose the Black to Transparent gradient from the Gradient Picker, click-and-drag out a gradient, then you'd change the blend mode of this layer to Soft Light, and it would effectively do the trick. In Lightroom, you'd use the Graduated Filter instead. Just get the Graduated Filter **(M)** from the toolbox, double-click on the word "Effect" to reset all the sliders to zero, and click-and-drag the Exposure slider to the left a bit. Then, click-and-drag the tool from the part of the photo where you want the light to be darker, up toward your subject's face. Once you've dragged the tool, you can control how dark the lower part of the image appears using the Exposure slider.

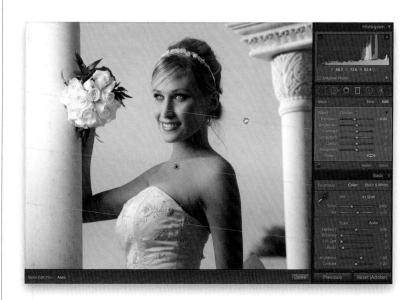

Continued

#5: SHARPENING WOMEN'S SKIN

In Photoshop, you'd duplicate the Background layer, apply the Unsharp Mask filter, then add a black layer mask to hide the sharpened duplicate layer. You'd then paint in white over the areas you want sharpened (like the lips, eyes, eyebrows, hair, etc.) and avoid sharpening the skin. In Lightroom, you can do the same thing faster and easier: Just go to the Detail panel, under Sharpening, and set your Amount, then press-and-hold the Option (PC: Alt) key, and click on the Masking slider. The image turns solid white, meaning the entire image is being sharpened, but as you drag the slider to the right, the image starts to turn black, leaving just the detail areas of your subject in white. Only the areas that appear in white will be sharpened, and if you drag far enough to the right, all that will be left in white will be those detail areas you want sharpened (like her eyes, eyebrows, lips, etc.).

#6: RUNNING PHOTOSHOP PLUG-INS

Photoshop has a plug-in architecture that lets you add third-party plug-ins for effects, for sharpening, and for a whole host of ways to expand Photoshop's power. Although they're usually called "Photoshop plug-ins," today most of these plug-ins have a version made to work with Lightroom and they work exactly like their cousins over in Photoshop (but without going over to Photoshop). Once you've installed a Lightroom plug-in, you can access it by going under the File menu, under Plug-In Extras, and choosing the plug-in you want. This plug-in here is one of my favorites. It's OnOne Software's Perfect Photo Suite 8, and this is their Portrait module running on an image I selected in Lightroom.

#7: CREATING A SHALLOW DEPTH OF FIELD BACKGROUND EFFECT

In Photoshop, you'd duplicate the Background layer, add the Lens Blur filter to make the entire image blurry, and then add a layer mask and paint over your subject in black to remove the blurriness from them. In Lightroom, you can blur the background by getting the Adjustment Brush **(K)**, lowering the Sharpness to –100, and painting over the background areas with the Auto Mask checkbox turned off. Now, turn on Auto Mask and paint right up to the edge of the area you want to remain sharp (again, keep the + [plus sign] crosshair in the center of the brush from crossing onto that area or it will become blurry, too).

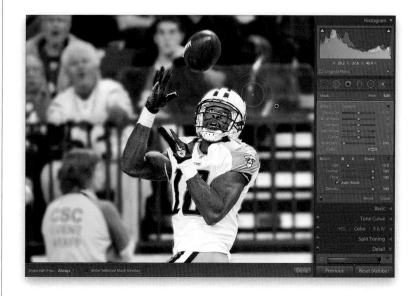

#8: REDUCING NOISE

You don't have to jump over to Photoshop to use a plug-in or filter to try to reduce noise in an image, because the best noise reduction out there is built right into Lightroom. Just go to the Detail panel and, in the Noise Reduction section, drag the Luminance slider to the right to reduce the amount of noise. (If you shot in RAW on your camera, this really rocks because you're applying the noise reduction directly to the RAW image, rather than creating an 8-bit image in Photoshop and then applying a plug-in.) If the image looks a little flat after applying noise reduction, drag the Contrast slider to the right. This behind-the-scenes shot was taken at 10,000 ISO and, by increasing the Luminance amount here in Lightroom, the noise is hardly visible.

Continued

#9: USING THE LIGHTING EFFECTS FILTER

Photoshop has a great filter that lets you apply a spotlight effect over any part of your image you want to highlight by darkening all of the area around that spotlighted area (I like the Flashlight preset. In fact, it's the only one I ever use). You can get the same look here in Lightroom: Get the Radial Filter **(Shift-M)** and double-click on the word "Effect" to reset all the sliders to zero. Now, drag the Exposure slider to the left a bit to darken the exposure, and click-and-drag out a circular or oval shape over the area you want to add the spotlight effect to. Turn off the Invert Mask checkbox, and the rest of the image is darkened while the area inside your circle remains unchanged, so it looks brighter. If you want it even brighter, click the New button, click-and-drag out a circle inside your existing circle, and then drag the Exposure slider to the right, and it brightens that area as much as you want.

#10: ADDING A PHOTO FILTER ADJUSTMENT LAYER

Photoshop has an adjustment layer that tries to replicate the look of traditional screw-on warming or cooling lens filters, like an 81 warming filter to add an orange tint for a warmer look, or an 80 cooling filter to add a bluish, cooler look. There are two ways to get this look right within Lightroom: Normally, I would do this by just dragging the Temp slider toward yellow for a warmer look or toward blue for a cooler look. Easy enough. If you want to try an alternate method, go to the Split Toning panel and, in the Shadows section, drag the Saturation slider over to 25, then drag the Hue slider toward yellow (for a warmer look) or blue (for a cooler look). For more of the effect, drag the Saturation slider to the right; for less, of course, drag it to the left.

#11: USING CURVES

Since we do our color correction in Lightroom by correcting the white balance (if necessary), we really don't have to jump over to Photoshop to use Curves for that. But, you could use Curves to create extra contrast, though, honestly, I never feel I need to do this, especially since Curves is right here in Lightroom if you really need it. Just go to the Tone Curve panel and there it is! You can click anywhere on the diagonal line to add a point. To create contrast, click once in the center of the diagonal line, then again in the top quarter of the line, and again at the bottom. Now, drag the top point you added upward to increase the highlights, and drag the bottom point you added downward to increase the shadows. This forms what's called an "S-curve" and the steeper you make that curve, the more contrast it creates, all without jumping over to Photoshop.

#12: SETTING YOUR WHITE & BLACK POINTS USING LEVELS

One of the reasons people love Photoshop's Levels is that they can use it to set an image's black point (the darkest the shadows will appear without turning them to solid black) and the white point (the brightest the highlights will get without clipping). Luckily, you can set your white and black points right within Lightroom. To set the white point, press-and-hold the Option (PC: Alt) key and click on the Whites slider, and the image turns black. Drag the slider to the right until parts of the image start to turn white (those areas are clipping, or losing detail), then back it off just a tiny bit. That's it. You've set your white point. The Blacks slider works the same way, but the image turns white (as seen here). Drag to the left and when parts of the image start to turn black (those parts are now solid black), back off just a tiny bit.

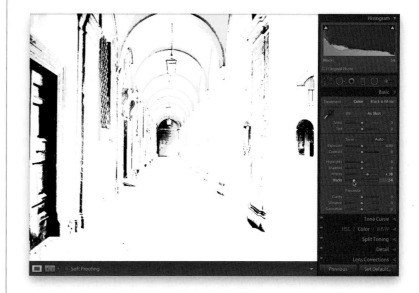

INDEX

NATIONAL ASSOCIATION OF PHOTOSHOP PROFESSIONALS

INSPIRATION
IS WAITING

NAPP members know how to take an ordinary image
and turn it into something extraordinary. Just like featured
Guru Winner Ang Lee Cheng. **You can too**.

NAPP

Join the community at **photoshopuser.com**

BECOME A MEMBER OR RENEW TODAY & GET 2 MONTHS FREE! Use promo code **PS4LR**

Adobe, the Adobe logo and Photoshop are registered trademarks of Adobe Systems, Incorporated. Image courtesy of Ang Lee Cheng. This promo cannot be combined with any other offers. International prices may vary.